A Chanticleer Press Edition

William H. Amos

WILDLIFE OF THE RIVERS

HARRY N. ABRAMS, INC., PUBLISHERS, NEW YORK

First frontispiece. *A Eurasian kingfisher* (Alcedo atthis) *bursts from the water. Although only 10 percent of its dives for fishes are successful, this bird makes at least a hundred plunges a day into streams from overhanging branches and so manages to feed very well.*

Second frontispiece. *The Canadian river otter* (Lutra canadensis) *is one of 11 species distributed throughout the Old and New Worlds. A remarkably swift and nimble swimmer, it can remain underwater for several minutes in pursuit of fish prey. Serious hunting is done at night, but during the day, if undisturbed, the otter plays and basks in brooks and streams.*

Third frontispiece. *Weighing over 700 kilograms, the Kodiak brown bear* (Ursus arctos middendorffi) *is the world's largest terrestrial carnivore, although at birth it weighs less than half a kilogram. It is carnivorous only during spring salmon runs up Alaskan rivers; during the rest of the year it consumes berries, tubers, roots, and other plant matter.*

Overleaf. *Once the spawning migration of Pacific salmon* (Oncorhynchus) *has begun, no natural obstacle can bar the way of these powerful, determined fishes. They ascend raging torrents and battle their way through exposed, rocky shallows, until finally each battered fish finds its own home spawning ground—the very brook in which it was hatched years before.*

Library of Congress Cataloging in Publication Data

Amos, William Hopkins.
Wildlife of the rivers.

(Wildlife habitat series)
"A Chanticleer Press edition."
1. Stream ecology. I. Title. II. Series.
QH541.5.S7A45 574.5'26323 80-21928
ISBN 0-8109-1767-X

Library of Congress Catalog Card Number: 80-21928

Composition by Dix Typesetting Co. Inc., Syracuse, New York
Printed and bound by Amilcare Pizzi, S.p.A., Milan, Italy

Note: Illustrations are numbered according to the pages on which they appear.

Prepared and produced by Chanticleer Press, Inc., New York:

Publisher: Paul Steiner
Editor-in-Chief: Milton Rugoff
Managing Editor: Gudrun Buettner
Project Editor: Mary Suffudy
Assistant Editor: Ann Hodgman
Production: Ray Patient, Helga Lose
Art Associate: Carol Nehring
Picture Library: Joan Lynch, Edward Douglas
Map: H. Shaw Borst
Design: Massimo Vignelli

Consultants: John Farrand, Jr.; Franklin Daiber, The University of Delaware

Appendixes, text: pp. 194–203, 222–225 by William H. Amos; pp. 206–221 by Gareth Nelson, The American Museum of Natural History

Appendixes, art: Dolores R. Santoliquido

Contents

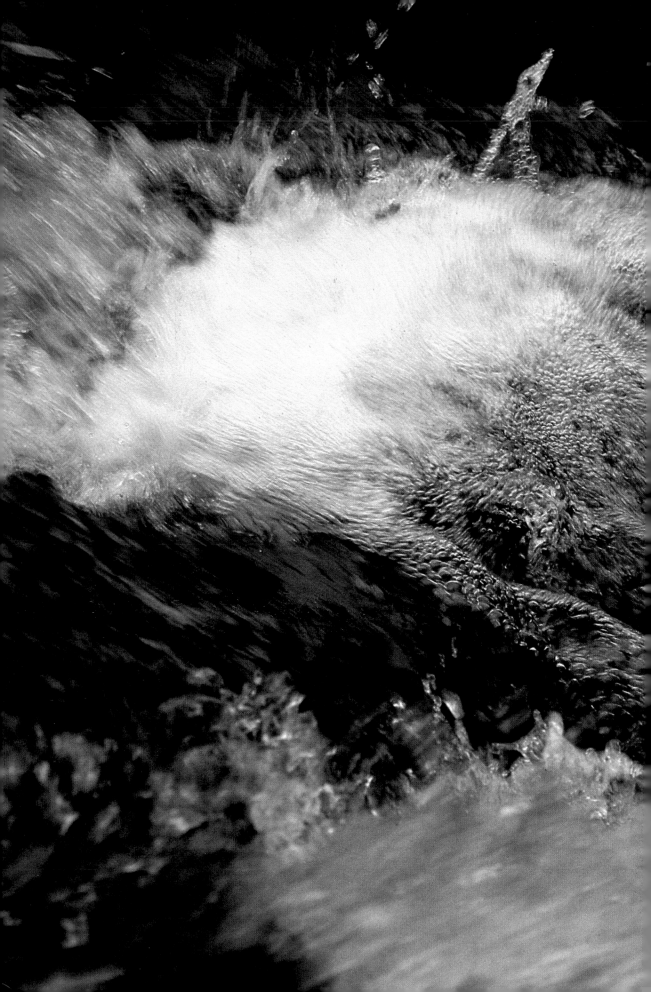

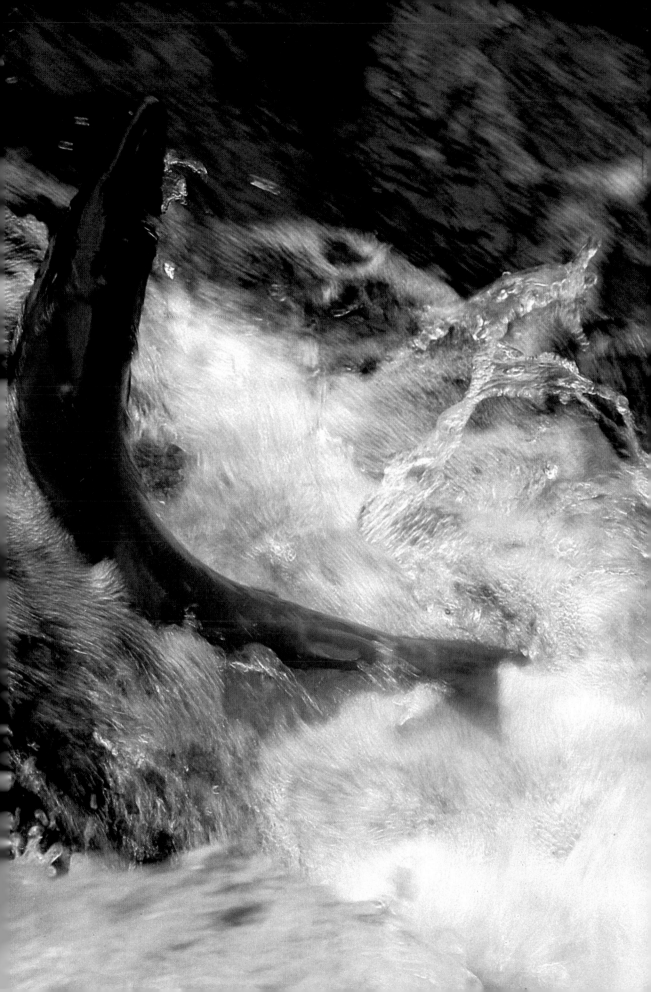

Preface

The essence of a river is that it *flows*. Leonardo da Vinci wrote, "When you put your hand in a flowing stream, you touch the last that has gone before and the first of what is still to come." It is almost as if river animals have read this statement and taken heed. Every form of life associated with flowing water exists only because a streaming current brings food and oxygen, makes life difficult for all but the most specialized competitors and predators, carries wastes away, and provides an avenue to the farther penetration of the land.

Rivers thread through all the Earth's continents, bringing aquatic habitats to regions where otherwise there would be none, or draining away rainfall that might inundate forests. Rivers re-work the face of the land by the force of their eternal flow and the ceaseless grinding of fine abrasive sand against great rock faces. Canyons and floodplains, waterfalls, marshes, and estuaries are all phenomena created by water running from high country to a final meeting with the sea. These features occur on a planet whether or not life exists. Only water is required. Thus our neighbor, Mars, displays evidence of a previous existence of large rivers in its massive valleys, meanders, and deltas. Yet what fascinates me is the life such waters here on Earth contain, life that all too often is hidden from us, or neglected.

I remember stepping easily over the Connecticut River where it is less than thirty centimeters wide, on wet black rocks where a single devil's paintbrush bloomed from a crevice. I remember later discovering the source of the Delaware River as a moist spot in a forgotten meadow. In both instances I was aware of life present within the shallow waters but, having traced both rivers hundreds of kilometers to their headwaters, I experienced a kaleidoscopic vision of all the habitats from source springs and torrential brooks through lowland streams, great spreading rivers, and on out into sea-fronting estuaries. The scores of animals I had seen and studied I knew could live nowhere but in their own particular reaches of the two rivers. So it is with every river, whether it lies within the Arctic Circle, floods amid wide rain forests, or churns along through arid wasteland. Each river has its own life; every river is unique.

Rivers contain the same life forms only if certain plants and animals reach different streams, and there survive. Or perhaps they evolve almost identical adaptations to the rushing flow, even though they are continents and oceans apart. I travel the world looking at rivers. In some, I find old friends, usually small creatures or certain plants, that I have seen time and again on different continents. A familiar face, whether it bears tentacles or multi-faceted eyes, is a strangely comforting sight to a biologist. But always each river holds it own unique inhabitants, specialized lives that differ little or very much from those elsewhere. Each river plant and creature has in some fashion solved the one great problem facing it: how to survive in the mass of rushing fluid that tugs at everything in its path, forcing major changes in confining channels, and loosening boulders which then tumble booming through rock-faced gorges. Brute force or rigidity in holding fast are seldom successful solutions. More often it is a delicacy, a bending, an evolutionary ingenuity, that is the key: a means of using the current to

advantage, of finding the hidden pockets, of waiting patiently for precisely the right conditions before emerging from shelter, of remaining motionless for the rare bit of food to come flashing by and be caught by outstretched legs or gaping mouth.

The British scientist, J. Arthur Thomson, once wrote, "Living creatures press up against all barriers; they fill every possible niche all the world over. . . . It is hard to say what difficulties living creatures may not conquer or circumvent. . . . We see life persistent and intrusive—spreading everywhere, insinuating itself, adapting itself, resisting everything, defying everything, surviving everything." He could have been writing about organisms in the smallest mountain brook or in the broad, majestic Amazon.

What is a river? Who is to say? In this book we trace a few rivers, most of them familiar names. Some of them are healthy; others suffer from man-induced illnesses, yet given the opportunity, each can recover. Even the most cursory glance at photographs included here tells us there is no limit to life supported by rivers: strange rare river dolphins; giant fishes from the ancient past; ducks that live in the wildest torrents; bizarre frogs that swim in somersaults; huge rodents submerged to their eyes and ears; log-like crocodiles waiting, waiting. We travelers cross the surface of a flowing world populated more heavily than we can ever know. T. S. Eliot characterized the river as "a strong brown god—sullen, untamed and intractable." The river god hides his subjects well. It is the intention here to show a little of what goes on beneath the surface, what happens in the air above and in spreading reedbeds along shores.

It is time for us to understand the river, for we treat it cruelly, obliterating marshlands, destroying entire habitats and the special wildlife they support. Knowledge may bring reason, and reason, action toward saving and restoring some of the most remarkable ecosystems on our fragile planet.

William H. Amos

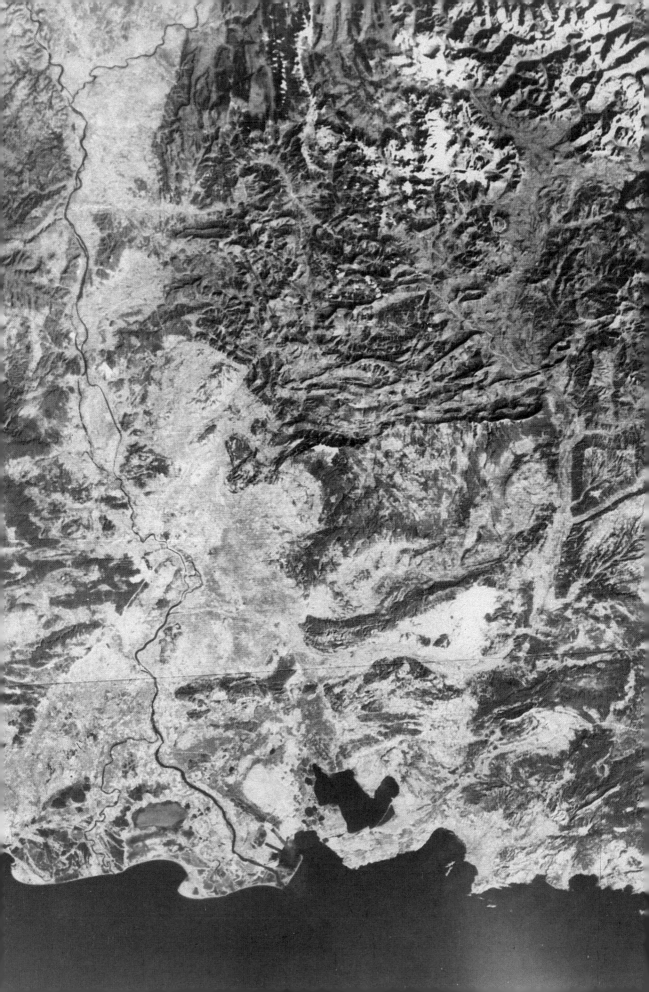

The Sources of Rivers

Ours is a planet of water. Billions of tons of water move each day across the face of the planet—great currents circulate slowly in the deep, while tiny droplets scud through the atmosphere as wind-driven clouds. Water in its most active form cascades down from high elevations through channels we know as brooks, streams, and rivers. It is in these fluviatile waters that we find some of the world's most intriguing creatures and specialized plants.

Aristotle understood the evaporation of water, its condensation and precipitation: the essence of the water cycle that was later described more thoroughly by Leonardo da Vinci. These early scientist-philosophers were unable to comprehend the magnitude of the cycling, for they had no means to measure the immense amounts of water involved. Today we know in approximate terms the volumes of water in motion and marvel at this magnificent, delicately balanced process that works to sustain equable temperatures and life itself on our planet. Roughly 249,480 cubic kilometers of water evaporates from the Earth's surface each year, 91 percent of it from the oceans. A precisely equal amount falls as rain and snow over both sea and land. Landmasses receive only about 40 percent of the total, or 100,380 cubic kilometers, as rain and an additional 9 percent as snow. The remaining 51 percent falls back into the sea.

It might seem that all rainwater falling on the land and the snow that melts on the ground should run off in streams, but only one-fourth does, or approximately 25,000 cubic kilometers flowing across the surface to reach the sea. Of the other three-fourths, some reevaporates at once, some percolates into the soil to become groundwater, and some is taken in by plants or held by absorbent surface materials. Much depends upon the season, the geology, and the climate of the region; certain areas receive less than 2.5 centimeters of rain a year, while others get very much more. Research currently in progress suggests that the wettest spot on Earth is high in the mountains of Maui in the Hawaiian Islands: at least 13.7 meters of rainfall per year—a figure calculated from measurements taken during the "dry" season!

Evaporation, a familiar yet mysterious process, occurs when water molecules, excited by a rise in temperature, break their loose bonds with one another and spring into the air, where they are held aloft, then borne away on the wind. Evaporation is the ascending part of the water cycle, a worldwide pump that lifts huge volumes of water thousands of feet into the atmosphere, high enough to descend later upon towering peaks of the greatest mountains. Once in the atmosphere, suspended water droplets perform a vital function: they serve as a kind of global thermal blanket, allowing the sun's rays to pass through the atmosphere and warm the Earth, while retarding the loss of heat radiated upward from the Earth. Were this not the case, the Earth would lose much of the warmth that allows life to exist throughout different latitudes.

Water molecules in the atmosphere coalesce most often by collecting around salt crystals from the ocean or soil and organic particles blown from the land. As they grow, droplets become visible as clouds, and when they are heavy enough to be attracted by gravity, as rain.

Rain, of course, is anything from a gentle misting to

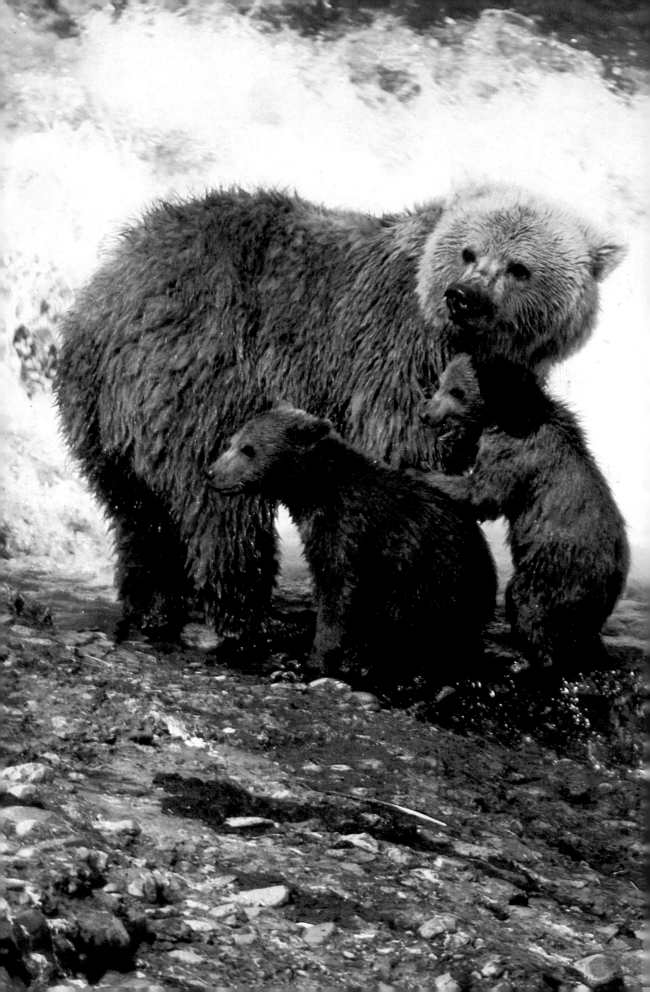

12. *Flowing southward into the Mediterranean, the Rhone is viewed from an altitude of 914 kilometers. This satellite infrared photograph reveals a wide spectrum of vegetal zones: Alpine meadows, cultivated valley croplands, and coastal plains.*

14–15. *Braided channels along the Zaire River are characteristic of a great river carrying huge amounts of sediment. The result is extensive deposits of sediment and redirection of the water flow. This infrared satellite photograph reveals dense, almost unbroken tropical rain forest, colored orange.*

17 top. *Greatly convoluted meanders of the Mississippi River reveal that even a great river pursues the path of least resistance.*

Center. *The huge Amazon River passes through Brazil in a somewhat braided pattern. It carries more sediment than its southerly tributary, the Purus. The latter's meanders are so looped that some are in the process of being cut off. Remnants of older isolated meanders, known as oxbow lakes, persist on either side of the main channel.*

Bottom. *Man has settled within the security of river systems for millennia. This satellite photograph shows the Seine and the sprawling city of Paris.*

blinding torrents. When the rainfall finally strikes the Earth, gravity continues to pull the water downward, either into the soil or along rivulets and broad seepages. No matter where a raindrop hits, it joins others in a flow, the direction of which is determined by the immediate slope of the land. Every hill has a peak, every ridge has a crest, so two raindrops falling only millimeters apart may eventually end up in different oceans. The highest point of a segment of land is a divide, which may be either an insignificant feature or a world-circling formation that influences the face of a continent by creating enormous watersheds.

Each of the continents has one or more major river divides. These, in turn, are related to the movements and collisions of the great crustal plates that make up the ever-moving face of the planet. One huge divide composed of the Andes and Rockies runs from the southernmost tip of South America north to Alaska and then west into northern Siberia. In Asia it separates into two divides, one crossing northern Russia and the other extending down through the Himalayas. They join again south of the Black Sea, cross Asia Minor, and run as a single divide southward into Africa through the Great Rift Valley lakes to the Cape of Good Hope. Most of the rivers described in this book were created by this world river divide, and they flow into watershed basins on either side.

Not all fallen water runs across the surface where it can be seen. Much travels underground, through porous soils or even deeper, trapped beneath rock strata to emerge after years—even millennia—into riverbeds hundreds or thousands of miles away. Groundwater may bubble up in cool springs or, if there is geothermal activity nearby, as hot springs, geysers, or fumaroles. All these sources may contribute to river flow. Less than half the volume of a river comes from surface runoff.

Vast quantities of water come from melted snow and ice. Glaciers and seasonally melting polar ice caps contribute water that may have been frozen for thousands of years. When the globe-girdling ice caps retreated after each glacial epoch, gigantic rivers of a size beyond our imagination roared down to the sea, scouring broad valleys and depositing continental shelves beyond the ocean shoreline.

River Patterns

River watersheds fall into three basic patterns. First, there is the *branching dendritic pattern* found frequently in granite or basalt uplands and mountains. The pattern resembles that of a tree, with the main downstream channel corresponding to the trunk and the tributaries (each with its own tributaries endlessly subdividing) to the branches. It ranges in scale from small assemblages of channels to huge river systems such as the Rhine.

Where mountains are pushed against one another in long folds, rivers may run parallel in a *trellis pattern*. One impressive example is found in the Himalayas, where the Mekong and Yangtze flow in nearly adjacent valleys for hundreds of miles, never joining and each eventually diverging to empty into different seas thousands of miles apart.

A third pattern, more common in local drainages than across large areas, is the *radial river system* in which

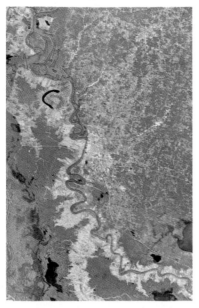

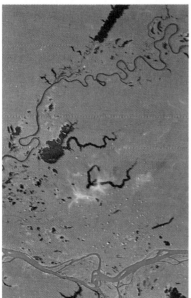

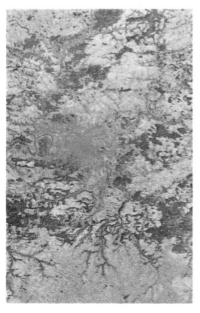

many separate rivers flow downhill away from a central high point, like spokes of a wheel. The rivers of the Bié Plateau in Angola, Africa, provide a large-scale example of this pattern.

Rivers are dynamic—never quiet, never resting in one bed for long. As they migrate across a landscape, they may invade one another's territory and engage in stream capture, which occurs when one dominant river cuts directly into the channel of another and diverts its flow into its own channel. An excellent example of this is found on the eastern seaboard of the United States where the Delaware River—over a long period of time after the retreat of the glaciers—succeeded in "capturing" the waters of a number of sizable rivers. From their headwaters these rivers flow seaward until encroached upon by the Delaware, at which point each turns abruptly to add volume to its captor. Their amputated downstream channels must begin over again with comparatively feeble trickles.

River Regimes

A truly large river can have an effect upon local weather, especially where its cool waters flow through arid regions. In far temperate and subarctic zones the comparatively warm water mass of a large river can affect the dry, frigid land through which it flows. Furthermore, a river can separate and isolate specific regions, preventing the migration of animals from one area to another. The Colorado, cutting deeply into a vast plateau, has left standing numerous isolated buttes that resemble flat-topped mountains. The vegetation and sparse animal life atop such a butte exist in virtual isolation from the rest of the world—unless they are organisms that can fly or be borne on the wind. A small mammal, such as a ground squirrel, may show slight evolutionary changes from its relatives on the main body of the plateau only a few kilometers away, much as would an animal isolated on an island in the ocean.

Well over fifty rivers in the world have lengths of more than 1,600 kilometers, and all drain areas totaling at least several hundred thousand square kilometers. These rivers alone, if stretched end to end, would extend 180,200 kilometers and drain 73 million square kilometers of land. Each has its own characteristics, its own populations of wildlife, its own geology and chemistry. No two are alike, and in fact each changes markedly within its own course. Complex as this may seem, the river habitat is a distinct one, unlike any other on Earth, and that is what we undertake to explore in this book.

Map coordinates and labels:

150° 120° 90° 60° 30° 0°

60°

30°

0°

30°

60°

Numbered locations on map: 1, 2, 8, 3, 4, 5, 9, 10, 6, 11, 16, 17, 19, 20, 7, 12, 14, 18, 13, 15, 21, 22, 26, 27, 32, 28, 28, 33, 34, 23, 24, 35, 29, 30, 31, 25, 90, 91

36
37
38•39•40
41•42•43
44•45
46•47
48
49

Each of the continents has one or more major river divides. These, in turn, are related to the movements and collisions of the great crustal plates that make up the ever-moving face of the planet. One huge divide composed of the Andes and Rockies runs from the southernmost tip of South America to Alaska and then westward into northern Siberia. In Asia it separates into two divides, one crossing northern Russia and the other extending down through the Himalayas. These chains join again south of the Black Sea, cross Asia Minor, and run as a single divide southward into Africa through the Great Rift Valley lakes to the Cape of Good Hope. Most of the Earth's rivers were created by this world river divide and flow into watershed basins on either side.

With the exception of water locked in snow, all water that falls on the land seeks lower elevations along paths of least resistance, thus eventually reaching the sea.

North America

1. Yukon
2. Mackenzie
3. Slave
4. Peace
5. Adams
6. Columbia
7. Colorado
8. Thelon
9. Nelson
10. Saskatche- wan
11. Missouri
12. Arkansas
13. Rio Grande
14. Ohio
15. Mississippi
16. Saint Lawrence
17. Delaware
18. Potomac
19. Connecticut
20. Hudson
21. Everglades

South America

22. San Juan
23. Purus
24. Manú
25. Colorado
26. Orinoco
27. Rio Negro
28. Madeira
29. Paraguay
30. Parana
31. Uruguay
32. Amazon
33. Xingú
34. Tocantins
35. Sao Francisco

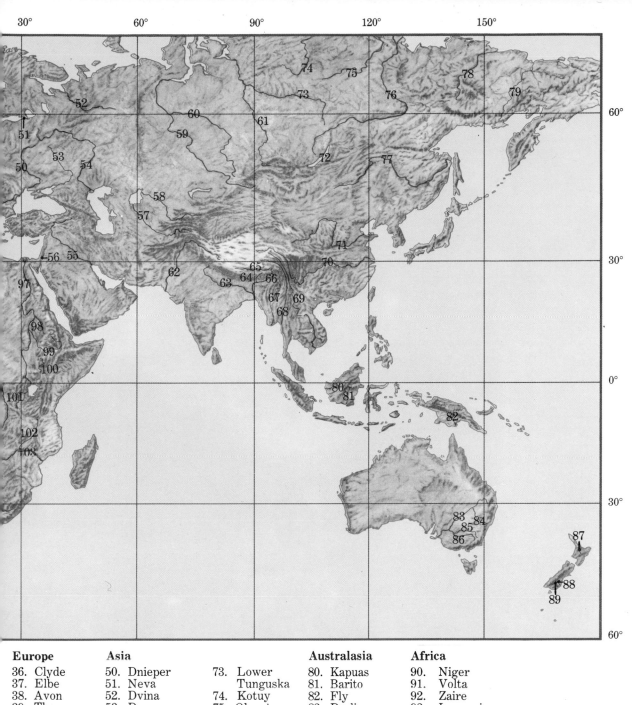

Europe	Asia		Australasia	Africa
36. Clyde	50. Dnieper	73. Lower	80. Kapuas	90. Niger
37. Elbe	51. Neva	Tunguska	81. Barito	91. Volta
38. Avon	52. Dvina	74. Kotuy	82. Fly	92. Zaire
39. Thames	53. Don	75. Olenek	83. Darling	93. Lomami
40. Meuse	54. Volga	76. Lena	84. Macquarie	94. Kasai
41. Seine	55. Jordan	77. Amur	85. Murrum-	95. Okavango
42. Rhine	56. Euphrates	78. Indigirka	bidgee	96. Orange
43. Oise	57. Amu Darya	79. Kolyma	86. Murray	97. Nile
44. Loire	58. Syr Darya		87. Waikato	98. Atbara
45. Rhone	59. Irtish		88. Waitaki	99. Blue Nile
46. Po	60. Ob		89. Clutha	100. Omo
47. Danube	61. Yenisei			101. Kagera
48. Tiber	62. Indus			102. Luangwa
49. Tagus	63. Ganges			103. Zambesi
	64. Manas			104. Chobe
	65. Tsang Po			
	66. Brahmaputra			
	67. Irrawadi			
	68. Salween			
	69. Mekong			
	70. Yangtze			
	71. Hwang Ho			
	72. Lake Baikal			

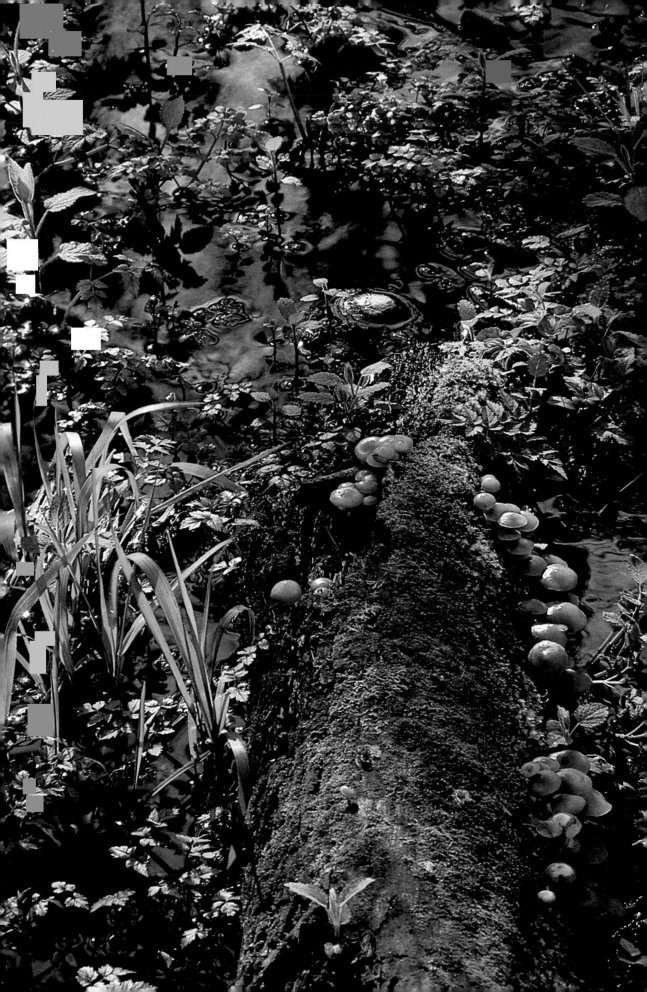

Rivers and Life

Looking at a mighty river, such as the Mississippi, one has difficulty imagining that somewhere, perhaps more than a thousand kilometers away, there is a tiny beginning. I remember stepping easily over the Connecticut River where it is less than 30 centimeters wide, and finding the headwaters of the Delaware in a moist meadow. Many rivers are born in high country, where the brooks that give them life are rapid and cold. Miles below, streams widen and flow more quietly, eventually converging to form rivers. When a river finally feels the rhythmic tidal influence of the sea, it becomes an estuary. Upstream, anywhere along the nontidal course of flowing water, natural or man-made dams may impound the water, creating lakes and ponds. They too are part of a river system, although their characteristics and the life they support are entirely different.

A Mountain Brook

High in the hills no sight is so welcome as a small brook dashing musically among rounded, scoured boulders. Normally a brook is turbulent, its water rushing over rocks to form highly aerated riffles. Except in times of unusually heavy flow, the brook world is unbelievably clear. It looks almost as though there is no water at all, except for the constant interplay of shadows across the rocky bottom as light is filtered and refracted through the rippling surface. The great velocity of the water is not apparent until one sees torrent moss (*Fontinalis*) streaming almost horizontally in the current. It is cold, almost frigid, in an upland brook, and the amount of oxygen dissolved in the water as a result of its temperature and bubbling turbulence is greater than in any other body of water.

A brook habitat is a special one, seemingly hostile if one believes that a warm, quiet pond is the ideal freshwater environment. There may not be so many species in a brook as in a pond, but those which are present are admirably adapted to its particular conditions and, in fact, could not survive elsewhere.

How to Live in a Brook

Of all the characteristics of a brook, the one that dominates is the rapid flow of water. It creates conditions that are impossible for a plant or animal to withstand unless it possesses special adaptations.

Perhaps the most obvious ability is the sheer power of a trout or salmon. Yet even these cylindrical, powerfully muscular fishes do not remain in the mainstream of a torrential brook longer than they must, but seek quiet pools and shelter behind rocks. Only when ascending from one pool to another do they resort to an enormous burst of swimming power. They explode through the surface below a riffle and, clearing it, fall back into the water near its crest, where they have a chance of gaining the next level. Large as they are, trout depend heavily upon food brought downstream by the current. They may capture insects flying over the water surface, but the bulk of their diet consists of other insects, aquatic or land-dwelling, that have been caught in the swift water and carried over riffles into pools. But a brook trout leaping out of the water to snatch a dragonfly from the air reveals an extraordinary degree of coordination on the part of the

fish: it must see the insect flying overhead, note its direction and speed, compensate for the difference in refraction of light between water and air, emerge from its quiet pool into the main force of the current, thrust its body upward, and snap up the swift insect. A fish's brain may not be complex by our standards, but it is a marvelous computer nevertheless.

Feeding on flotsam is common among animals highly specialized for brook life. One of the most remarkable is found among the many kinds of caddisfly larvae. Certain species (*Hydropsyche*) live in protective tubes hidden between two adjacent rocks on the brook bed and construct, just beyond their lair, a beautifully woven net composed of a precisely spaced mesh. Usually made with double strands to increase strength, the seine net is securely anchored to both rocks and bottom and billows out in the rush of water. Bits of organic debris and insects both dead and live are caught in the net. Periodically, the elongated caddis larva emerges to feed on the nourishing catch. If large objects damage the net, the larva promptly repairs the broken strands.

Some species build a fairly simple seine as described, while others construct elaborate silken funnels which channel bits of organic flotsam to a central collection point. Other caddis larvae do not build nets at all, although they are equally adapted to brook life. Some of these (*Psilotreta*) construct elongated cases, or "houses," of small, selected pebbles which not only serve as protective retreats but also are heavy enough to anchor them to the bottom in all but the swiftest water. Some species (*Goera*) place long, narrow ballast stones along their sides that act as weighty anchors. Others (*Mystacides*) construct their cases from small sticks; one or two especially long twigs stick out far behind the tubular case to serve as a rudder, keeping the insect facing upstream, the direction from which food comes. Each caddis larva has strong, clawed legs which can grasp the rocky bottom and also silk glands in its mouth that can be employed to spin anchoring mooring lines. Certain species (*Brachycentrus*) of caddis larvae raise their hair-fringed front legs into the current to snare food particles as they are swept past; other kinds (*Glossosoma*) cling tightly to a rock precisely under the brim of a riffle, secure in little humped cases of selected pebbles, while they rasp off algae and bits of organic matter on the rock surface.

Other forms of life also anchor in the swiftest part of a brook's fall. Some simple plants, such as torrent moss, grow only on the brink of small waterfalls and directly under the swiftest portion of riffles. The moss, once established, serves as a habitat for a wide variety of very small animals: mites, worms, rotifers, water bears (*Tardigrada*), and one-celled creatures (protozoans). The torrent sweeps by only centimeters above these organisms, but deep down in the moss all is quiet and serene—and these small, weak, and fragile creatures survive without difficulty in a world filled with food and saturated with oxygen.

Oxygen, dissolved in brook water more extensively than in any other natural aquatic habitat, is vital to all mountain brook animals. Examination of brook insects reveals that many of them have greatly enlarged, tufted gills, which are efficient in removing the essential

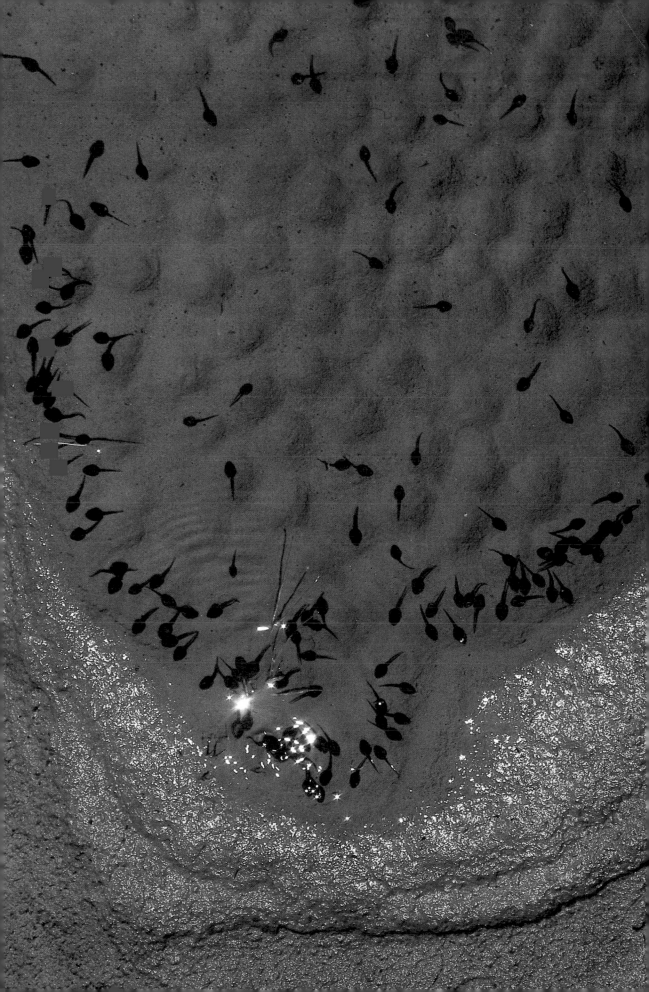

dissolved gas from the water.

Another adaptation for survival in an upland torrential brook is streamlining. One of the most symmetrically beautiful examples is the torrent beetle (*Psephenus*) of North America. This oval larva has movable spines around its flexible shield that it uses to seal its body to a surface. Similar spines are found on a European beetle larva (*Elmis*). Mayfly nymphs (Ephemeroptera) from North America, Africa, and Australia not only are flattened—a common adaptation among many insects in the brook environment—but have hairs or gills that extend outward to grip the substrate.

True suckers exist among some brook animals, such as leeches, broad-footed snails, and an amazing insect larva, the net-winged midge (Blephariceridae). This tiny larva has six suckers running in a line down its underside, one to each of its specially arranged and fused segments. The soft-rimmed suckers have a central funnel-shaped concavity, with a raised piston in the center. When the piston is withdrawn into its body, the result is a true suction cup that grips the rock surface (if it is sufficiently smooth) firmly enough to keep the animal in place even in the swiftest flow. Among lesser brook animals, hooks and grappling devices found on legs or other protuberances are sometimes used to hold onto the rock surface, but in other species the insect may first spin a silken mat on the rock and then hold onto that.

Silk is used not only by many insects in brook habitats around the world but also by certain small shrimp-like crustaceans (*Corophium curvispinum*) in rivers leading to the Caspian Sea. Some midge larvae build silken tubes that are tightly attached to rocks and have walls reinforced by bits of debris. The larva of the common blackfly pest (*Simulium*) feeds directly on the brim of a riffle, immediately under the crest of water flowing its swiftest. It weaves a tangled silken mat on the rock surface, which it grips with hooks on posterior leg-like appendages. The larva strains food from the plunging current by means of fringed, free-swaying appendages on its head. Should the small insect become detached from its mat, it is hurled downstream—but not far. Slowly it returns through even the swiftest flow to its original place. It accomplishes this unbelievable feat by reeling in a silken dragline that it had attached earlier to the rock as a safety measure.

Anchors and lines not only hold immature insects and a few species of freshwater clams in place, they also are widely employed to secure eggs to brook beds. Stoneflies may coat their eggs with an adhesive, while the eggs of some mayflies extrude long, sticky threads that quickly snare the substrate. Anchoring, however, may not be quite so elaborate. Weight itself is an effective anchor. Freshwater clams (Unionidae) living in rapid-flowing brooks and streams invariably have much heavier shells than their relatives in lakes and ponds, providing them with better survival capabilities.

Of course, survival in a brook has as much to do with behavior as with size, shape, or unusual anchoring devices. Many creatures living in rapid brooks cannot successfully combat the full force of the current, but spend their entire lives secure in sheltered spots, such as crevices between rocks and in deep pools or near the edge

of a brook where the water runs more slowly. Some brook creatures move from spot to spot during times of reduced flow after a springtime torrent has become a mere midsummer trickle.

All brook creatures show great sensitivity in selecting their precise habitats. Specific rock surfaces may be required; a certain water velocity is needed to spin a proper net; miniature channels are important for funneling food material downstream; shadowed crevices are sought by waiting predators; deep, still pools with a lessened supply of dissolved oxygen must be avoided by certain creatures; and so on.

Visitors to Brooks

A brook is not an entirely self-contained world. It is visited repeatedly by animals from the outside and receives organic contributions from both soil and fallen leaves and vegetation. Those remarkable compact birds, the dippers (Cinclidae)—whose range extends from Europe throughout northern Asia and the Americas— enter the swiftest currents and descend to the bottom, where they walk, using their wings as flippers in their search for aquatic insect food. Female dragonflies (*Cordulegaster*) hover over the rippled surface, extending their long abdomens into the water to deposit eggs, from which will later hatch a ferocious, jawed nymph. Deer, mink, tiger—animals of all kinds—come to a brook to feed or drink. During salmon runs in northern latitudes, brown bears (*Ursus arctos*) gorge themselves with easy catches of spawning fish trapped in shallow water. Torrent ducks (*Merganetta armata*) follow streams of the high Andes, moving skillfully through tumultuous rapids and falls.

Lowland Streams

Brooks do not remain cold and torrential for long, although in high, precipitous mountains they may fall from ledges and through chasms for many miles before reaching the gentler slopes of sediment-filled valleys and the lowlands. Without a steep descent they flow more quietly and slowly; they are warmer and laden with particles carried from high above, so they are no longer clear but increasingly turbid. With warmth comes a loss of dissolved oxygen, now replenished mostly through surface diffusion or in those few spots where rapids run again and turbulence aerates the water.

The flow is now far greater in volume, for a lowland stream is the product of the confluence of many brooks in the higher altitudes. Its volume promises further growth downstream. Because a stream is larger than a brook, its cross section is more complex. Along the shoreline the flowing water is retarded by friction, but toward the center the current snakes along at twice the shoreline speed. Along the bottom and the shore, fine sediments build up, fallen out of suspension in the quieter water. The newly created muddy substrate offers fresh opportunities to those plants and animals that find it a favored spot. Worms, insect larvae, and small invertebrates burrow down in the rich organic material. But they must be able to tolerate extremely low oxygen supplies, for there is little if any of this vital gas dissolved in the unmoving water of saturated mud.

Top. *A water scorpion* (Ranatra) *—actually an insect and not at all related to scorpions—lives in quiet backwater streams.*

Center. *The water scorpion's rigid body covering serves as a surface to which multitudes of tiny white stalked ciliated protozoans attach. The insect may be temporarily parasitized by the larva of a water mite* (Acarina), *shown here attached to the front leg.*

Bottom. *The mite's extremely small size makes it barely visible in the top photograph; but later, when it matures and assumes an independent existence, the mite resembles an animated scarlet sphere, tumbling along through the water by means of eight hair-fringed legs.*

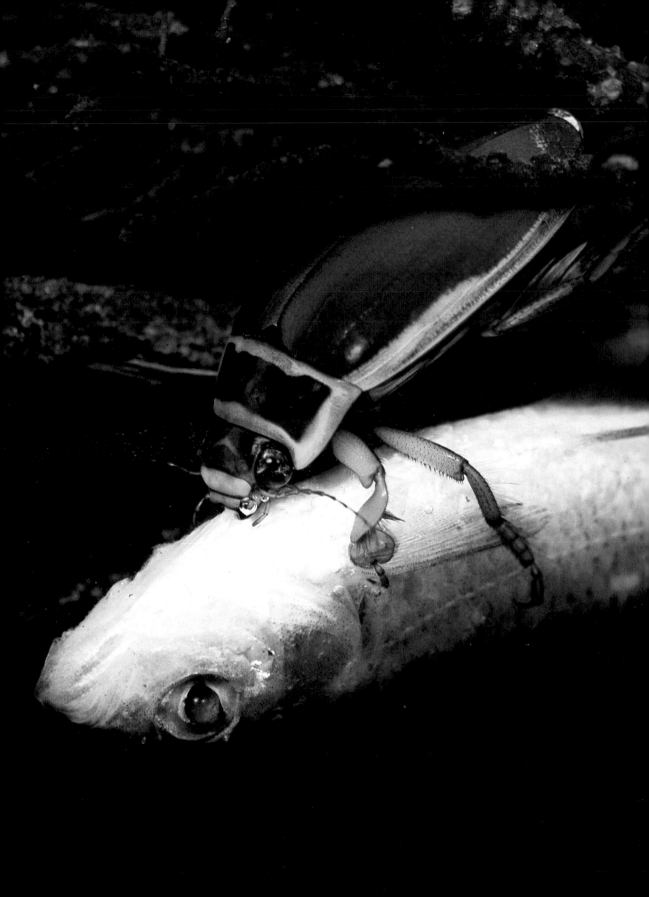

Many scavengers now crawl on the bottom: crayfish, snails, and a variety of insects different from those of cold rocky brooks. In lowland streams of Europe are harbor chub (*Leuciscus cephalus*), dace (*L. leuciscus*), grayling (*Thymallus thymallus*), and other minnows. Where streams are especially wide and slow, with quiet backwaters, pike (*Esox lucius*), roach (*Rutilus rutilus*), perch (*Perca fluviatilis*), and eel (*Anguilla anguilla*) abound. The great variety of habitats within a lowland stream offer increased opportunities for air-breathing animals as well. River otters (*Lutra*)—represented by a total of eleven species in the New World, Eurasia, and Africa—appear in increasing numbers in larger streams as they pursue prey and sport. Turtles bask on muddy stream shorelines or on protruding tree trunks carried downstream by the current and lodged on the banks. Water snakes and even some partly aquatic lizards appear in streams of the warmer latitudes. Swimming, wading, and diving birds abound.

The surface film is an untenable habitat in the dashing waters of a brook, but downstream it becomes a whole new world. Close to shore the surface is dimpled by insects that find its elastic film an almost limitless expanse over which to swim or skate, seeking food and mates. Water striders (Gerridae) skim along the surface on water-repellent feet, casting six oval shadows on the shallow bottom.

Whirligig beetles (Gyrinidae) course about in rapid circles across the surface, often in great numbers, but dive below when alarmed. Whirligigs and other water beetles (Dytiscidae, Hydrophilidae) that spend much of the time swimming beneath the surface are also air-breathers. They rise to the surface, posterior end up, and project water-repellent hairs through the film, where they remain anchored briefly while air is taken beneath their wing covers in the form of a single elongated bubble. After submerging again, they do not draw directly upon this source of air, for it would soon be depleted. Instead, the film surrounding the bubble serves as a physical gill, allowing an exchange of oxygen from the water into the bubble, while carbon dioxide exhaled by the beetle diffuses outward. An aquatic beetle can remain underwater for long periods of time, until the bubble eventually grows smaller as the inert nitrogen it contains (80 percent of its volume) is slowly lost to the surrounding water. Only then does the insect return to the surface to replenish its physical "gill." A few very small beetles, once they have their bubble, never require another.

Swimmers and Hitchhikers

Surface swimming and diving insects have extraordinarily well-developed paddles and oars. Back swimmers (Notonectidae) and water boatmen (Corixidae), both true bugs and not beetles, have long, oar-like legs with fringed paddles at the tips. Beetles display a wide variety of highly efficient, folding paddles composed of blades and bristles. Upon the power stroke, these paddles open fan-like to provide maximum thrust; but with the recovery stroke, they fold neatly and offer little resistance to the water. Many of the larger aquatic beetles are so efficiently designed that their bodies resemble the cross section of an airfoil or hydrofoil: convex on top and nearly flat on the

Opposite. *A large diving beetle (*Dytiscus marginalis*) is swift and powerful enough to capture other insects, as well as fishes several times its size.*

27. *The little male three-spined stickleback (*Gasterosteus aculeatus*) is a formidable match even for an attacker much larger than itself. Sharp dorsal fin spines that lock into place serve as an efficient defense mechanism.*

Overleaf, top row, left. *A male three-spined stickleback begins building a nest. Plant material is carried to the nesting site.*
Center. *The fish secretes strands of a mucilaginous substance from its kidneys to glue the nest together.*
Right. *It then spits sand on the nest, leaving entrance and exit holes clear.*

Center row, left. *The nest is ready, and the male pokes its head in the entrance hole, indicating the opening to the female.*
Center. *Once the female enters the nest, the male nudges her tail, stimulating her to lay eggs.*
Right. *The male enters the nest to fertilize the eggs.*

Bottom row, left. *The male chases the female away; otherwise she would eat the eggs.*
Center. *While the fertilized eggs develop, the male fans them with its pectoral fins, ventilating them with oxygenated water until they hatch.*
Right. *The newly hatched young will remain in the nest for approximately two days. The male guards them until they are able to swim away.*

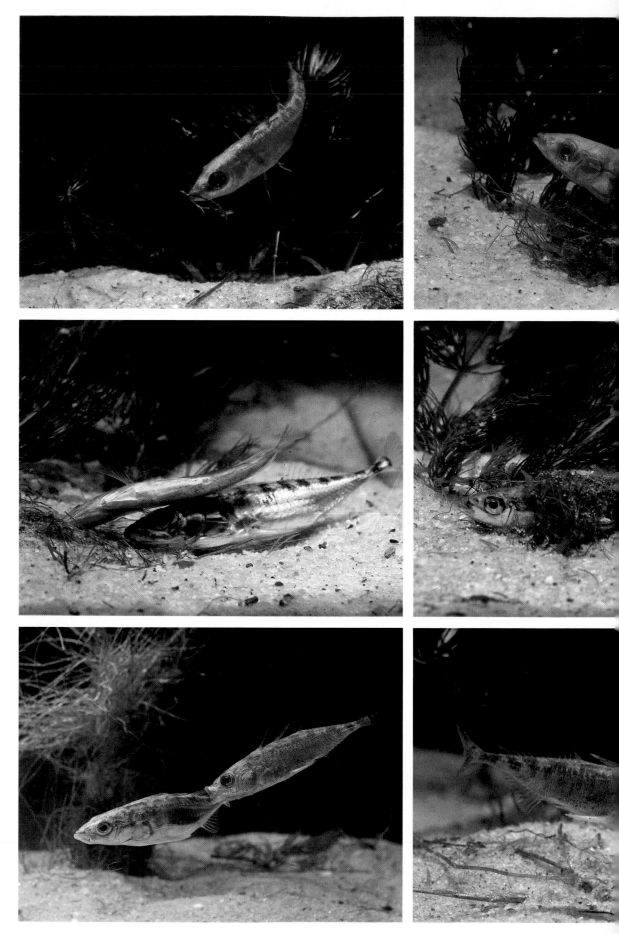

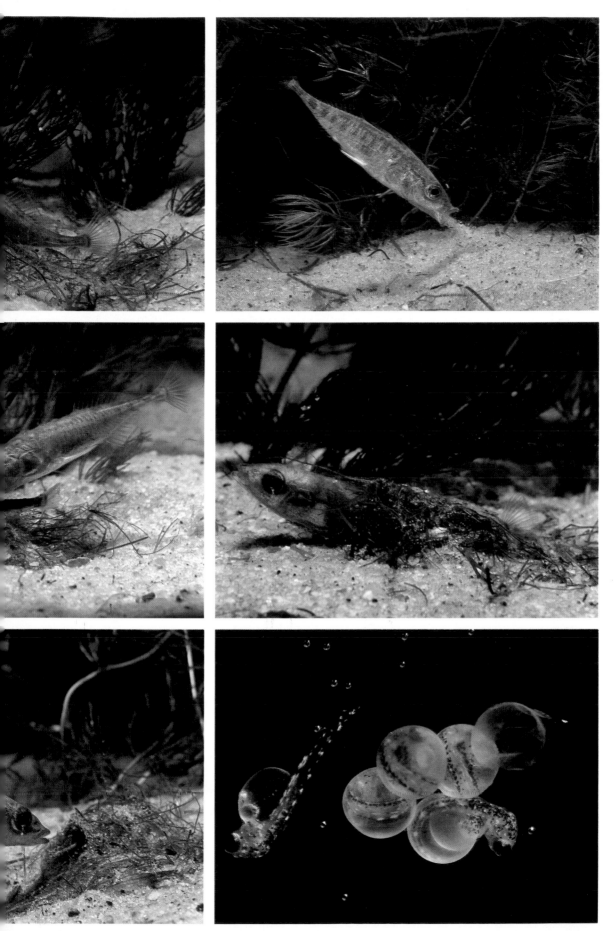

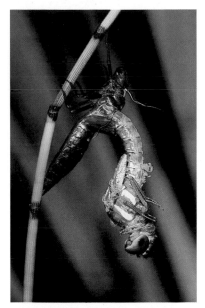

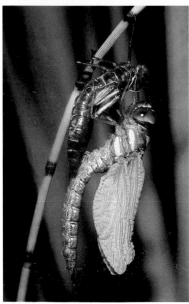

30 top. *Dragonfly nymphs
(Anisoptera) are purely aquatic
creatures that live in streams or
in quiet water. When the nymph
is approximately a year old, it
emerges from the water and
crawls up the stem of an aquatic
plant. The drying exoskeleton of
the nymph splits down the back,
and the soft adult crawls out.*

Bottom. *The newly emerged adult
pumps blood into its wing veins
until they extend fully, after
which the veins dry out. The
wings are then essentially lifeless
structures that are moved by
powerful muscles in the thorax.*

Opposite. *Few insects fly during
rain; most seek shelter or cling to
vegetation, as this adult North
American dragonfly (Libellulidae)
has done.*

bottom, thus creating a "lift" as they dash through the water.

Large fisher spiders live along the banks of slower streams, often dashing across the quiet surface after dark to hunt for insect prey. If startled or in pursuit of an elusive aquatic prey, one of these spiders may dive beneath the surface, its hairy body glistening while encased by a silvery coating of trapped air. I have watched such spiders remain submerged for three-quarters of an hour, clinging to an underwater leaf to keep from popping back up to the surface.

The muddy, silty bottom of a lowland stream offers a new kind of habitat to animals that find life impossible in the cold rocky brooks with bottoms composed of pebbles and harsh sand. Freshwater clams (*Anodonta cygnaea*) dig easily into the substrate, furrowing the bottom as they inch their way by means of a protrusible muscular foot. They are filter feeders; from the current they extract tiny particles of organic food, primarily one-celled algae. Water is inhaled through a gaping, tentacled siphon, and the food particles carried in are captured by mucus flowing across the layered gills, which obtain both oxygen and nourishment. Water is exhaled through a smaller rounded siphon.

The freshwater clam—or "mussel," as it often is mistakenly called (true mussels live in estuaries and the sea and are distinctly different in their anatomy)—relies on fish to disperse its young. After the eggs develop within thickened gills, they emerge through the excurrent siphon as fully developed larvae and appear as miniature clams, except for a few sharp teeth lining the edge of their paired shells. When a fish swims by, the tiny larval clams snap their shells wildly like miniature traps. Clamping on fish fins and gills, they grow and mature in the fish's tissues, living a parasitic life that doesn't harm the host. Later, the young clams drop from the fish to take up life on the bottom. A few river clams actually attract fishes by developing a fleshy protuberance of the shell-producing mantle which mimics a small fish, complete with black eyespot and fanning tail. When a minnow swims alongside to investigate, hundreds of larval clams are shot out of the siphon in its direction, assuring the attachment of at least a few dozen for a parasitic ride to maturity.

In Europe and Asia certain minnows, the bitterlings (*Rhodeus*), turn the tables on freshwater clams and use them for their own breeding chambers. A male bitterling will stake out a clam of its choice and lead a passing female to it. Into the gill chamber of the clam through its incurrent siphon, she then inserts a long tube, stiffened for the occasion, and lays her eggs. After she withdraws the tube and departs, the male releases a cloud of milt, or sperm, above the incurrent siphon, where it is drawn into the gill chamber and there fertilizes the eggs. The tiny bitterling young pass through their most vulnerable developing stages completely protected within the shell of the mollusk.

Lowland streams attract a wide variety of birds, although not so many as when streams merge to form great rivers. Water thrushes, kingfishers, small herons, rails, waterfowl such as the ubiquitous black duck (*Anas rubripes*), and others seek streams as a place to feed, nest, and rear their young.

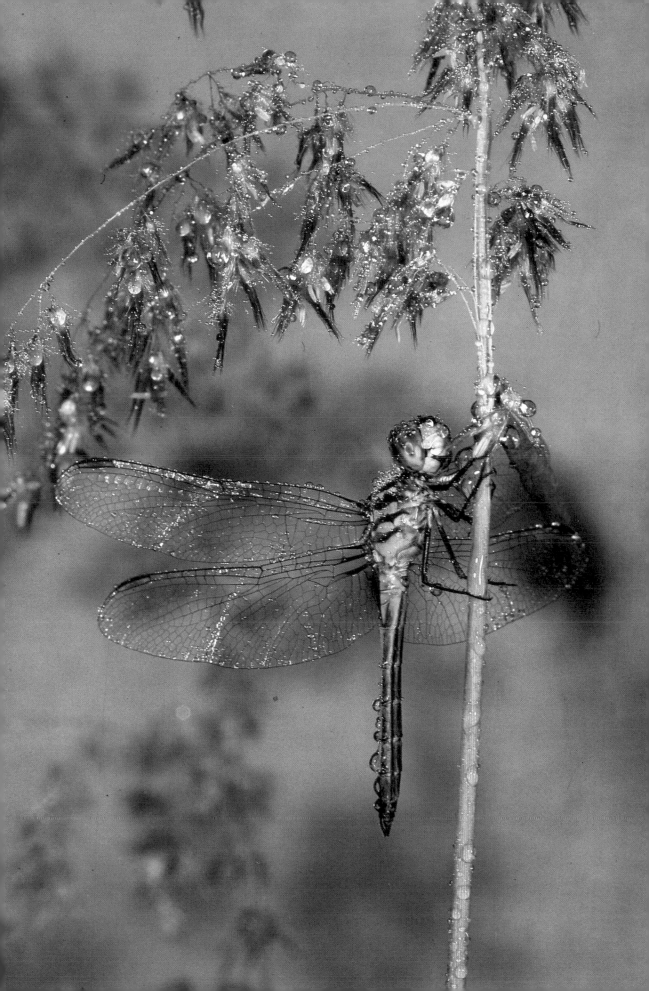

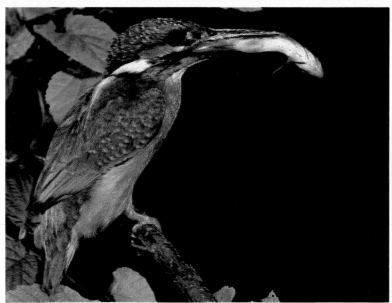

Above. *The malachite kingfisher
(Corythornis cristatus) is one of
the most widely distributed and
common African birds. It flies
swiftly over swamplands and
open water, but seeks more
secluded streams for nesting. A
pair excavates a nesting hole in
the stream bank, where eggs and
nestlings will be secure until
young are able to fly.*

Left. *The Eurasian kingfisher
(Alcedo atthis) is found
throughout most of Eurasia.
Extremely territorial, it excludes
others of its kind from an area
stretching some 120 meters
upstream and downstream from
its nest. Like most kingfishers,
members of this species beat their
fish victims to death against a
branch before swallowing them.*

The Work of a Stream

Streams course through flattened, sediment-filled valleys and across spreading lowlands. In such flat areas they exhibit dynamic forces very different from those of the upland brook, which simply plummets down, often knocking trees and rocks from its path. Because a lowland stream follows a gentle gradient downslope, it does not flow in a straight line but follows lines of least resistance, often not apparent to us. As a result, it usually wanders over the landscape.

The most obvious feature of a stream's course may be its meanders. When a stream encounters an obstruction like a landslide on one bank or a protruding rock or tree trunk, the current is deflected, swerving back to the opposite bank. Here erosion continues until new resistance that serves again to deflect the current is encountered. The forces involved never stop. The result is a gentle, serpentine wandering over the flat landscape that increases with time, until the river channel from high above looks like the looping of an enormous snake. Frequently meanders make such hairpin turns that not much land separates the water in the loop that has doubled back on itself so tightly. Sometimes the current erodes this narrow strip of land until a breach is opened. The stream now flows more directly, avoiding the loop's "detour." Isolated from the main flow, the amputated loop —known as an *oxbow pond*—stagnates; without an exchange of water, its oxygen level falls, and the populations of life it harbors become entirely different from those of the aerated, flowing stream. It is, in fact, a true pond with a population of plants and animals suited only to still water. Gradually, shoreline plants invade its area, it fills with sediment, and in time it vanishes. It leaves no more than a faint scar on the valley floor, but enriches that part of the fertile floodplain. From an airplane flying over a wide, flat valley, one can usually see hundreds of traces of old stream beds and ox-bow ponds left during the thousands of years the stream has writhed and twisted across the alluvial plain.

Sediment is deposited along the inner curves of a meander where the current slows and across the floodplain when water levels rise. This process is more dramatic farther downstream in larger rivers, but it begins upstream when tumultuous brooks give way to the quieter flow of small streams. The accumulation of sediment provides new habitats for burrowing animals and rich soils in which moisture-loving plants thrive. The banks of a lowland stream support an abundance of plants and small terrestrial creatures that find shelter and nourishment there. Streams within a watershed eventually merge to form the beginnings of a mighty river, and it is these massive bodies of flowing water that we shall now consider.

Above. *An American wood ibis
(Mycteria americana) probes for
fish. This bird, the only American
stork, nests in huge colonies in
trees from Florida southward
through Central America.*

Overleaf. *A great blue heron
(Ardea herodias) and an
American alligator (Alligator
mississipiensis) stalk their
respective prey side by side in the
shallow waters of the Florida
Everglades. Much of this region,
now protected, supports an
abundance and wide variety of
wildlife.*

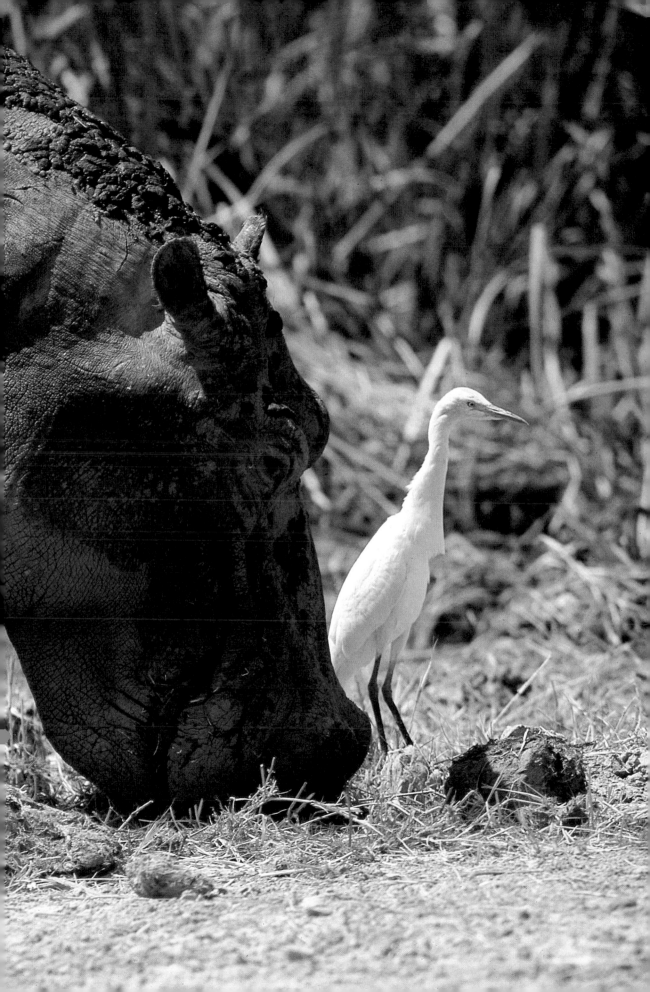

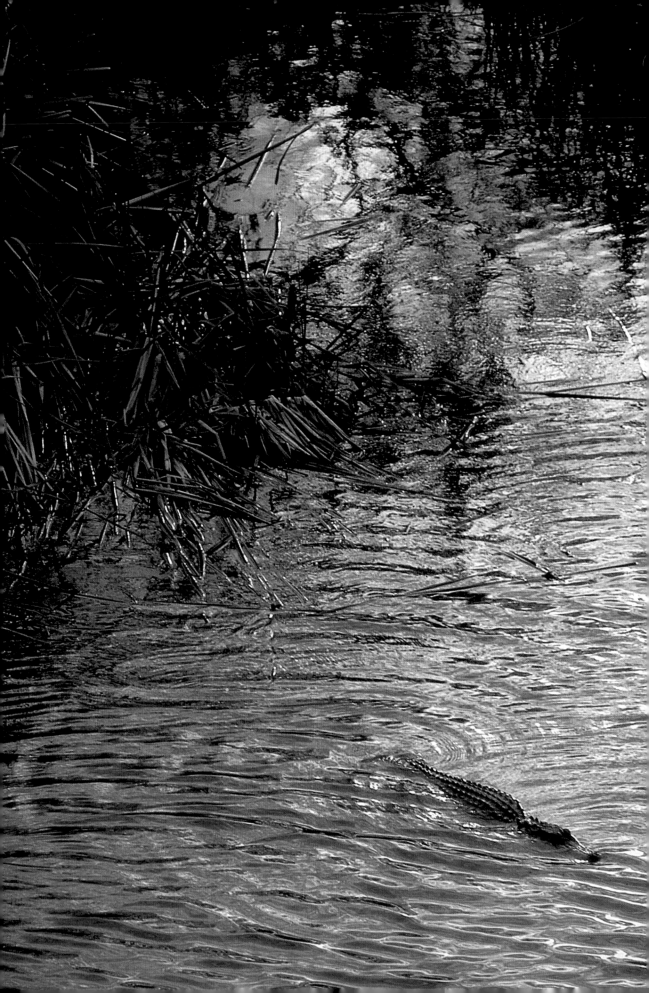

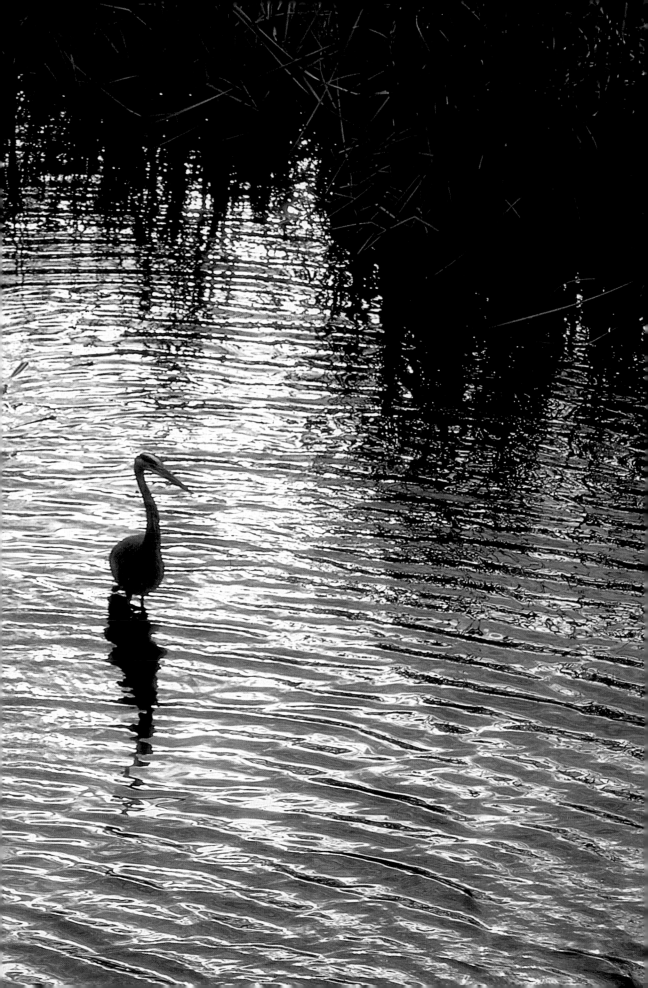

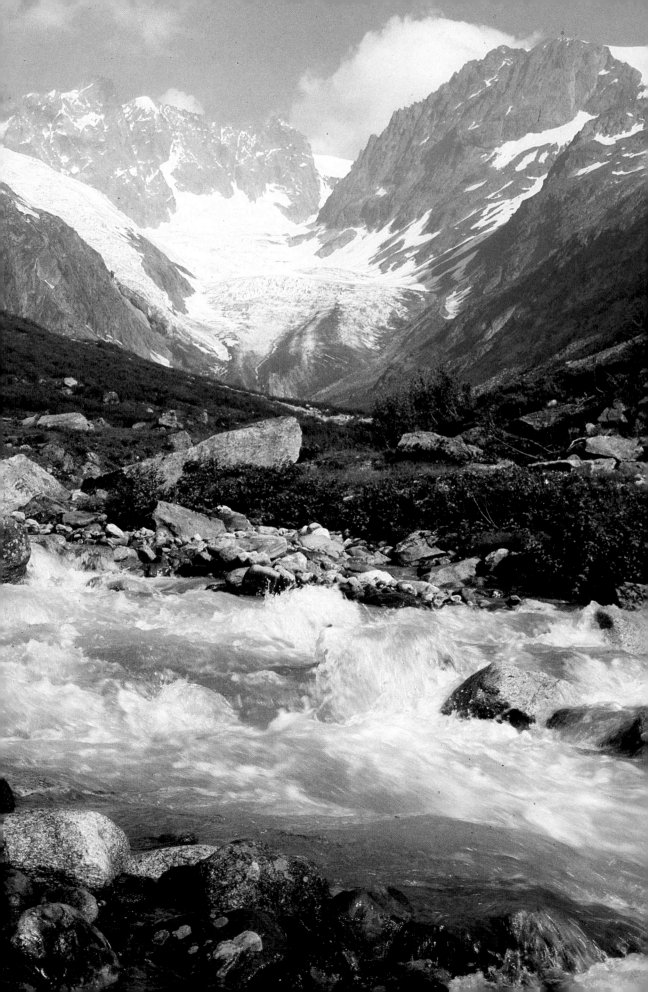

Europe: Rivers from the Alpine Divide

On a world map Europe is not an imposing landmass, and its rivers do not compare with the Amazon, Mississippi, or Nile. Yet these European rivers have an aura of historic importance far beyond their relatively modest size. The Moselle, Seine, Loire, Meuse, Thames, Avon, Po, and Tiber are only a few of those whose names ring throughout Western history. Every river has characteristics of its own and distinct flora and fauna. Here, however, I have decided to focus on just the Rhine and the Danube, two of the most legendary streams, yet only partly representative of all European rivers. Nevertheless, these two great rivers, arising in the same mountain range but flowing off in different directions (one northward, one eastward), offer dramatic contrasts in the wildlife they support.

Like most of the world's major rivers, the Rhine is actually many rivers, coursing from Alpine headwaters to North Sea delta. Its two primary sources are tucked away high in the Alps of southeastern Switzerland. The Hinterrhein, the smaller and southernmost of the two, arises from a glacial complex at the base of the Rheinwaldhorn, not far from the famous San Bernardino Tunnel. The Vorderrhein begins in Lake Toma, a deep lake just below the summit of Piz Badus. This mountain, close to 2,400 meters in elevation, has another distinction: on its southwestern slopes the Rhone commences its flow south to the Mediterranean. This single great mountain thus serves as a divide between two of the great rivers of Europe.

The two source rivers, the Hinterrhein and the Vorderrhein, join at Reichenau, Switzerland, to form the Alpine Rhine, a tumultuous, rough and boulder-strewn river of heroic proportions. The fauna of the source rivers is much like that of any cold mountain stream. In the rapid upland portions enclosed by the Alps, where water temperatures average about 13°C, a small flatworm (*Planaria alpina*) lives beneath stones in the cold, clear water. But a little lower down, where the water warms to 16° or 17°C, its place is taken by another similar flatworm (*Polycelis cornuta*). In winter, when the temperature gradient moves downstream, the alpine planarian moves with it; in spring it retreats upstream with difficulty, against the current. It is rare that temperature so clearly defines a habitat for an animal as it does for these simple creatures. Even when the water temperature rises a little above its optimum, the alpine planarian shows signs of stress and may eventually die.

By the time the Rhine passes the tiny state of Liechtenstein, it is turbid with suspended sediment and populated only by those aquatic animals capable of surviving in darkened, near-suffocating water. The abrasive particles carried along scour algae and small aquatic plants off submerged rock surfaces, leaving the river poor in plant life. The volume of the river at this point consists of four-fifths of the precipitation—rain and snow—fallen into the upper regions of the watershed. The Rhine is clearly the primary escape route for such precipitation and the sediment brought with it. The great lake which it enters, Lake Constance, serves as a settling basin for the silt, and by the time the river recommences at the western end of the lake its waters are clear and sparkling once again.

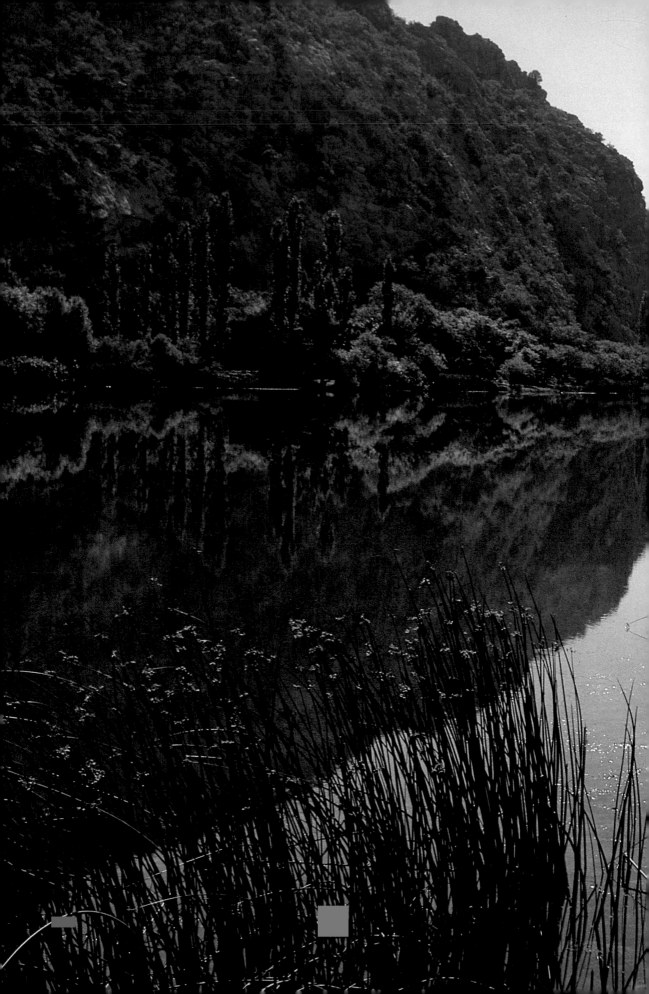

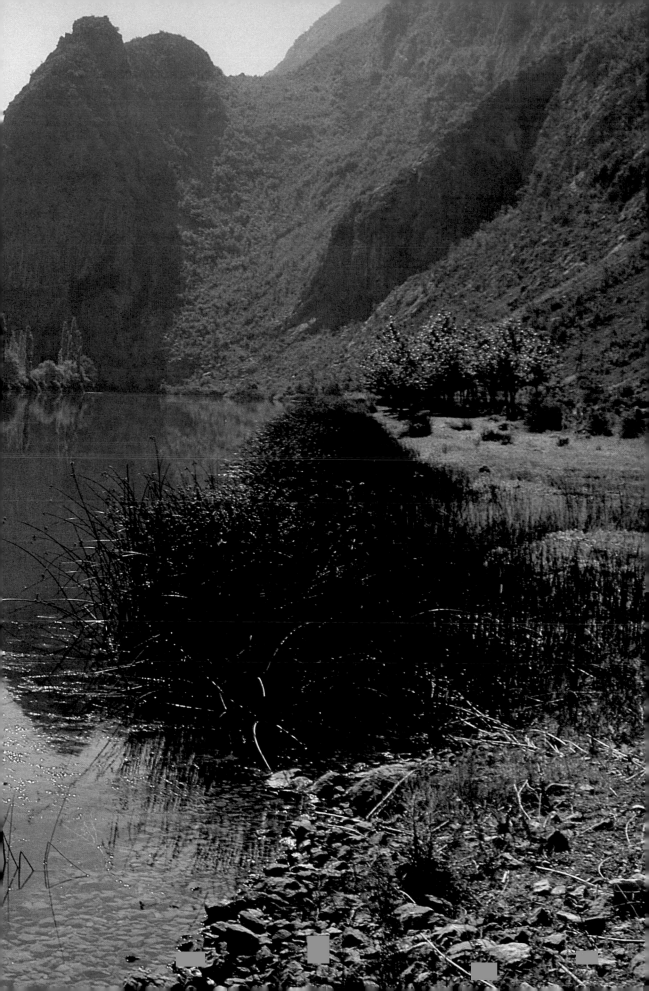

38. *As glaciers melt, they give rise to frigid, torrential brooks, such as the one shown here emerging from Chelen Glacier in Switzerland. Many European rivers owe their origins to such meltwater streams.*

40–41. *The Cetnje River in Yugoslavia broadens as it reaches a lower elevation. As rivers descend their course, innumerable tributaries may increase their volume. They become warmer and less turbulent as they seek their way toward the lowlands. There they deposit more sediment than they remove, permitting growth of diverse vegetation along their banks and the existence of a wide variety of aquatic life in their calmer depths.*

43 top row, left. *Marsh marigold* (Caltha palustris) *is a widespread inhabitant of bogs, swamps, and slow streams. A perennial semiaquatic herb, its yellow flowers are a familiar sight during April and May.*
Right. *Yellow flag* (Iris pseudacorus) *grows in marshy soil where water seeps into the banks.*

Center row, left. *The marsh violet* (Viola palustris) *brightens the moist banks of brooks.*
Right. *Military orchids* (Orchis militaris) *grace the banks of a German stream.*

Bottom row, left. *Water crowfoot* (Ranunculus aquatilis) *is found among currents, provided the water flow is not extremely swift.*
Right. *Water chestnut* (Trapa natans) *flourishes in the rich sediments of the Danube delta, amid a very wide variety of vegetation.*

Since the end of the last Ice Age, the number of lakes in and near Switzerland have decreased by half, leaving many flat, fertile valleys in their place. Actually, all the present lakes are also on their way to extinction and will be gone after some tens of thousands of years. Lake Constance itself probably will be completely filled with sediment in about 17,000 years, as a result of the gradual extension of its eastern delta. The Rhone is similarly filling Lake Geneva.

Lake Constance has an interesting and important effect upon the Rhine below it. A lake, with its quiet water, harbors multitudes of plankton—small, often microscopic, life that floats or feebly swims close to the surface. A river seldom has much plankton, since the flow of water constantly removes breeding populations of such minute plants and animals from a given locality. But this is not the case with the Rhine, or at least the stretch below Lake Constance.

Inevitably, the lake's plankton are carried over its brim into the effluent river. Not all are swept to destruction, for some find sheltered bays and coves in which to live and breed. With a constant source of plankton populations from the lake, the Rhine supports such diverse organisms as species of rotifers, flagellate protozoans, the large ciliate protozoan *Stentor*, and two crustacean types, *Cyclops* and *Bosmina*, as well as various species of diatoms, microscopic geometrical plants. Because the river is clean and clear below Lake Constance, plant plankton flourish and are eaten, in turn, by planktonic animals—commencing a food chain that continues through larger invertebrates such as freshwater clams and shrimp, fishes, and ultimately birds and mammals.

In the fish species they support, the Rhine and its neighbors are impoverished compared with certain other great rivers in the Northern Hemisphere, such as the Mississippi. During periods of extreme glaciation, fishes moved down the Mississippi to warmer latitudes to escape the advancing ice front. But in Europe their way south was blocked by the Alps, where they were caught, frozen, and eliminated. The result is that the Rhine has only some 40 species of freshwater fishes—migrants entering from the sea. Its great eastward-flowing neighbor, the Danube, has only about 80 species—still very few compared with the hundreds of species in the Mississippi.

An example of the consequences of glacial disruption of fish distribution and migration is the European charr (*Salvelinus alpinus*). In northern latitudes this member of the salmon family ascends tributaries, swimming southward to spawn in the warmer waters of their ancestral origins. But there are varieties of charr now living isolated in alpine lakes, furnishing evidence that when the Ice Age ended and the ice cap withdrew, some of these fishes were left in high-altitude lakes. These remnant populations consist of stunted, minnow-size fishes, about 80 times smaller than their unrestricted migrating relatives.

Lake Constance, which might be considered a still-water interruption of the Rhine's flow, harbors a number of fish species. The plankton-eating houting (*Coregonus lavaretus*) rarely is found deeper than 20 meters, while the Lake Constance whitefish (*C. acronius*) lives and feeds near the bottom at depths of 100 meters. Other

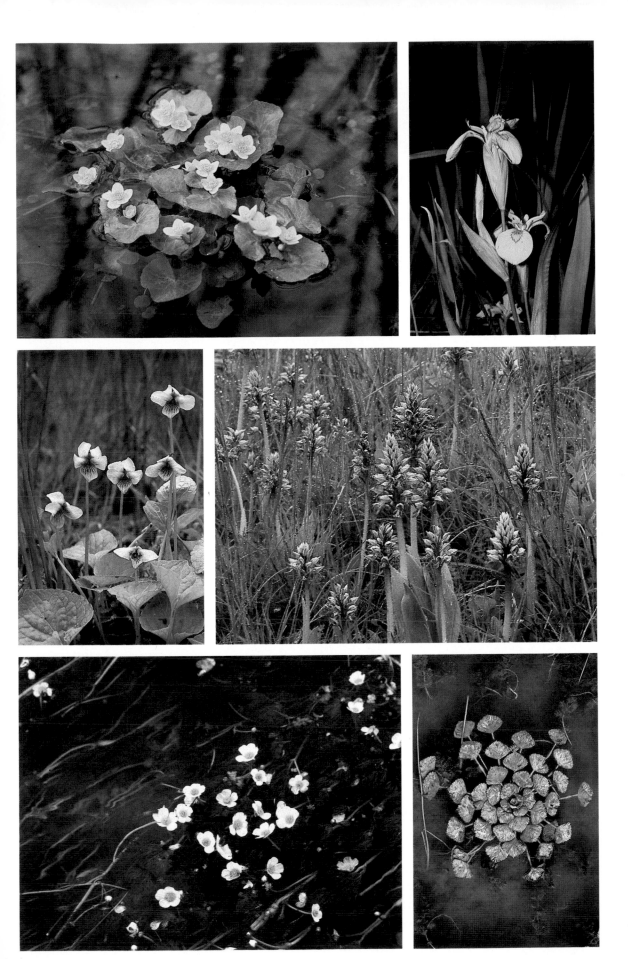

members of the salmon family, the graylings, live both in rivers and in lakes; originally, it seems, they were river species, but some became isolated in lakes. Unlike solitary brook and river trout, graylings tend to congregate and therefore have been heavily fished. Truly large specimens of European grayling (*Thymallus thymallus*) are no longer found in Alpine rivers and the headwaters of the Rhine, but evidently the graylings once grew to a meter in length and could weigh 10 kilograms.

One of the great stories of fish life was a long time unraveling. The European eel (*Anguilla anguilla*) has been known and written about for thousands of years, but its life cycle was so hidden and mysterious that it became an object of legend. Aristotle thought eels emerged from "the bowels of the earth," because the ones he found never had eggs or milt (sperm) or, for that matter, reproductive organs. Pliny stated that eels had no identifiable sex, and that pieces of their bodies which had scraped off against rocks turned into tiny eels. Others said eels derived from fish gills, the hair of horses, or small aquatic beetles. Such were the attempts of the human mind to conjure answers to a question that became more intriguing as the centuries rolled on. The single, true answer did not emerge until the first two decades of this century.

From 1904 to 1922 a Danish biologist, Johannes Schmidt, searched the Atlantic from the shores of northern Europe to Maryland, and from Greenland to the Caribbean. He finally centered his investigation upon the Sargasso Sea, itself a place of legend and mystery, a great eddy in the North Atlantic where flotsam, abandoned ships, and sargassum weed drift in endless circles. Every year eels of the Rhine and similar rivers in Europe, as well as certain closely related North American eels (*A. rostrata*), head for this remote spot, for it is only here that they spawn. It is also here that the adults die, never to be seen again.

But the story should begin in the rivers where the yellow eels familiar to us live. Female eels live far upriver; the males remain lower down in estuaries and coastal rivers. Males grow to about 45 centimeters in length; females, to about a meter or more. They are essentially scaleless, although after five years in rivers and ponds tiny scales begin to appear. They remain in their inland or coastal environment for as many as 15 years—all the while growing and becoming more muscular. Their feeding habits alter from dependence on worms, insect larvae, crustaceans, small clams, and other invertebrates to development of an ability to capture and eat fishes. To this end, even the shape of their jaws and head changes with age.

Finally, in late summer and early fall, when males are 8 to 14 years old and females 10 to 20, the eels mature and transform into the silver phase. They become darker on the back and silvery on the belly. They cease to feed, the eyes enlarge, the digestive tract degenerates, and they begin to swim toward the sea, traveling downstream most actively at night. So strong is their migratory urge that the eels will leave an enclosed body of water, even crossing dew-wet meadows in their irresistible need to find a river that flows to the ocean.

Top. *The predatory larva of the great diving beetle* (Dytiscus marginalis) *stalks a tadpole as it rasps algae off a rocky stream bottom. The larva in turn may fall victim to a trout, thus becoming another link in the complex food web that exists in every stream.*

Bottom. *The European swan mussel* (Anodonta cygnaea) *creeps over river bottom sediments by extending and retracting a long muscular foot. Although it is eyeless, light-sensitive cells on the shell-producing mantle margin detect shadows passing overhead and cause the mollusk to withdraw into its shell.*

Done with feeding, their jaw muscles begin to atrophy; for nourishment the eels draw upon the fat stored in their tissues over so many years of voracious predation upon other creatures.

Huge numbers of eels, one species from North America and the other from Europe, are believed to swim in long processions from the two continents to this remote spot in the mid-Atlantic. The trip from the Rhine and Elbe alone is over 4,800 kilometers and probably takes as long as six months. The American eel, with a shorter distance to travel, arrives within two months. At what depths they swim is not known with certainty; but when they reach the Sargasso Sea in March and April, they likely congregate at a depth of about 400 meters, relatively near the surface, since the ocean is over 6,000 meters deep there.

The spawning of these two vast populations in such a restricted area has never been witnessed. We have no idea what type of courtship displays may take place, whether or not the eggs adhere in clusters, how many eels succumb to the predators that must inevitably be attracted to such an annual event, or how the two species distinguish one from the other in such murky depths. All we know is that after spawning the adults die, sinking into the ocean depths in a rain of rich organic material. Do their bodies reach bottom, or on their way down are all snatched by predators and scavengers?

The eggs, which have never been found in the sea, are probably suspended hundreds of meters beneath the surface. They hatch into tiny leptocephalus larvae totally unlike their adult form. In fact, in the last century the designation *Leptocephalus brevirostris* was given to these small, transparent, blade-shaped creatures by marine biologists who thought they had discovered a new species. The larvae are active plankton-feeders, seizing their even smaller prey with tiny sharp teeth. As they grow larger, the larvae become broader and more distinctly leaf-shaped. All the while they have been carried along by the Gulf Stream, even though within their miniworlds they are active swimmers. Samples taken in the great circular current would reveal leptocephali of both species, almost indistinguishable from one another. Yet one year after hatching the American species begin to appear along the North American coast, while it takes three times longer for the European species to reach their home waters. Their development into tiny elvers or glass eels is perfectly coordinated with regard to the time each species must spend drifting from the spawning grounds in the Sargasso Sea.

As leptocephali metamorphose into elvers, they become somewhat shorter, much thinner, and cylindrical. In enormous numbers they swarm into the estuaries of rivers; a thousand or more could be found in a single bucketful of river water. Again predators congregate to feed upon these small fishes that are only 7 centimeters long, but the very number of elvers ascending the rivers guarantees their survival, for not all can be eaten. The males remain in the brackish water of estuaries, while the females keep swimming upstream. Gradually, pigment cells develop, causing the eels to lose their transparency. At this stage they are called yellow eels, as they have a golden belly and greenish-brown back.

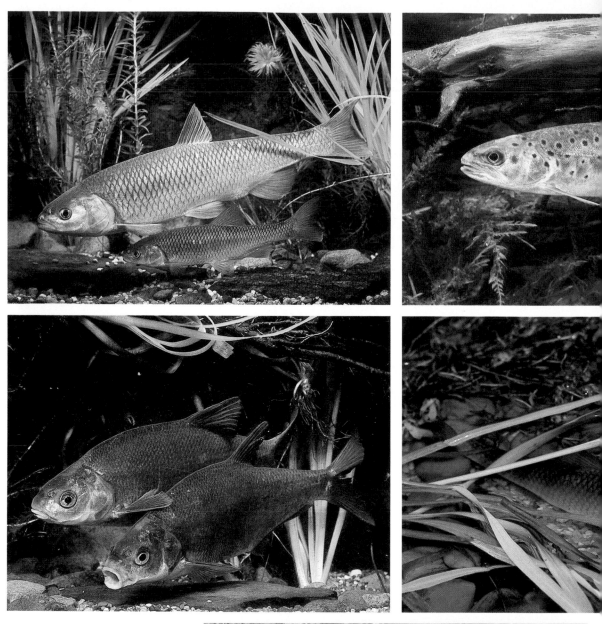

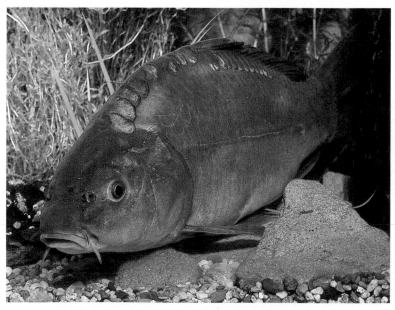

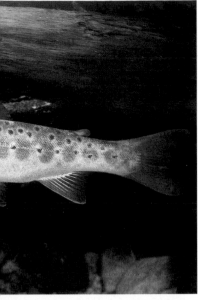

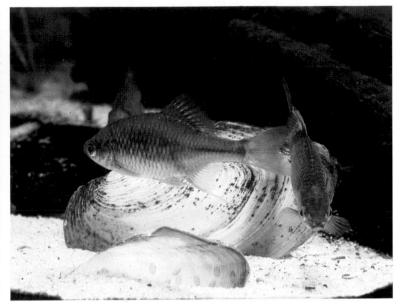

Top row, left. *An agile swimmer found in the swift waters of trout streams, the chub (Leuciscus cephalus) may weigh up to 4 kilograms.*

Center. *Brown river trout (Salmo trutta fario) are rather small members of their family. Tending to remain in one area, they do not migrate up- and downstream.*

Right. *The bitterling (Rhodeus amarus) lays its eggs inside freshwater mussels (Anodonta cygnaea), injecting them into the clam's mantle cavity with a long fleshy tube. The male's milt, or sperm, is drawn into the mussel's gill chamber and fertilizes the eggs. Developing young remain within the mussel's mantle cavity until able to swim away.*

Bottom row, left. *Bream (Abramis brama), large minnows weighing up to 6 kilograms, are among the most common and commercially important of European river fishes.*

Center. *The European roach (Rutilus rutilus) is widely distributed throughout many of Europe's estuaries, but it usually migrates upriver to spawn. Although the female roach is remarkably fecund — laying upward of 150,000 eggs at a time —the natural mortality rate is so high that adult numbers are held in check.*

Right. *The golden tench (Tinca tinca) prefers quiet backwaters and is never found in rapid streams.*

Bottom. *The mirror carp (Cyprinus), unlike other carp, has one or two rows of exceptionally large scales along either side of its spine.*

The cycle is now complete. Nowhere in the world is there an animal whose life history is more remarkable. How did it come about? It is not known for sure, but the spreading of continents suggests one possible origin. When both North America and Europe were once joined, perhaps their distant ancestor had a common breeding ground not far offshore. As the Mid-Atlantic Rift caused gradual sea-floor spreading, carrying the divided continental landmasses away from one another, perhaps the urge to retain their common ancestral breeding grounds was sufficient to make them swim ever greater distances each year. Of course, the continental drift was slow—only centimeters per year—so behavioral adaptation by these fishes was not a pressing or immediate affair. We may be sure that in the distant future, with even greater distances to travel, the two species will continue to seek the Sargasso Sea for their annual ritual of spawning.

Mother Danube

For centuries the two great rivers that arise so close to one another have been known as Father Rhine and Mother Danube. To the naturalist, the fecundity of the Danube lends support to these familiar names.

The Danube, or Donau, is one of the great rivers of the world and, aside from the Volga, the largest in Europe. It ranks eleventh among world rivers in length: 2,862 kilometers. It originates at an altitude of 1,087 meters and empties through its large delta into the Black Sea, one arm in Romania and the other separating that country and the Soviet Union. Together with its tributaries, it drains 805,000 square kilometers and discharges over 200 billion cubic meters of water a year and nearly 62 metric tons of sediment that builds the delta outward.

The Danube arises from two small streams, the Brigach and the Breg, in the crystalline rocks of Germany's Black Forest region. The two join 48 kilometers downstream near Donauschingen, but the current soon seems to disappear in an area of permeable limestone, then reappears in a large spring a few kilometers away. From there to the Black Sea its course is clear. Close to the Czechoslovakian border the Danube is joined by two major tributaries: the Isar and Inn Rivers, both of which have their own sources not far from that of the Rhine and drain large areas of the eastern Alps. The nature of the upper Danube and its tributaries differs little from that of the Rhine, for once the Danube has joined the glacial waters of the Inn River it is, for a while, a true alpine river with impoverished fauna.

The two great rivers, Rhine and Danube, have been locked in combat for millions of years. Over two million years ago, the Wutach flowing south and the Neckar going north each captured several of the Danube's tributaries, forcing the great river to give up huge tracts of watershed to the Rhine. Both of these rivers now flow eventually into the Rhine, whereas long ago they had contributed to the Danube. Both are still eating away at the sides of the high valley floor where the Danube's headwaters arise, and in the geological future one of the two will succeed in capturing the remaining wild and beautiful headwater streams of the mighty, eastward-flowing river.

After leaving the granite gorges of the Bohemian massif, which forces the Danube to flow southeast, the river

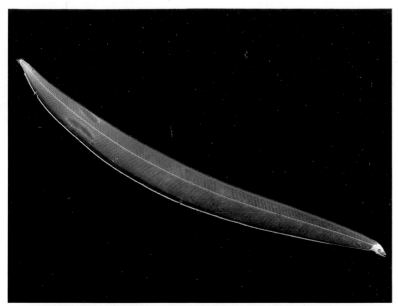

The life history of the European
eel (Anguilla anguilla) is
remarkable. Adults (bottom) may
travel nearly 5,000 kilometers to
spawn in the mid-Atlantic
Sargasso Sea at depths of over 400
meters. Their eggs float upward,
hatching into blade-shaped
leptocephalus larvae (top), which
swim as transparent members of
the plankton until carried by the
Gulf Stream to European shores.
There they metamorphose into
small slender elvers (center),
which often swarm at river
mouths as they begin the ascent
upstream. Males remain in
brackish water, but females seek
inland waters far from the sea,
where they remain for six years
or more as they grow, darken,
and mature.

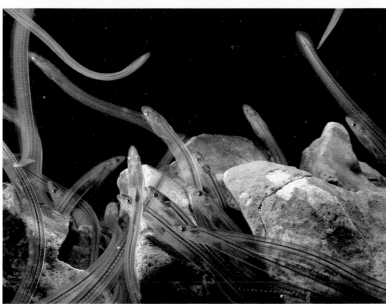

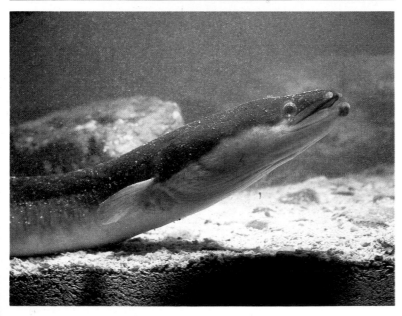

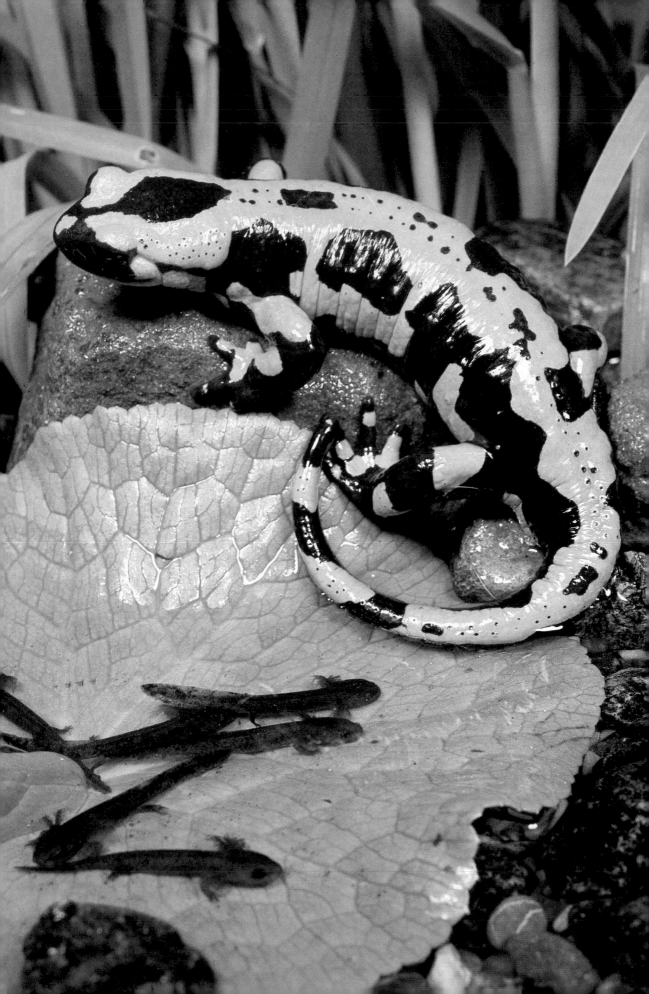

eventually passes through Vienna, one of the many historic and beautiful cities along its path. At Vác in Hungary, the Danube turns abruptly south to flow for 370 kilometers across the Great Hungarian Plain——once an inland sea which, when it drained long ago, unified the lower Danube into one mighty course. Soon it passes the twin cities of Buda and Pest as a wide and peaceful river, but not for long, since it must pass through the Carpathian Mountains that join the Balkans. Here within a towering defile of sheer rock faces up to 300 meters high, the river is squeezed to a width of only 146 meters. Immediately afterward it spreads to a width of nearly 1½ kilometers.

The Danube has still another trial ahead: 13 kilometers of rapids culminating in the terrifying Iron Gate, which for 3 kilometers is the greatest and most dangerous obstacle in the middle and lower courses of the river. The Iron Gate is a scarp-like gap through the Banat region and East Carpathian Mountains, separating the two major provinces of the river, the middle and lower courses. The huge rocks that jut up through the channel form great eddies and cataracts almost impossible to traverse. One of them, the Prigrada Rock, is 250 meters wide and stretches about 2 kilometers downstream. It is over and around this rock that the Danube pours in violent rapids and whirlpools. Over the centuries hundreds of vessels have been lost trying to navigate this stretch of the river, where the water is forced over a shelf of rock, followed by a series of jagged rocks, through a channel only 108 meters wide.

The Delta World

During its millions of years of existence, the Danube has dramatically altered its course many times over. This has influenced not only the regions through which the Danube flows but also the Black Sea, into which the river has emptied for so long.

One of the most remarkable events took place 15 or 20 million years ago as the ancient Tethys Sea retreated across Europe to form the Mediterranean. The European coastline of the Atlantic assumed its present form shortly thereafter. However, the Mediterranean, which was separate from and lower than the Atlantic, continued to drain and evaporate until it was dry. Northeast of this now-dry basin there remained a huge isolated body of water that also began to diminish and separate into a number of smaller freshwater "seas," including some that we still have today: the Aral Sea, Caspian Sea, Black Sea, and the Carpathian Lake. The Danube passed through the Carpathian Lake, gradually filling it with sediment until, a little over a half million years ago, it became the plain we know today. The Black Sea then became the main focus of the Danube's transport system. Meanwhile, the Mediterranean Basin was refilled, flooded by salt water of the Atlantic pouring through the Straits of Gibraltar, in what must have been the most spectacular waterfall of all time. Then, about 10,000 years ago the channel now known as the Bosporus cut its way through to join the Black Sea and the Mediterranean. Salt water from the Mediterranean flowed into the Black Sea, causing the stratification of fresh water from major rivers over a salty, brackish underlayer. Down to the present the Black

The fire salamander (Salamandra salamandra) bears fully metamorphosed young that take up a free-living existence without going through an aquatic egg stage. Larvae of typical salamanders, like those shown here, live underwater and have external gills.

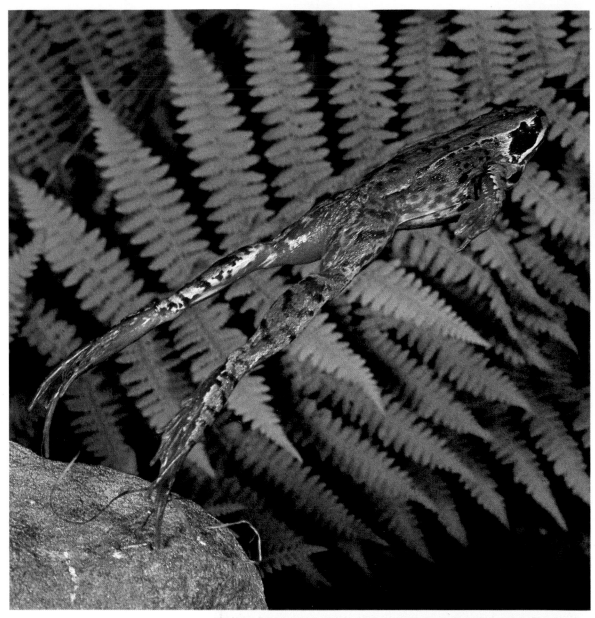

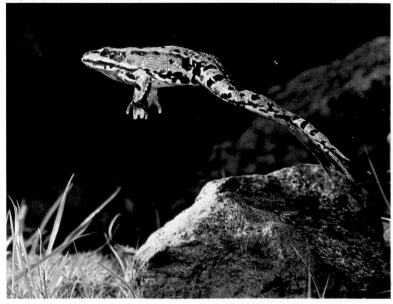

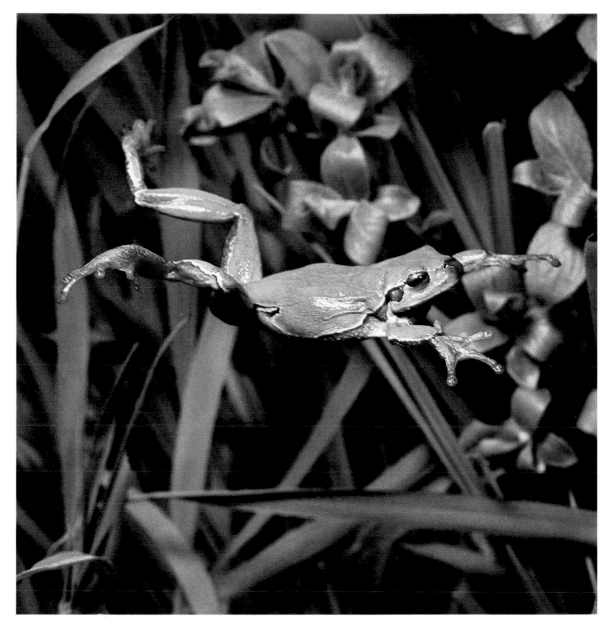

52 top. *All breeding activities of the common European frog* (Rana temporaria) *are completed in only a few nights. Consequently, large numbers of egg masses are crowded together in the chilly water of late winter.*

Bottom. *The edible frog* (Rana esculenta), *a colonial frog that prefers quiet backwaters and ponds, is one of the most familiar and widespread amphibians of Europe. Its range extends from the Mediterranean to Scandinavia and far into Russia.*

Above. *The Central European tree frog* (Hyla arborea), *like all tree frogs, has suction pads on the ends of its toes that enable it to cling to vegetation along the shores of streams. This tree frog has the loudest call of all European frogs.*

Sea has lifeless depths, although life is found near its surface. The modern Black Sea is much shallower than formerly, because of the thick muds contributed by the Danube and its lesser sisters, the Dniester, Dnieper, and Don.

The Danube's delta, lying mostly in Romania, is one of the natural wonders of the world and, fortunately, remains relatively unspoiled. Encompassing over 5,640 square kilometers, it is second in size only to the delta of the Volga and is growing at a rate of 45 meters a year from sedimentary deposits carried downstream from at least a half dozen countries. Sedimentation does not cease at the water's edge, for deposits of silt and sand extend far out into the Black Sea, with over 50 percent of the delta lying beneath the surface. Someday the unceasing building process may cause much of this to emerge. Geologically, the Black Sea is on its way to the same sort of extinction as overtook the Carpathian Lake.

The delta is a complex of three main channels, innumerable lesser streams, narrow creeks, and thickly grown marshland, all teeming with fish, amphibians, reptiles, birds, and mammals. Not many people live there, except in regions where slight elevations have made it possible for towns and small cities to develop over the centuries.

With such rich sediments to nourish growth, it is no wonder the Danube delta supports a vast array of vegetation, from enormous expanses of reeds that seem endless, to the forests of Letea and Caraorman consisting of elm, ash, and gray oak, all linked and festooned with vines and creepers. Great linear stands of oak, beech, and willow usually delineate old coastlines left when the delta margin advanced. Alders (*Alnus glutinosa*) grow abundantly along marshy shores or where rich soil has accumulated. Wildflowers are everywhere: marsh thistles and water lilies grow in the quieter reaches, while the moist banks are decorated with marsh lilies, yellow iris, forget-me-nots, and small orchids.

As one goes from open water in a delta stream toward firmer ground, an entire series of vegetation zones is traversed, beginning with yellow water lily (*Nuphar lutea*) floating on the surface, followed by water soldier (*Stratiotes aloides*), bulrush (*Schoenoplectus lacustris*), great reedmace (*Typha latifolia*), common reed (*Phragmites communis*), great water dock (*Rumex hydrolapathum*), meadow sweet (*Filipendula ulmaria*), and finally, common black sedge (*Carex nigra*). The transition zone between water and marshy soil is marked by water dock and meadow sweet. Each zone of vegetation provides distinct habitats for birds and land animals.

Fishes of the Delta

The Danube Basin, especially in the delta, supports nearly all the common European fishes. Some of the more familiar species include the small, silvery bleak (*Alburnus alburnus*), which gathers in large schools during spawning season, when females glue small clusters of a few eggs to every available submerged plant and stone.

The bream (*Abramis brama*) is a large minnow with an almost humpbacked body and a small mouth designed for feeding on minute invertebrates in muddy bottoms. Other

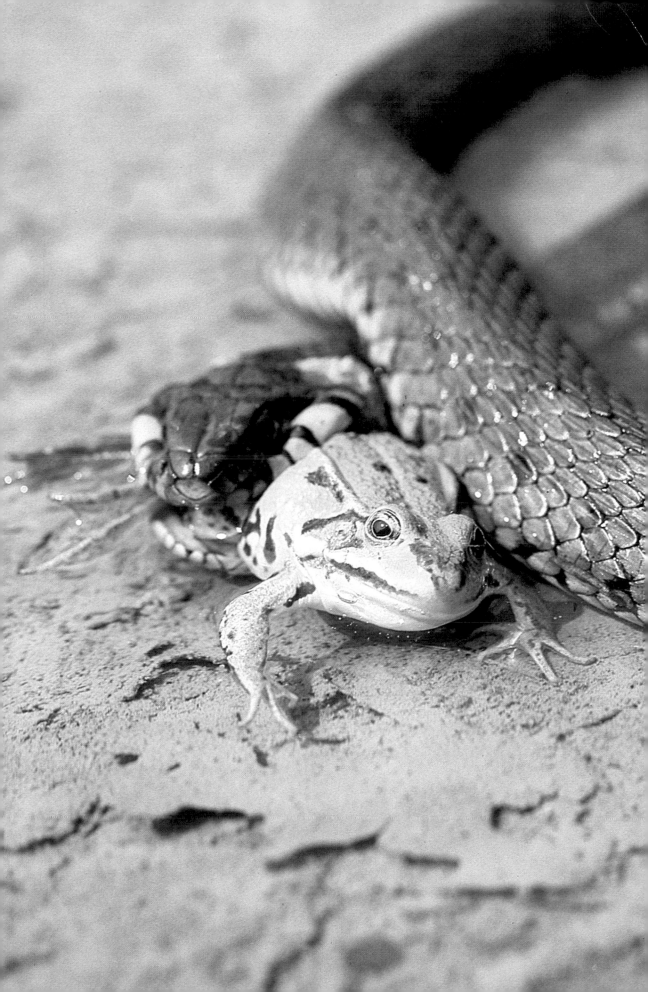

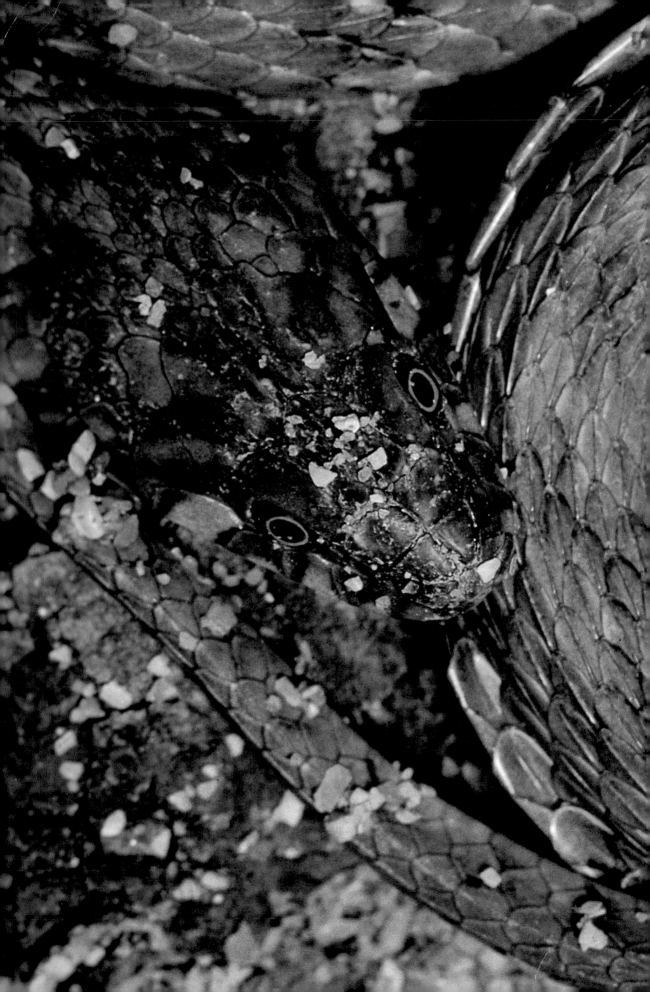

members of the minnow family include the gudgeon (*Gobio uranoscopus*), which lives only in the Danube Basin, although three other closely related species found elsewhere live there as well. Another denizen of the Danube is the true large carp (*Cyprinus carpio*), a very large fish that is dark gray or brown on top, with golden sides and yellow belly. Widely distributed throughout Europe before the Ice Ages, it had to retreat southward as the glaciers crept down from the north. Later, after the ice receded, the carp succeeded in establishing itself mostly in the Black Sea and Danube Basin area, although today it has been transplanted by man to many other areas. In the Danube it migrates only slightly; during spring floods it moves out of the river to lay its eggs over floodplains. Later, as the volume of water diminishes, both young and adults return to the river proper. They are hardy and prolific fishes, laying as many as a million and a half eggs at a time.

One of the truly remarkable fishes found in the Danube is the wels, or sheatfish (*Siluris glanis*), a gigantic catfish that can grow to over 5 meters in length and weigh as much as 300 kilograms. It is a calm, slow-moving fish, but one whose habits are not very well known despite its being hunted extensively. The dark gray, scaleless body of a wels has a huge, broad head with a wide, almost bulldog-like mouth; two long barbels hang from the upper jaw, and four smaller ones reach down from the lower jaw. Its eyes are tiny; undoubtedly, then, its most acute and important senses are centered both in the barbels and in the fish's lateral-line pressure-sensing system. It has a ridiculously small dorsal fin, which is nothing more than a bump, but a very long anal fin extending back the whole length of the laterally compressed tail, where it joins a short, stubby tail fin. No wonder it is sometimes mistaken for a giant broad-headed eel. Wels build crude nests surrounded by plant material they fashion into a simple wall. Once eggs have been laid and fertilized, the male guards the nest, even after the tiny tadpole-like young hatch. When the young grow large enough to survive on their own, they leave the nest and the male's duties are over. The wels is much sought by fishermen.

The Danube and its delta region are repositories of a number of species of sturgeon, such as the small sterlet (*Acipenser ruthenus*), which reaches a maximum of 100 centimeters long and weighs up to 15 kilograms or more. A subspecies of the Russian sturgeon (*A. guldenstaedti colchicus*) once ranged upstream as far as Bratislava, while another species (*A. stellatus*) today migrates up to Tokay and Komaron in Hungary. The common Atlantic sturgeon (*A. sturio*), a widespread species, reaches great size in the Danube: it may reach a length of 3½ meters and weigh as much as 200 kilograms.

The most impressive Danube fish of all—and by far the largest freshwater fish in eastern Europe—is the beluga (*Huso huso*), which has been known to reach a length of 8½ meters and weigh as much as 1,300 kilograms, or 1½ English tons! This giant once had the entire river as its province, leaving the delta as soon as spring thaw broke up the ice and migrating all the way upstream to Bavaria. Today, with its numbers depleted, it can only arrive as far as the Iron Gate in Romania. The catch of a single large female can yield over 100 kilograms of caviar.

Sturgeons are an ancient group, with origins dating back over 200 million years. Their appearance does not belie the fact, for their elongated armored body, with protruding bony plates along the sides and back, differentiate them from any other fish. Their only scales are on the upper edge of their tail fins, and even their internal anatomy is primitive: they have a cartilaginous skeleton and no true vertebral column. Their intestines have a special and highly efficient device known as a spiral valve, which is otherwise found only in paddlefishes of North America and sharks. The Danube apparently was an exceptionally favorable habitat for this largest of inland fishes, since in the mid-eighteenth century so many were being caught that the population was severely depleted. Today the giant European sturgeon is preserved through conservation efforts being made in the Danube delta and in other large rivers emptying into the Black Sea.

Dwellers of the Reeds

The dense growth of reeds and related grasses over much of the Danube delta provides a unique and extensive habitat for a great many animals which are not truly aquatic but which find it necessary to maintain a close association with water for breeding or finding food. For example, the Central European tree frog (*Hyla arborea*) spends the daylight hours clinging to vertical reeds and shoreline shrubs. Normally green, it can turn gray-blue on dark, overcast days or can even change to brown, olive, or slate gray. After dark, it descends to water level, where it inflates its balloon-like vocal sac under the lower jaw and begins to call, faster and faster, with its loud familiar cry, "Kay, kay, kaykaykay." Once one begins, a whole chorus will follow suit until the marshy pools reverberate with the songs of these little frogs. It is quite a noise, for this species is the loudest of all European frogs.

Another amphibian, the Danube crested newt (*Triturus cristatus dobrogicus*), emerges from eggs laid in water, later spends a period on land, then returns to the water to live its fully adult life. It swims by means of a laterally compressed, finned tail. Males in breeding season not only change color but also develop a high toothed membrane crest along their backs, making them look like little and harmless amphibian dragons.

A dark brown and yellow swamp turtle (*Emys orbicularis*) may be seen basking on sunlit logs along the riverbank; this shy and reclusive creature quickly slips into the water when movement is detected nearby. While it is a predator, this is not a turtle which will attack large prey; it prefers invertebrates and small, sickly, or weakened fishes.

Snakes of many sorts inhabit the delta, including the innocuous smooth snake (*Coronella austriaca*), which has a menacing defensive maneuver of rising, hissing, and striking despite its essentially harmless nature. This tactic undoubtedly causes it to be killed in error by humans if they mistake it for the poisonous viper (*Vipera*), which lives in the same general area. The ringed snake (*Natrix natrix*) is a handsome reptile conspicuously marked by orange or yellow bands around its head. A true water snake, it feeds on aquatic prey such as frogs and crayfish. It is an excellent swimmer and spends much of its time in water; on land it can be pugnacious, though harmless.

Reptiles are also found in very different regions of the delta, such as the sand dune areas where heat-tolerant and drought-resistant lizards, tortoises, and snakes dwell. One of these is the ladder snake (*Elaphe scalaris*), an active predator on small mammals such as mice.

Delta Birdlife

For the naturalist-visitor, the greatest attraction to the Danube delta is the enormously varied birdlife. There are the great predatory sea eagles and marsh harriers, tall purple herons and pure white little egrets, long-legged avocets and black-winged stilts, shy bitterns and snipe, geese and other waterfowl, including the magnificent mute swan and two species of pelicans. Smaller birds are legion in the reeds and marshlands of the delta.

The Dalmatian pelican (*Pelecanus crispus*) is the world's largest pelican, having a wingspread of nearly 3 meters. Despite its great size, this bird is lightly built like other pelicans, with porous bones and air sacs branching through the body. What makes pelicans unique is the enormous beak with its distensible pouch. When the pelican dives into the water, the pouch balloons out into a capacious membranous cavity that helps the bird scoop up fish. On the surface, pelicans float high in the water, with head and bill tucked back. In flight they are graceful, using strong wing beats interspersed with long sailing glides. The silver-gray Dalmatian pelican builds flat nests from piles of reeds in the open marshland; it often shares breeding grounds with another species, the Eastern white pelican (*P. onocrotalus*), which is not only more numerous but also more gregarious. As the breeding season continues, one nest merges into another, until a wide reed platform results; this is filled with fledgling, hungry young birds eating partly digested fish from their parents' bill pouch. When a young pelican feeds, it thrusts its entire head into the pouch of the parent, gobbling at the nutritious meal.

White pelicans hunt cooperatively. They frighten fish by noisily thrashing their wings against the water, driving them into shallow water where they can be scooped up. The Dalmatian pelican, in a faint behavioral echo of its brown North American cousin, may leap into the air before splashing down in a shallow dive to catch fish in deeper water.

The mute swan (*Cygnus olor*)—with an original distribution much more restricted than its cousin the whooper swan—is possibly the most familiar of all its kind as a result of domestication. It is now found in almost every European park. The graceful S-shaped curve of its neck and raised, outward-thrusting sail-like wings poised in threat have made it almost the stereotype of swan appearance. With its orange bill, black mask, and great size, it is a majestic and beautiful bird. The northern shores of the Black Sea and the Danube delta have always been a part of its natural distribution.

One of the thrilling sights over the delta is that of the great white-tailed sea eagle (*Haliaeetus albicilla*) as it wheels high overhead, wings broad and steady, calling repeatedly in a shrill whistle. This great bird, dark brown except for its wedge-shaped white tail, is an effective predator, able to snatch fish and bird victims in its enormously powerful talons. With a wingspread of 2½

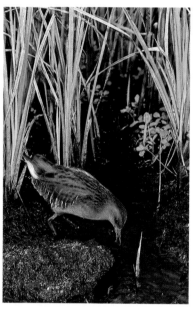

Above. Water rails (Rallus aquaticus), *native to much of Europe and Asia, have compressed bodies that enable them to slip through thick swamp vegetation. Their long toes allow them to walk over bent or floating reeds and even over the stems of swaying marsh grasses.*

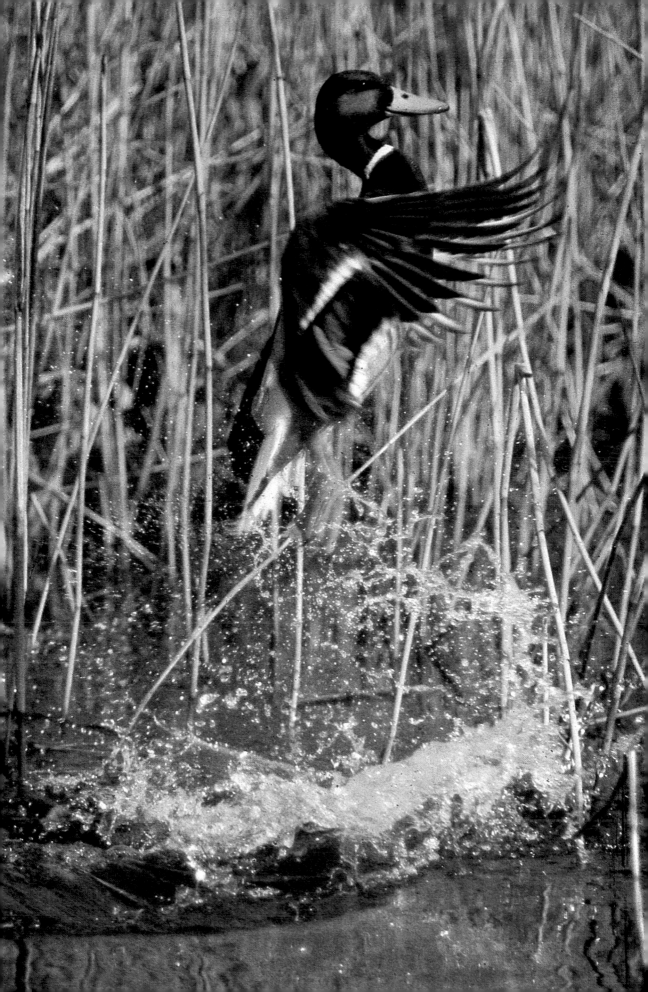

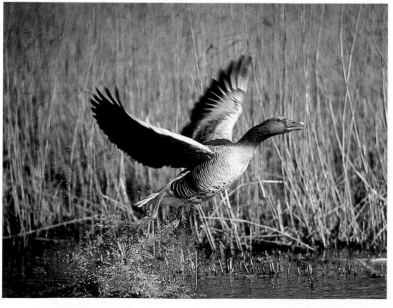

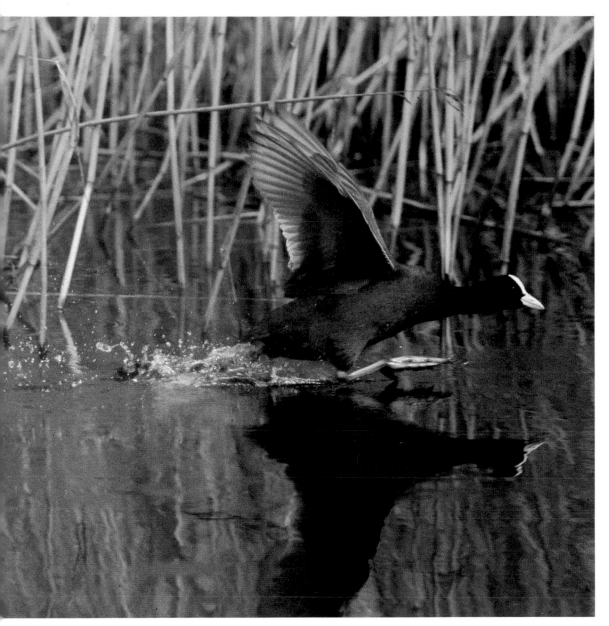

Above. *The European coot*
(Fulica atra), *a member of the rail
family, builds floating nests of
aquatic vegetation in the
backwaters of river reedbeds. The
birds' broad, lobed toes enable
them to swim well, but they
expend considerable effort in
becoming airborne as they run
over the water to gain speed.*

Left. *The graylag goose* (Anser
anser), *which once had wide
distribution, now breeds only east
of the Elbe River. It is among the
most familiar and well-studied of
all European waterfowl.*

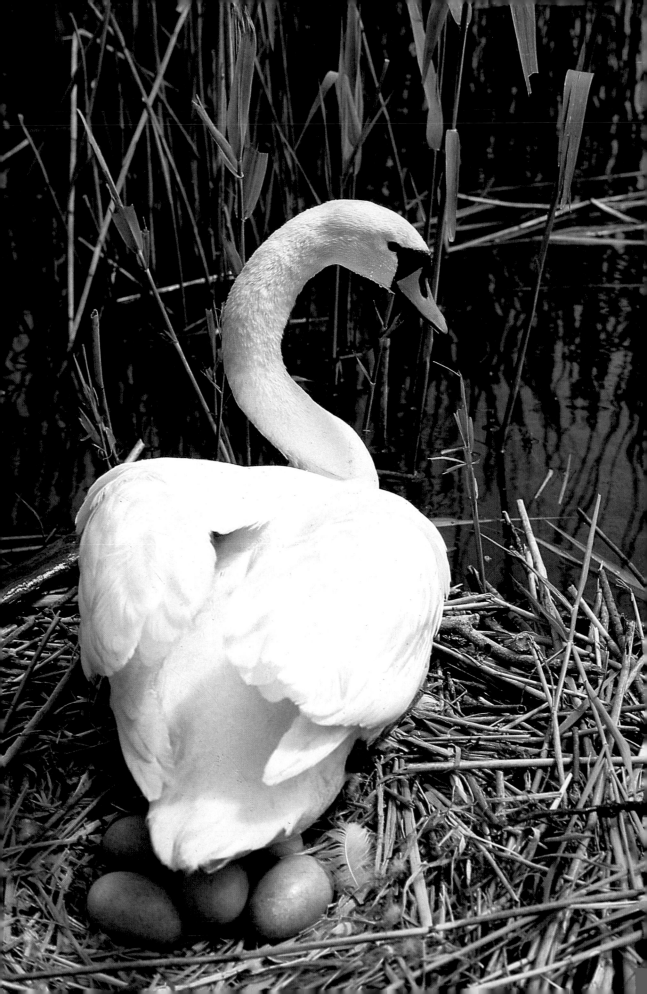

meters, the sea eagle is an impressive sight in the skies over delta marshland and the Black Sea.

The marsh harrier (*Circus aeruginosus*), with a wingspan of half a meter, is among the largest of its particular sort of hawk. It is a busy, relentless hunter, coursing low over the vast reed thickets in its search for small rodents and birds. Although its eyes are excellent at spotting the slightest movement below, it also has a keen auditory sense, enabling it to hear the faintest peeping of unhatched chicks inside the eggs of ground-nesting marsh birds. The sharp, muscular talons of the marsh harrier allow it to grasp and kill birds the size of ducks, grebes, and cygnets (young swans) that are exposed or left temporarily unprotected in the marshland reeds. Its hunting success is largely the result of surprise, for it silently glides directly over the reed tops, then swoops down instantly on whatever startled victim is spotted in a small opening in the thick vegetation.

Marsh harriers, like their prey, nest in the marshes, where they construct ground-level nests of twigs and reeds, but usually in places with difficult access. Their young are better protected than those of many of their hapless victims.

Birds of the delta inhabit particular zones and have highly specific, noncompetitive habits. Four long-legged waders clearly show this separation. The purple heron (*Ardea purpurea*) hunts for sizable fish in water deep enough to require every centimeter of its elongated legs. Patiently standing well out from shore, it will spear a fish with its stiletto bill, flip it into the air, and swallow it headfirst. The pure-white little egret (*Egretta garzetta*) fishes for smaller prey in shallower water, often probing amid submerged aquatic vegetation. The black-winged stilt (*Himantopus himantopus*), despite its extraordinarily long legs, hunts in the shallowest water, where it seeks aquatic insects and other invertebrates. The bittern (*Botaurus stellaris*), stalking patiently through the tall reeds and at times venturing into the water, holds its sharp beak ready to seize prey with a lightning jab. If it is disturbed in its dense shoreline reed habitat, it camouflages itself by extending its long neck and bill vertically upward so that its sharp, brown-and-white streaked plumage blends with the vegetation. Not one of these four long-legged fishing birds competes directly with another, thereby illustrating the concept of the ecological niche, or way of life.

In the spring, where open spots exist in the marshland, male ruffs (*Philomachus pugnax*) gather to put on a brave display in competing for mates without resorting to actual physical combat. Each bird extends its white ruff and prances around in ritual display, pretending to attack the others in an elaborate dance. Order dominance is thereby established: the winners choose their mates ahead of those who defer to them. The rest of the year the birds go their separate ways, with the females preferring to stay closer to water and thick reedlands than do the males.

It is among small birds that the Danube delta region is truly one of the richest in Europe. With such a variety of vegetation and habitats, from forest to reed marshland, they fill every conceivable ecological niche. The reeds either provide support for nesting or are themselves incorporated in the final construction of a nest. The reed

Opposite. *Mute swans* (Cygnus olor) *build mound nests of reeds that are constantly rearranged. During nesting these birds are aggressive, especially the male, who will charge any intruder while the female is incubating the eggs.*

Above. *The black-winged stilt* (Himantopus himantopus) *walks through water probing for insects, crustaceans, and other invertebrates that make up its diet.*

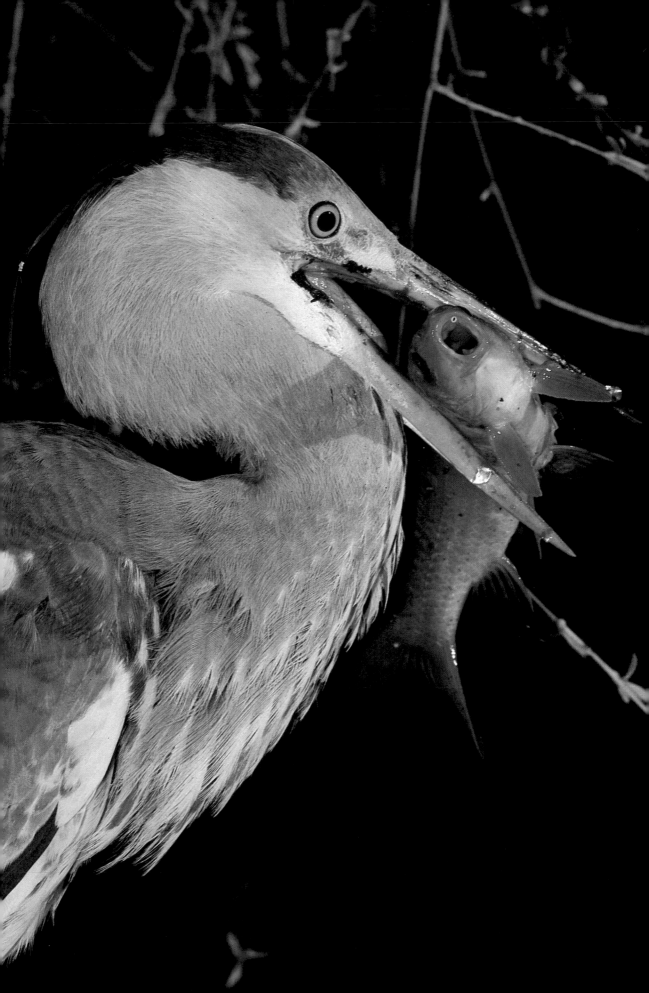

warbler (*Acrocephalus scirpaceus*) builds a deep conical nest halfway up the tall reeds, using a number of the stems as part of the structure to make it secure against high winds and safe from attack. The nest is so well built that it often serves as a hatching place for the solitary egg of the much larger parasitic cuckoo (*Cuculus canorus*). When the single cuckoo egg hatches, the fledgling cuckoo is so large and powerful it edges out the reed warbler's own young, which fall to their death below. The parent reed warblers, intent on feeding any occupant of their nest, are kept busy satisfying the voracious appetite of the young cuckoo, truly a giant parasite. More than any other bird in the delta marshland, the reed warbler is victimized in this fashion.

Several other small birds build nests well above the waterline and off the ground: the sedge warbler (*Acrocephalus schoenobaenus*) and reed bunting (*Emberiza schoeniclus*) are two others that construct secure nests supported by the thick towering reeds. The penduline tit (*Remiz pendulinus*) weaves a remarkable basket-like nest suspended from reeds or branches of shrubs that hang out over water. The male encloses the whole fibrous structure except for an entrance hole, through which the female enters to line the interior with soft downy plant fibers before laying her eggs. Penduline tits are very particular about their habitat, which consists of the proper mix of reed thickets, meadows, and open water that is fresh, or at least not too brackish.

Unlike the birds that seek safety by building nests well off the ground, the bearded reedling (*Panurus biarmicus*) constructs its nest almost on the surface of wet marshland, usually directly at the base of the tall reedmace. These reeds form a towering, dense jungle all about the nest, affording security for eggs and developing young. Although also a ground-nester, the common moorhen (*Gallinula chloropus*) is a bird of a very different sort. It is one of the rails, a group of birds suited to life in the thick vegetation of marshes. In common with all rails, it has short, rounded wings; it is a poor and reluctant flier, relying more upon escape on foot through the dense forest of reeds than on its powers of flight. Its body is compressed laterally and covered by soft plumage, making passage through the crowded stems easy and noiseless. A common moorhen takes to the water readily and swims well, although it does not have webbed feet but only thin strips of skin between its toes. Like many other species of rail around the world, it has a distinctly colored bill and faceplate rising up its forehead—mostly red with yellow at the tip. The characteristic bobbing motion of its head when walking makes this bird simple to identify, if only it can be seen in its overgrown habitat.

Mammals of the Delta

Undoubtedly, the Danube delta once supported a larger number of European mammals than it does now. Did the great, almost totally extinct European moose (*Alces alces*) once feed on thickly grown watercourses in the luxuriant grasslands there? Another highly endangered mammal, now largely extinct in Western and Central Europe, the Eurasian river otter (*Lutra lutra*), still survives in the Danube delta. Although almost totally habituated to living near rivers, this species of otter also thrives around river

Opposite. A gray heron (Ardea cinerea) prepares to swallow a golden carp (Cyprinus carpio). This is a rare prize, since carp are bottom dwellers and the heron generally feeds only on fishes that come close to the surface.

Overleaf. The European polecat (Putorius putorius) hunts water-dwelling victims along the banks of brooks and streams. The polecat is widely distributed through Eurasia.

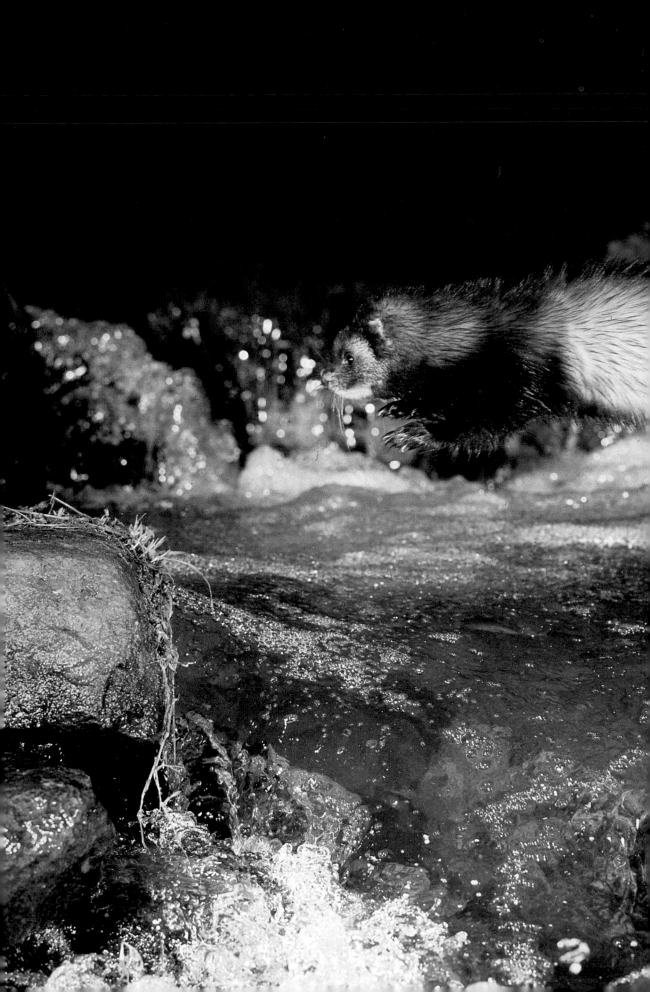

mouths along the delta, where it may swim considerable distances offshore. Generally, river otters rest basking in the sun during the day and confine their major hunting activities to nighttime. Graceful and powerful swimmers, they use their hind legs to propel their elongated, streamlined bodies through the water and press their front legs tightly against their sides, using their tails to assist in steering. While pursuing fish with great agility, one of these otters can remain submerged for seven or eight minutes, invariably capturing its prey. A Eurasian river otter does not rely exclusively on fish for food, but will consume aquatic birds, small rodents, crayfish, and even an occasional larger animal, for an otter is a formidable fighter if need be.

In the water, river otters—also known in Europe as fish otters—are extraordinarily playful and practice their swimming skills singly or with one another in a dazzling display of agility and coordinated acrobatics. They chase one another about, twisting longitudinally as they swim and leaving behind a glistening trail of bubbles from air trapped in their fur. In the delta they seek and improve mud slides leading to the water, which they use repeatedly in an unquestioned form of play. Because they deplete fish and bird populations and have a lustrous pelt of commercial value, they have been hunted widely wherever they occur. However, in the delta, with its sparse human inhabitants and huge expanses, these river otters are safer and more common than in most other parts of Europe.

The raccoon dog (*Nyctereutes procyonoides*), or Enot dog, is a less familiar predator in the Danube delta. While it looks very much like a raccoon—its eyes masked by dark bands as in its namesake—it is one of the canids, or true dogs, and is probably the world's most primitive member of that family. It is a stout animal with short legs and a pointed muzzle. Its fur is yellow-brown, tipped in dark brown, while its legs are also dark. In the delta the raccoon dog feeds mainly on birds and bird eggs, at times depleting an entire nesting colony. If given the opportunity, a raccoon dog will capture a fish—a habit it pursues with greater frequency elsewhere on the continent where birds are not so plentiful. Raccoon dogs are not restrictive in their diet but will consume small mammals, berries, nuts, and even an occasional toad, which is repellent to most animals because of its unpleasant skin secretions.

The raccoon dog is seldom seen in daylight, for it remains well hidden in a den or in thickets in swampy marshland far from human habitations. Although they live together in small groups of about a half dozen, raccoon dogs do not appear to cooperate as hunters and go their separate ways at night to seek prey. Their acute sense of smell serves as their most important means of locating food as well as of avoiding intruders.

It is fortunate that one of the greatest of European rivers, along which so much human history has been made, has created a huge, growing delta, formed through the dynamics of flow and sediment transport. This wilderness provides a haven and a multiplicity of ecological niches for an enormous variety of wildlife.

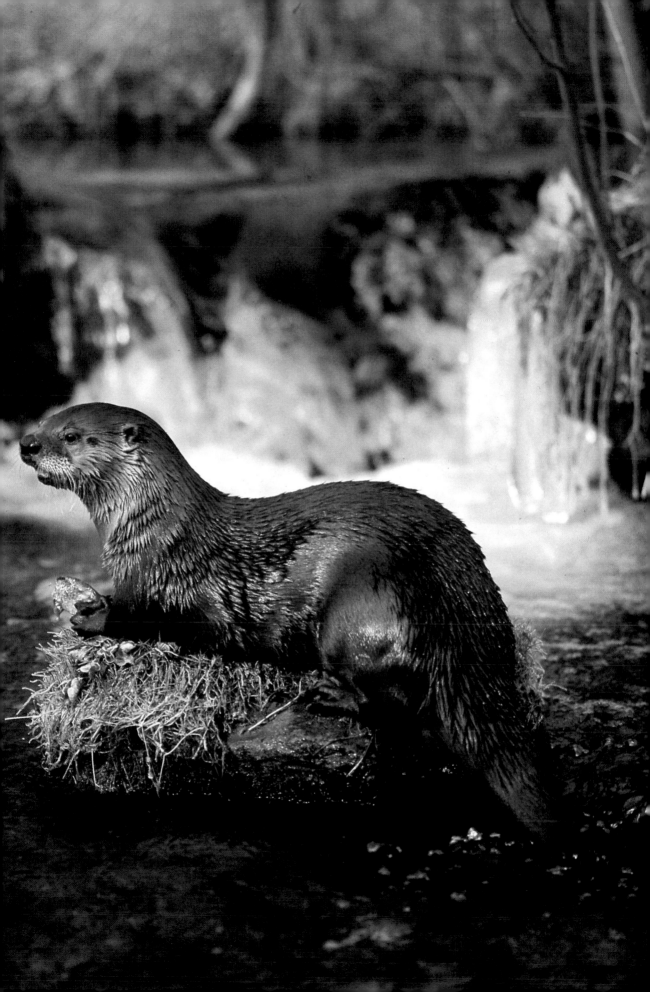

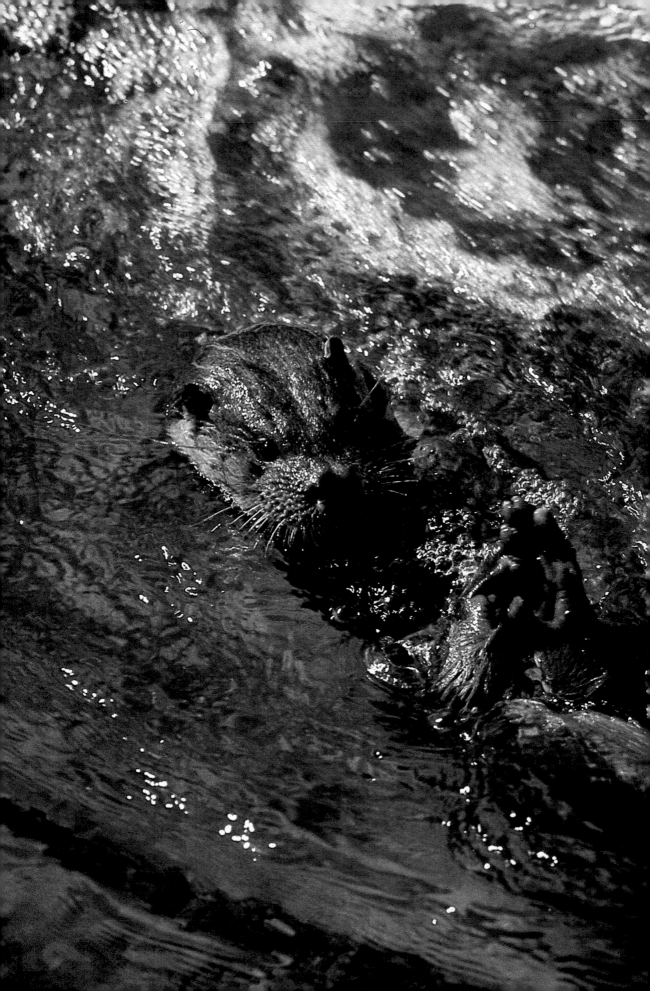

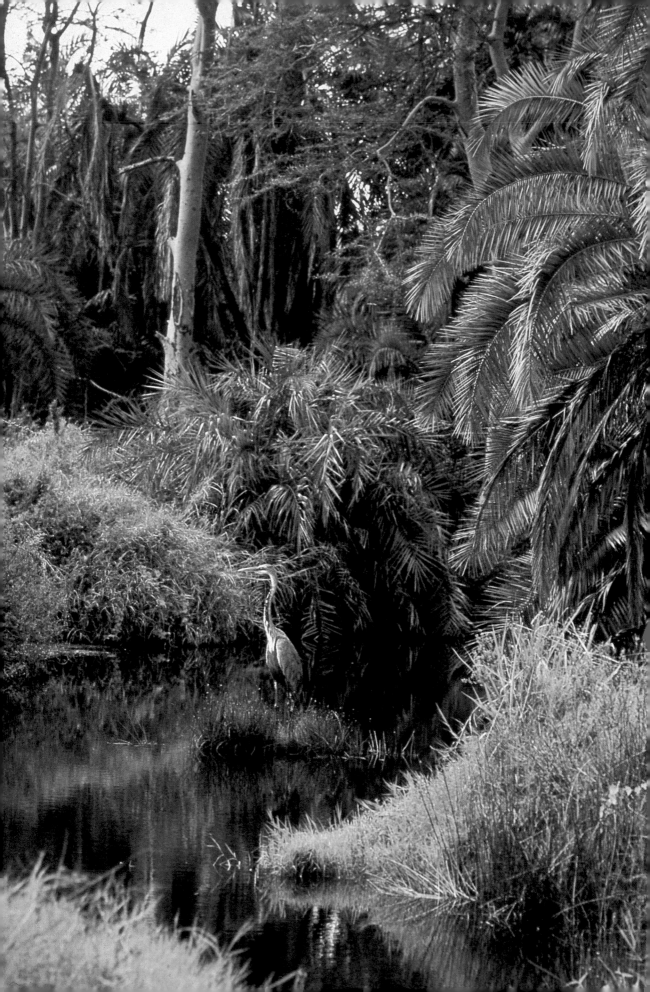

The Rich Waters of Africa

The globe-circling World Divide repeatedly gives rise to great rivers not far apart. Three of Africa's four great rivers—the Zaire, the Zambezi, and the Nile—arise a relatively short distance from one another; only the Niger, far to the northwest, has a different origin. The Zaire, formerly called the Congo, empties on the west into the equatorial Atlantic, the Zambezi into the Indian Ocean to the southeast, and the Nile due north into the Mediterranean. Each of these three rivers arises in highlands associated with the Great Rift zone, fed by water from lakes, mountain rains, and high plateau mists. In fact, the Lualaba River, the eastern mainstream of the Zaire, may have been a part of the Nile system 65 million years ago.

Some say the most remote headstream of the Zaire is the Chambezi River, arising in high country between Lake Tanganyika and Lake Nyasa. But the true source of the Zaire is considered to be the Lualaba, which commences at an altitude of about 1,380 meters nearly 100 kilometers southeast of the city of Kolwezi in Zaire. After a rapid descent to a wide plateau, it cuts deep gorges and descends into a trough that is part of a fault zone. Once it enters Lake Upemba, its flow is slowed by floating islands of vegetation and extensive papyrus beds. From here the Zaire, paralleling Lake Tanganyika, flows almost due north to the equator, where at Boyoma Falls (formerly Stanley Falls) it curves toward the west. The falls are a spectacular series of cataracts 96 kilometers long, below which, according to tradition, the true Zaire begins. Above the falls, the river is called the Lualaba as frequently as it is called by its more familiar name, the Zaire.

This midportion of the river, now grown huge, runs through a region which was once an enormous shallow lake. Even today the Zaire is only 1 or 2 meters deep but sprawls from 6 to 14 kilometers wide, depending on its flow. Shifting sandbanks are everywhere, large stable islands separate the mainstream, and broad forested floodplain extends for several kilometers on both sides of the river.

The final section of the river commences at Pool Malebo (formerly Stanley Pool), a large shallow lake. From here it runs over a series of 32 cataracts before reaching the sea. With a watershed basin of over 3,700,000 square kilometers, it is little wonder that the Zaire discharges its water into the ocean at an average of more than 42,000 cubic meters a second—a rate second only to the Amazon. And at flood times, it can be almost twice that volume.

The Great Equatorial River

The Zaire flirts with the equator. It hastens toward the equator on its initial flow north, crosses it, then returns again—never leaving it far away. Everywhere on both sides of the equator there are tributaries feeding the mighty river. Forests of the Zaire Basin, some of which are among the most famous in the lore of the tropics, are filled with wildlife: a dazzling array of plants and animals, organisms that in large part owe their very existence to the presence of the river and its effect on the surrounding terrain. Both river and forest are products of heavy rainfall over much of the year, the short dry season having only minimal effect on the life present. Animals

familiar elsewhere in Africa appear in special varieties in the Zaire region. At higher elevations, frequent precipitation and low-lying mists give rise to extensive bamboo forests, the home of the mountain gorilla (*Gorilla gorilla beringei*). Lower down, where bamboo is replaced by trees and hardwood shrubs, the forest giraffe or okapi (*Okapia johnstoni*) and small forest elephant (*Loxodonta africana cyclotis*) browse, and the Congo leopard (*Panthera panthera iturensis*) lies in wait on overhanging branches for its prey.

Finned Denizens of the Zaire

Exceeding most other great river systems of the world, the Zaire harbors approximately 600 species of fish, including some of its own specialties. The Congo upside-down catfish (*Synodontis nigriventris*) is one of the most startling of the endemic fishes—in behavior, if not in appearance. There are six species of these odd Zaire catfishes, most of them colorful and rather beautiful but not easily seen, for they are nocturnal and remain concealed during daylight.

During daytime hours these species adhere to any object on the bottom without regard to their position: head up or down, body upside down or at some oblique angle. Their name refers to their trait of swimming on their backs when at night they emerge to congregate in schools and swim from place to place. When they feed, however, they do so in the normal position, with their sensitive barbels trailing the bottom as sensory detectors of food. A few of the species produce clearly audible sounds, the importance of which is not known, although it is possible they are defensive tactics.

The mormyrids, a highly specialized group of electric fishes, are found throughout Africa except in the arid north and northeast. The Ubangi mormyrid (*Gnathonemus petersi*) is a fish of curious appearance, having a black body and setback dorsal and anal fins fringed with white. Its strangest feature is a very long, fleshy protuberance extending forward and downward from its chin. This is a sensory device which makes contact with the bottom, allowing the fish to locate and devour its prey of worms and crustaceans.

Like the Amazon electric eel, the mormyrids either live in nearly opaque, muddy water or are active chiefly at night. For this reason, the mormyrids generate a surrounding electric field that enables these fish to detect inanimate objects as well as possible prey or potential danger. The fishes can sense these objects because whatever enters their symmetrical field causes distinguishing distortions, depending on its own qualities of conductivity. The little mormyrids, only 20 centimeters long, have special receptor organs concentrated in the head zone that are extraordinarily sensitive to slight alterations of their electric fields. These organs allow the fishes to find one another in a habitat where vision is all but impossible. The electric field surrounding a fish also enables it to establish and defend its own territory preparatory to mating. However, the electrical functions of a mormyrid are only a form of sensory perception, rather than a means of electrical discharge used for massive attack or defense, as in the other larger electric fishes.

Among fishes in quiet backwaters of the Zaire Basin there

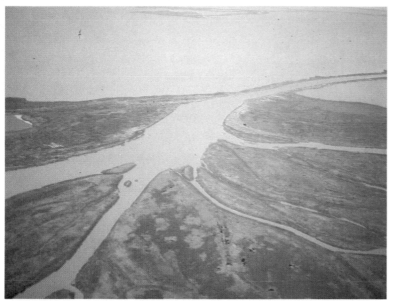

77. *The rivers of Africa demonstrate an endless variety of flow patterns as they descend from highlands across vast plains and forests on their way to the sea. Tributary streams converge from several directions to join the Omo River of Ethiopia* (top), *while the Blue Nile* (center) *reveals a pattern of meanders due to low stream velocity and an almost flat valley floor. An oxbow loop in the Luangwa River of Zambia* (bottom) *will continue to close until it breaks through the isthmus. The isolated oxbow lake will then gradually fill in, with its wildlife changing in the process as it becomes shallower and loses oxygen.*

Overleaf. *On a tiny island in the delta of the Okavango in Botswana, two male sitatungas* (Tragelaphus spekei) *rest from their travels through the flooded surrounding area. Because they have highly elongated, splayed hooves, these large animals are capable of walking easily through soft, muddy marshland.*

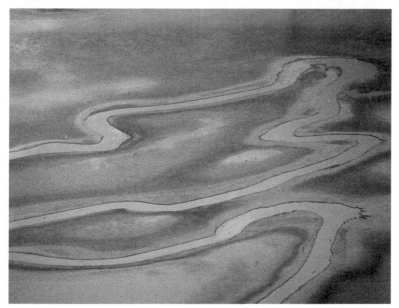

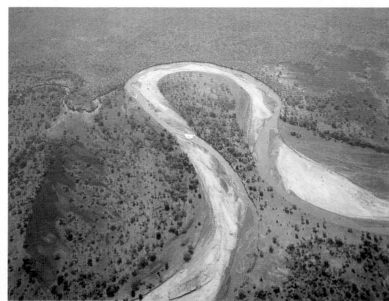

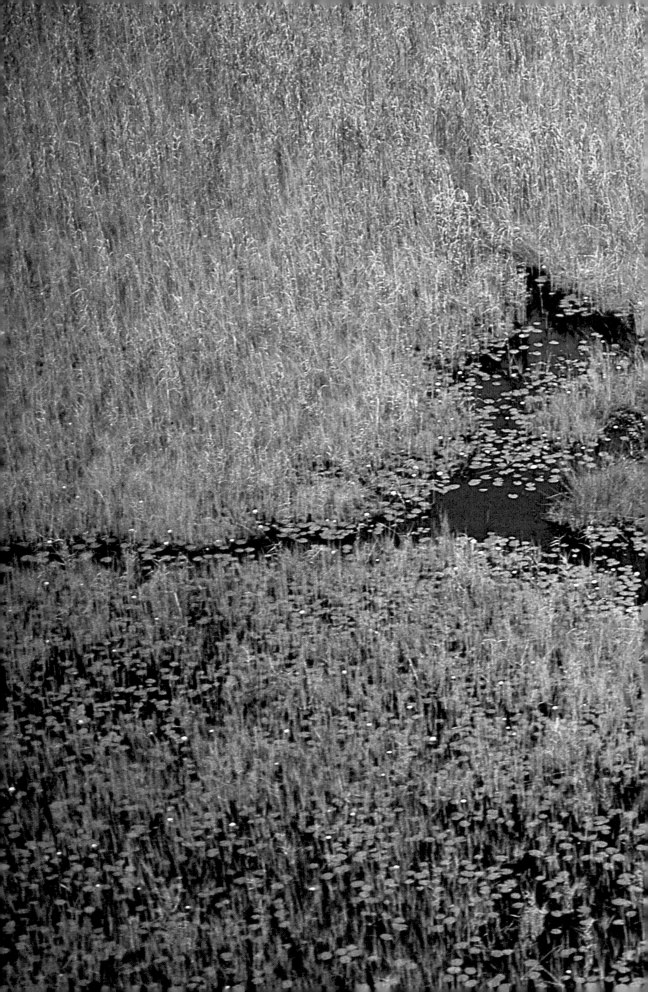

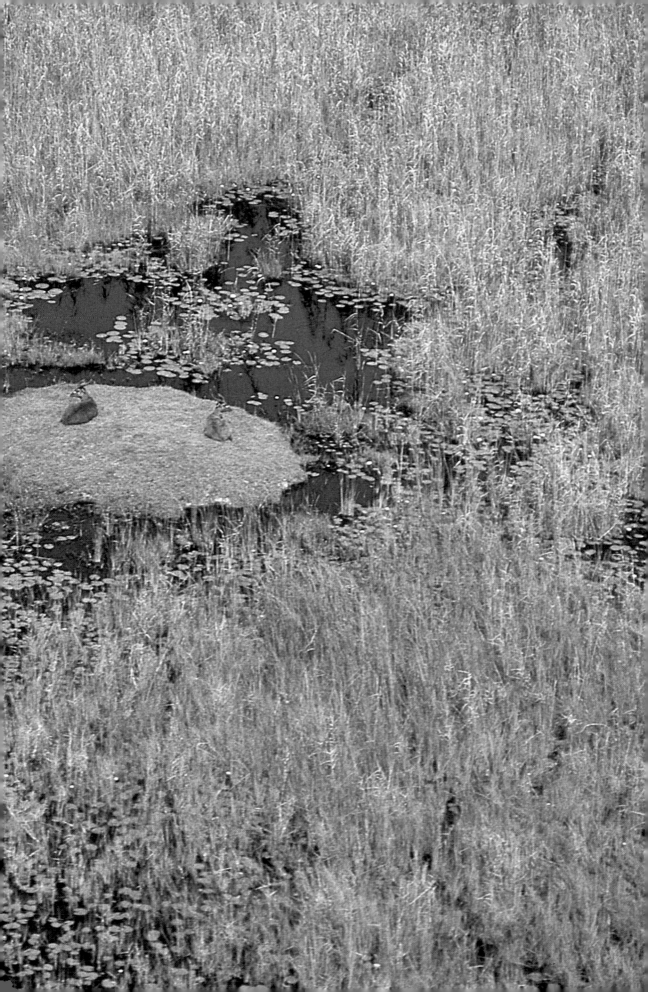

also swims an odd frog, the African clawed frog (*Xenopus
laevis*), now widely known around the world for its use in
human pregnancy tests. This is a thoroughly aquatic
amphibian which has short, dark claws on the three inner
toes. Amphibians in general are clawless, but this species
is so unusually slippery from mucous secretions of the skin
that during copulation the male needs some means of
holding onto the female, which also appears to have claws.
Extraordinarily fecund, female clawed frogs produce an
average of over 10,000 eggs a year.

African clawed frogs, with their huge webbed hind feet,
are powerful swimmers and so at home in the water they
may never emerge onto marshy riverbanks. They mate
frequently, and their egg-laying continues all year long,
but they suffer from an unusually high mutation rate,
which produces malformed tadpoles. Because abnormal
tadpoles do not swim as vigorously or effectively as
normal ones, they become easy prey for the cannibalistic
young adult clawed frogs. It has been suggested by
biologist J. M. Savage that the large number of eggs laid
and the high frequency of mutant tadpoles is in reality a
benefit to the species, since this ensures a ready food
supply for developing frogs when they are isolated in
pools that are cut off from the river during low-water
periods.

How different the clawed frog is from another species, the
hairy frog (*Trichobatrachus robustus*), which lives in cool
mountain tributaries of the Niger River to the west and
above the equator. This bizarre creature appears to have
"hair," or masses of fine filaments, streaming from its
body and thighs. Males live only in fast-flowing upland
brooks where there is a high level of dissolved oxygen; the
females remain most of the time on the banks. The thin-
walled filaments allow efficient oxygen exchange between
water and blood, thereby doubling the respiratory
function of the male frog's skin while it is submerged and
its lungs cannot be employed.

Father Nile

Although they empty through their mouths into the sea
and ocean over 4,000 kilometers apart, the Nile and the
Zaire both arise near the cloud-draped Ruwenzori
Range, named Selenes Oros, or "Mountains of the Moon"
by Claudius Ptolemy in the second century A.D.

From this mysterious, mist-shrouded highland with its
unearthly vegetation to the steaming lowland tropical
forests and shallow, reed-choked lakes, both rivers
have much in common. Nearly all the wildlife described
from here on in this chapter could apply to part of the
Zaire as well as the Nile; only a few are restricted to the
Zaire Basin.

The Egyptians survived and flourished solely because of
the Nile; they may have taken it for granted, but they
never abused it. Other nations, however, became
obsessed by it, starting with the Roman emperor Nero,
who sent an expedition in search of the river's source,
only to have the quest end in failure. Down through the
centuries the same attempt was made repeatedly, with
the same results until the last decade of the nineteenth
century. But such expeditions to discover the source of a
great river pale into insignificance when one finds stone
tools throughout the Nile Basin that date back over

Above. *In quiet streams and
backwaters of the Chobe River in
Botswana, aquatic vegetation
produces floating leaves that repel
water on their upper surfaces but
attract the water film underneath.
Air-filled stems and airspaces in
the leaves additionally guarantee
that the leaves will not sink or be
inverted. Both surfaces attract
multitudes of small aquatic and
terrestrial animals.*

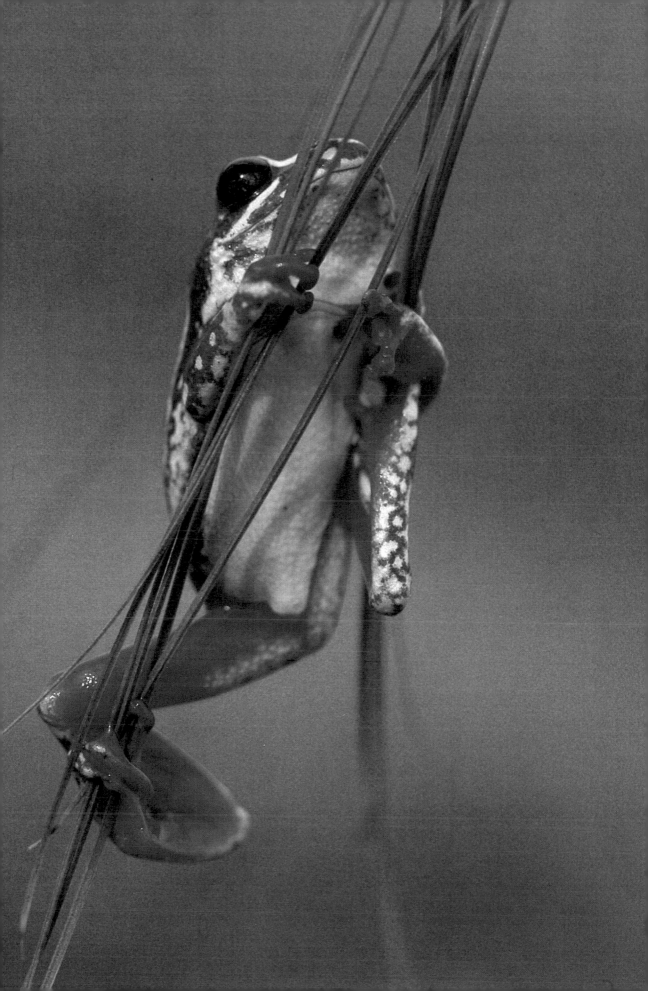

100,000 years, artifacts telling us this has been a favored place of human habitation for twenty times longer than recorded human history.

The River Horse

At 3,200 kilograms, the hippopotamus (*Hippopotamus amphibius*) is surely the largest river dweller in the world. Despite its name, which translates as "amphibious river horse," it has nothing in common with equines, other than being a vegetarian. Quite simply, it is one of the world's most remarkable mammals, familiar to zoo-goers, but more complex and highly adapted to its habitat than a casual observer might suspect.

Amphibious though it may be, its true habitat is somewhat difficult to identify, since it consists of two entirely different conditions. We think of these huge animals as living primarily in water, coming to the surface now and then to whirl their ears free of water, open their nostril valves, and inspect the above-surface world with protruding eyes. We have this impression because we travel the Nile and other African rivers during daytime, when hippos are resting in the shallows and floating easily in herds of a dozen or more. A few, collapsed on their stubby legs, may bask on exposed sandbanks along the shore. It appears a peaceful and tranquil scene, but with one necessity missing: none are feeding.

The great bulk of a hippo makes us think of a clumsy, rather "ill-designed" animal. We could not be more wrong. Underwater, this huge mammal is graceful and light-footed, seeming almost to dance along. It is not a powerful swimmer; rather, it sinks to the shallow bottom only a few meters down and trips along weighing almost nothing, with its large mass buoyed up by the water. After being submerged for three or four minutes, it rises to the surface to breathe before sinking again. Underwater it is attended by a fish (*Labeo velifer*), a member of the carp family, which hovers over the hippo's skin and picks away bits of algae and other organic matter. When it surfaces or lies on the banks and opens its cavernous mouth, a relative of the starling, the yellow-billed oxpecker, or tickbird (*Buphagus africanus*), alights on its back, walks about removing whatever it can find, and even boldly approaches the hippo's mouth to clean out food morsels lodged between the great teeth.

As the sun sets, the quiescent hippos begin to stir and seek access to the land. Young adults emerge first, followed by older dominant males. Over the centuries, herds of hippos have used the same trails repeatedly, until today they are worn meters deep in the banks and often are very steep—a condition that poses no problem for these ponderous animals. On top of the riverbank, their trails lead quite directly to favored feeding grounds several kilometers away and are marked along the way by the males with fairly regular meter-high piles of manure, continually added to as markers. Once they are in heavily grown grassland, the hippos spend the entire night grazing, clipping the grass close to the ground with strong incisors behind their broad muzzles. An adult hippo can eat more than 20 kilograms of grass a night.

It would seem a hippopotamus would be vulnerable on land, but such is not the case. A baby hippo remains very close to its mother's head, and always on the side away

from possible danger. Adult hippos are formidable antagonists, dangerous to any would-be attacker. Surprisingly fleet, they can cover ground in charges almost as rapidly as a rhinoceros.

Early in the evening and then again close to dawn, on their way back to their daytime pools, hippos may emit a peculiar series of moans, grunts, and bellows, but hardly a roar in keeping with their size. A common utterance is a sort of deep-throated "Baow-haowf-haowf-haowf," repeated many times. Once back in water, the sound becomes more a series of contented grunts, almost in anticipation of a quiet, restful day basking in the warm water and tropical sun. The big males, after entering the river, return to rather small but clearly defined territories, which they defend against intruding males. If a fight should occur, it is a loud, frightening, and serious affair: two huge males rushing at each other, colliding, cutting and tearing at their thick, tough hides and piercing it with their enormous canines, the enamel of which is hard and sharpened to a chisel-like edge. At times a fully grown male will be killed by another, possibly by a fatal thrust directly into its massive heart deep within the body. Threats occur more often than fights, however, and consist mostly of rising to the surface of the river and opening wide their gaping mouths to display the great teeth. Another device a male uses to intimidate a rival or impress a female is to spray his feces over a wide area, spreading them by rapidly whisking his tail. This accounts for the turbid water in which they dwell and is a phenomenon of considerable ecological significance. The rich nutrients of manure dissolved in the water fertilizes prolific algal growth, which, in turn, is fed upon by aquatic animals, eventually generating far larger fish populations than would normally occur.

The hippopotamus is no longer abundant throughout the Nile Valley or in other river basins, but, where protected, it flourishes, and large herds can still be seen, even though females bear only a single young at a time. Mating occurs in the water, and both birth and suckling take place underwater—all of this to the hippo's advantage, for it is where they are least vulnerable.

Other Mammals of the Nile

Other than the hippopotamus, few mammals do more than visit the Nile for food and water. Three exceptions are mammals of very different sorts that are tied by their adaptations to a marshy shoreline habitat. The marsh mongoose (*Atilax paludinosus*) takes readily to water and swims well, scrabbling about on the bottom for aquatic mollusks and other invertebrates or else seeking bird and reptilian eggs along the banks.

Both the other mammals inhabiting marshes are antelopes, one being the sitatunga (*Tragelaphus spekei*), a relative of the much larger greater kudu and mountain nyala found farther inland. The sitatunga grazes on low-lying marsh plants, supporting itself on the soft wet soil with its unusually widespread hooves. On dry land these same hooves make for a clumsy gait. The animal's soft brown hide with widely spaced vertical pale stripes blends effectively with the reed grass, making it all but invisible in its normal habitat. The other Nilotic antelope is the waterbuck (*Kobus ellipsiprymnus*), a creature which

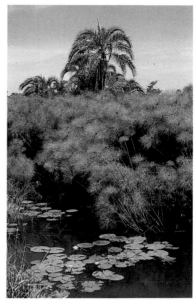

Top. *Papyrus* (Cyperus papyrus), *an aquatic grass also known as the paper reed, has an important place in history. Ancient Egyptians used it in making the first paper. They also ate its pith and tied bundles of it together to make rafts.*

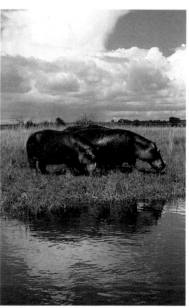

Bottom. *No other riverine creature exceeds the hippopotamus* (Hippopotamus amphibius) *in size. These animals may weigh 3,200 kilograms when full grown. Aquatic though it seems to be, it feeds exclusively on land, where it devours great quantities of grass, sometimes far inland and always at night. When aroused, the hippopotamus can run or charge with surprising speed.*

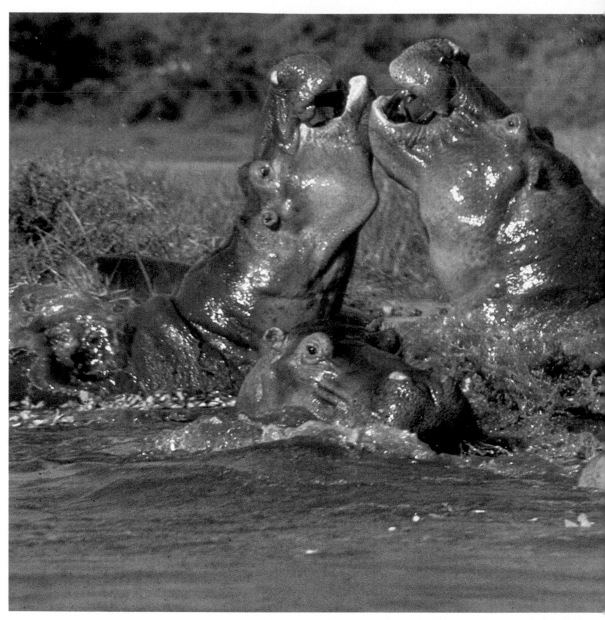

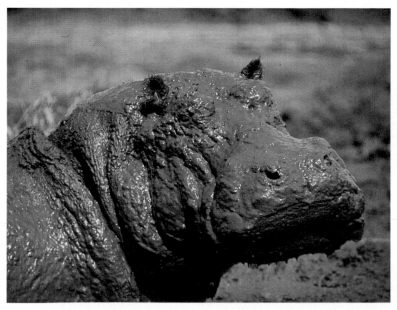

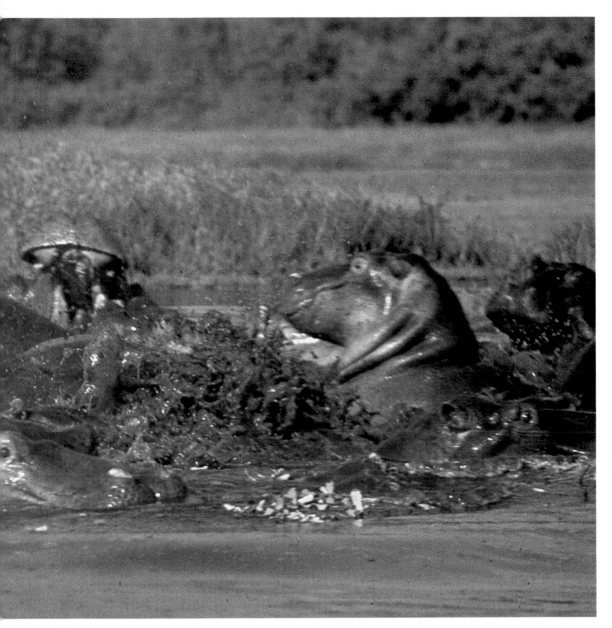

Above. *While hippopotamuses
tend to spend their days together
in groups or herds, partially
submerged in the river, males
sometimes establish territories
they defend against other mature
males. Their combats can be
serious affairs, though the event
pictured here is probably a
jostling, threatening maneuver
rather than a fight in earnest.*

Left. *A wallow in mud is good for
a hippopotamus's skin, to keep it
moist and supple and also to
discourage parasites and biting
insects. The hides of these great
animals appear soft, but in fact
they are extremely tough and
thick.*

prefers to feed on dry land but which immediately takes to nearby water when pursued by predators. There it can remain comfortably for long periods of time, its skin and coat being protected by copious oily secretions.

The Dragon of the Nile

Once the range of the Nile crocodile (*Crocodylus niloticus*) extended throughout all of Africa except the arid north, the Nile Valley being its one avenue to the Mediterranean and the Middle East. Today it is gone from much of its former range. A few years ago it was still common in the Victoria Nile between Lake Albert and Murchison Falls, but even this population is now diminished by indiscriminate hunting.

During much of the day, a crocodile will lie on the riverbank or on a sandbar, often with mouth agape. It must maintain its body temperature between 24° and 27°C, but the gaping attitude appears to have little significance in reducing temperature through evaporation, for a crocodile's mouth is rather dry and has few glands. Gaping is primarily a behavioral trait, a general warning to possible intruders or violators of one's basking spot. Actually a crocodile uses other means to keep its temperature from rising too high: it has shady areas to choose from, or it may leave its tail partly submerged in the cool river water, thus dissipating heat from its bloodstream.

On land a crocodile sprawls, resting its weight on its belly. To walk about or charge back into the water, the animal must raise its considerable bulk by pushing upward with its legs, which remain bent outward at the elbows and knees, in a far less efficient stance than that assumed by mammals with their thinner columnar legs. Once in the water, the large vertically flattened tail is used as the sole propelling organ, with the animal's legs held close to the body. When still and floating, a crocodile is a little unstable and spreads its legs out and downward as stabilizers. It dives with ease, and its lungs serve as hydrostatic organs to provide the proper density or buoyancy. Nearly all crocodilians ingest stones and other foreign objects, collectively called gastroliths, which are held in a gizzardlike portion of the stomach and aid in the mechanical digestion of food. Once it was thought these stones were used to give the reptile added weight to sink to the bottom or to help overcome prey, but this is highly unlikely, since a kilogram or two of stones would make little difference.

Nearly all accounts magnify the size of the Nile crocodile. In fact, it is not known to grow beyond 5 meters long, but that does result in a very impressive reptile, one of the largest in the world. The crocodile's diet is varied, ranging from sizable healthy mammals and birds to carrion floating downstream. Its attacks are launched underwater, with the reptile usually grasping a leg or other appendage of its prey, then whirling rapidly by means of tail action. Teeth are used only for gripping, so it is this twirling action which separates legs or chunks of flesh from the victim's body.

While the Nile crocodile may repeat an attack that once proved successful, there is no truth to the repeated statement that they lie in wait along well-traveled trails to catch oxen or humans, perhaps by sweeping them off their

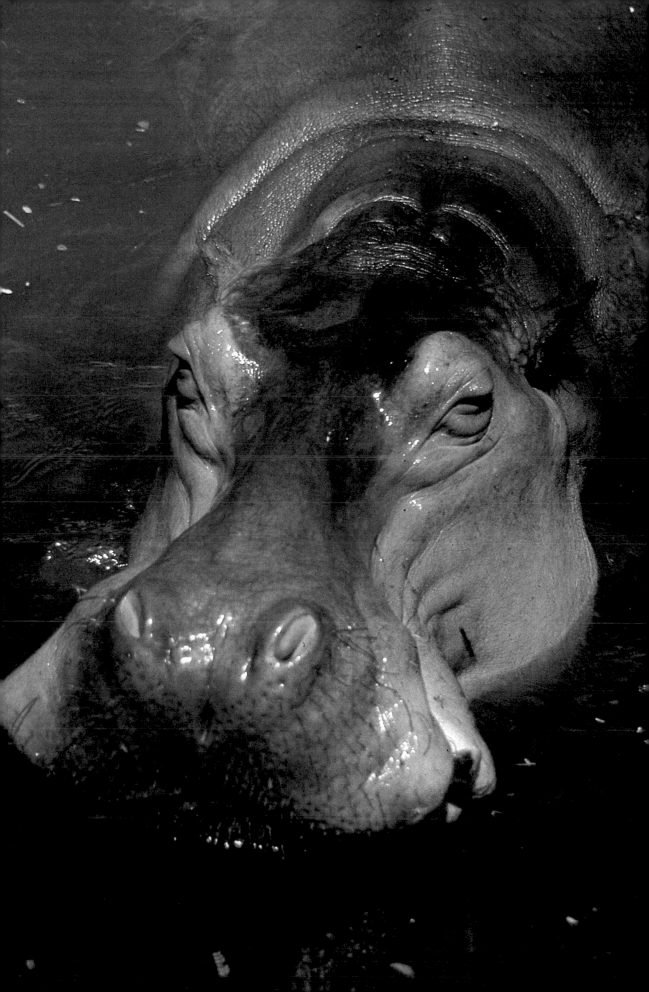

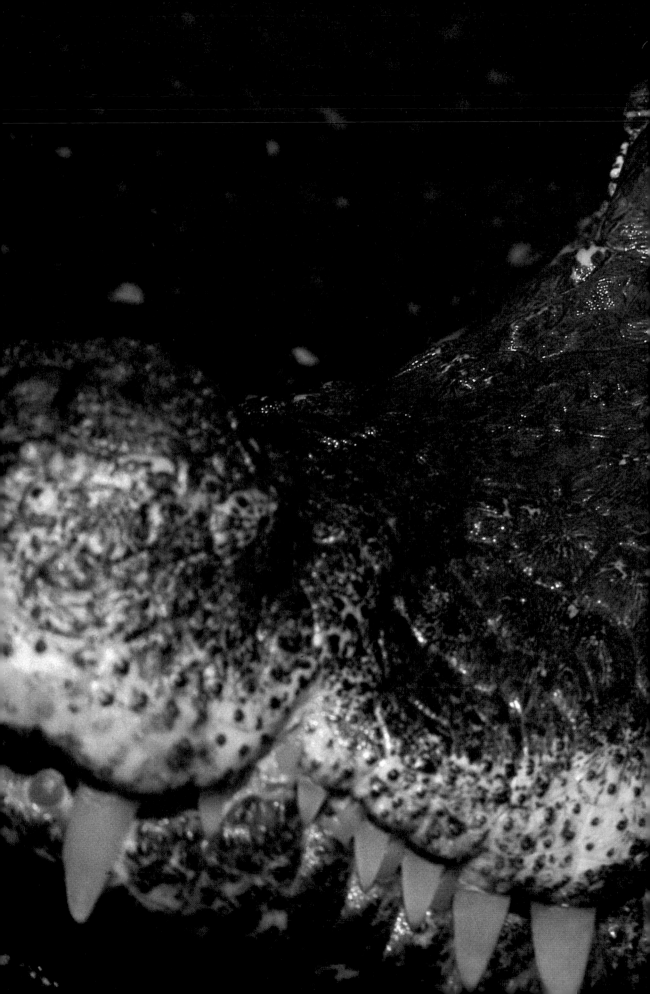

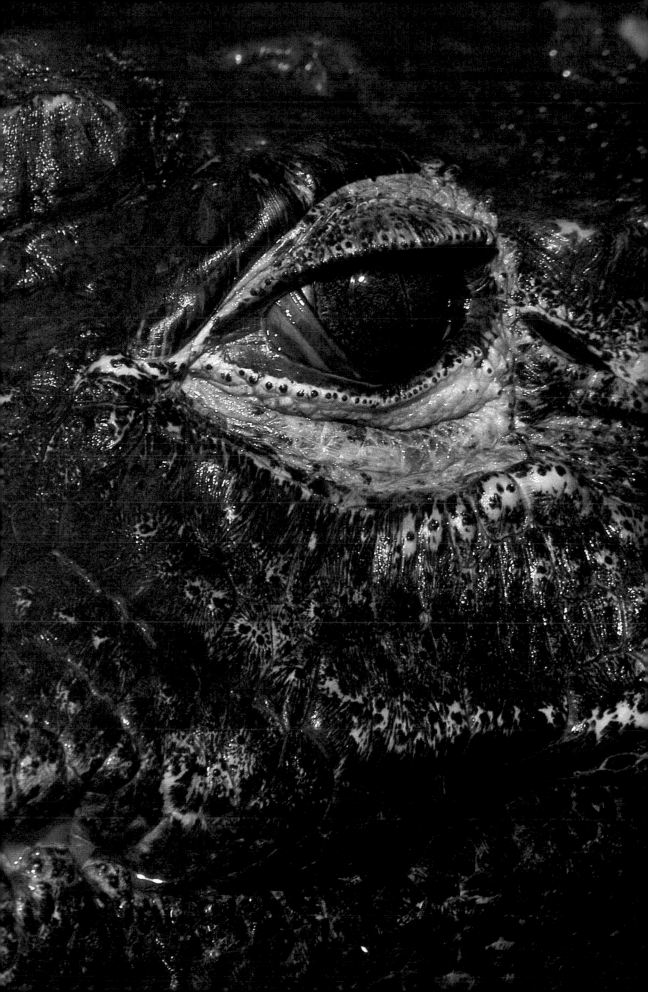

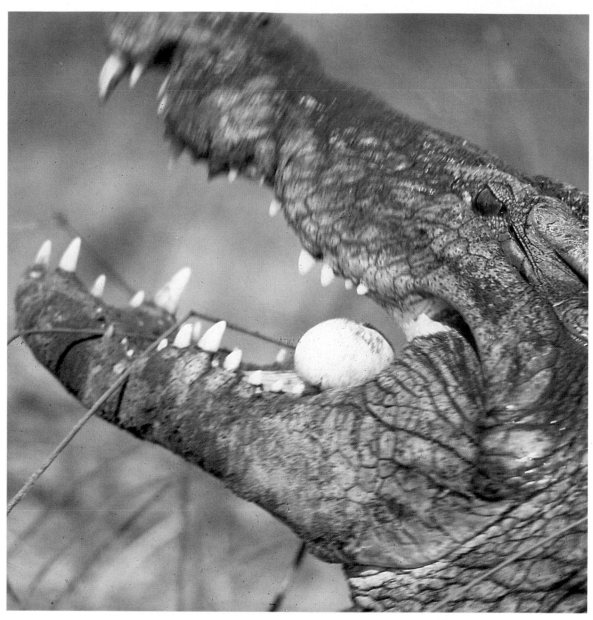

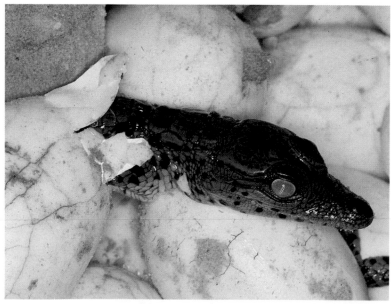

feet with a vicious blow of the tail. It would be a fortunate crocodile indeed to catch anything alive on the riverbank, but it is true that the reptiles have been responsible for the deaths of some people, mostly children, who have been swimming in certain localities of the river or in one of its lakes.

There is no evidence for another statement found even in modern accounts: that the Nile crocodile exhibits territorialism, at least during the day. Where there are still large populations of crocodiles, they can be found crowded together basking in the sunlight, often lying directly across one another. They may be equally crowded while lying quietly in the water.

The best study of the Nile crocodile was conducted in the 1950s by H. B. Cott, who was able to observe and record nearly all aspects of the great reptile's life. His account of its roar is vivid: "a growling rumbling, very deep in pitch, rattling, vibrant, and sonorous, like distant thunder. . . ." He found no evidence of the long burrows they reputedly dig, nor of estivation in the mud during dry seasons. A Nile crocodile is capable of crossing wide expanses of arid land in search of water, though few places in which they habitually live dry up completely.

Waters of the Upper Nile join other African wetlands in being a refuge for soft-shelled turtles belonging to the Trionychidae, a family of creatures found in only a few other spots in the tropics. Soft-shelled turtles do not fit the popular conception of more familiar turtles: they are highly active, aggressive, long-necked predators in which the soft shell, enriched with numerous blood vessels, serves as an accessory respiratory organ.

Not all reptiles associated with the Nile are as thoroughly aquatic as the crocodile and the soft-shelled turtle. The Nile monitor (*Varanus niloticus*), a 2-meter-long lizard belonging to a group of formidable reptiles found throughout Africa, Asia, and Australia, is not restricted to arid lands as are so many of its relatives, but readily takes to water, where it swims powerfully and dives beneath the surface to catch fish, frogs, and mollusks. It ranges along riverbanks, seeking the eggs of ground-nesting birds, and especially relishes crocodile eggs, which it digs from the hardened mud. The long, forked tongue of the Nile monitor is an exquisitely sensitive organ capable of detecting such nests even when they are well hidden from all other predators. In this way, even the mighty Nile crocodile is preyed upon at a stage when it is vulnerable and defenseless.

Birds of Lake and River

Wetlands and lakes of both the Zaire and the Nile systems support a vast number of bird species, although in each case riverine forms diminish on approaching the mouth downstream. For example, the African river martin (*Pseudochelidon eurystomina*) is restricted to the lower reaches of the Zaire. It is not lightly built like other members of the swallow family but shares with them a magnificently skillful flight, with a capability of catching large insects in midair and crushing them with a broad, strong bill. Curiously, its nearest relative lives nearly 9,000 kilometers away in Thailand and has precisely the same habits.

In the Nile region, the African fish eagle (*Haliaeetus*

90 top. *The female African crocodile (*Crocodylus*) may at times manipulate eggs from her nest with her jaws—a remarkably gentle feat considering the jaws' enormous crushing power. The crocodile nest is generally a pit excavated by the female. After the eggs are laid, the nest is covered with soil and surrounding vegetation.*

Bottom. *In 11 to 14 weeks, depending on the temperature, the young hatch and immediately take to water. Their survival rate is low, for crocodiles are vulnerable when small and are sought by many predators.*

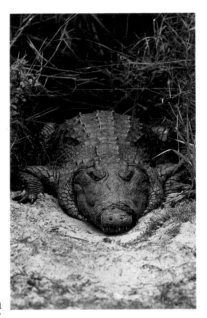

Above. *Crocodiles have limited ability to regulate their body temperatures. The most effective means of warming their massive bodies and maintaining a proper metabolic rate is basking in the sun on a riverbank. From here they can charge into the water if alarmed.*

Overleaf. *The white-faced whistling duck (*Dendrocygna viduata*), resident in both Africa and South America, is named for its high-pitched whistling call. These ducks feed primarily at night on shoreline and marsh plants and spend their days resting quietly on riverbanks.*

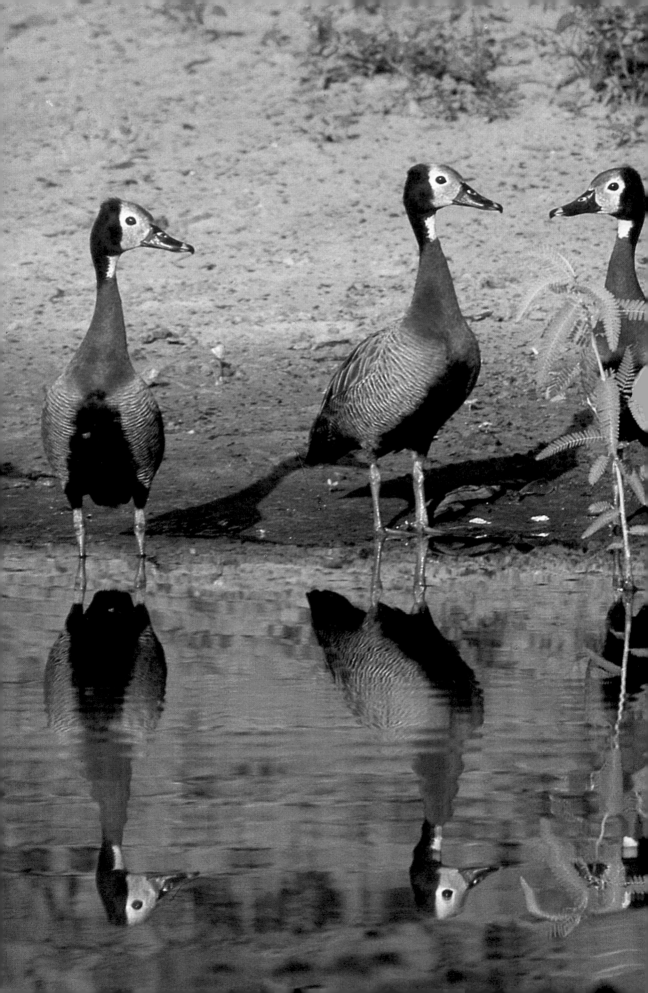

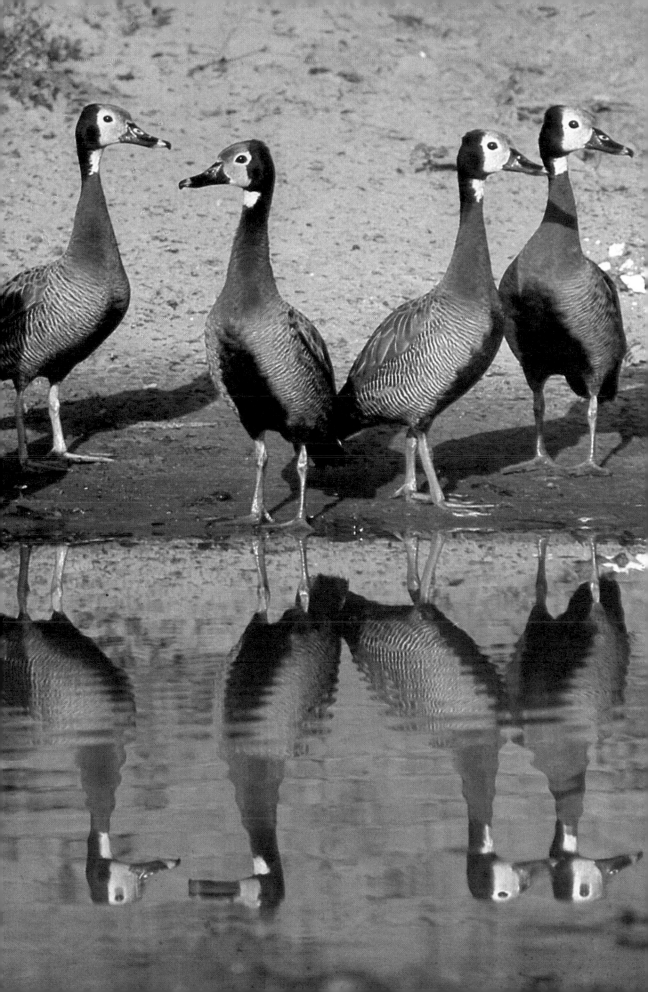

Top. *The African jacana (Actophilornis africanas) lives along streams up to altitudes of 2,200 meters. Like other jacanas, it has exceptionally long toes and nails that aid it in walking over floating vegetation and soft shoreline mud.*

Center. *The very large worldwide family of rails (Rallidae) includes the king reedhen. (Porphyrio madagascariensis). Reedhens are rather secretive inhabitants of thickly grown, marshy shorelines of African and Madagascan rivers. It is a distinctive bird, with a stout beak, reddish forehead plate, and red legs. Like most rails, rather than take flight, it prefers to run through the marsh to escape an intruder.*

Bottom. *The African black crake (Limnocorax flavirostra) is a denizen of thick papyrus beds. With its compressed body, short tail, and long powerful legs, it is able to penetrate these reed "forests," whereas less specialized animals cannot.*

vocifer) is found up and down the entire valley. Its species name reveals its vociferous nature—wild, shrill cries that carry great distances across the water. It perches watchfully on a shoreline tree, then glides out to snatch from the water, with one taloned foot, fish weighing a kilogram or more. Because the fishing generally is good in African rivers—Nile, Zaire, Zambezi, or Niger—fish eagles of this continent generally have rather small territories and nest close together.

Flamingos are found only in lakes and headwaters of the Zaire, but extend north through much of the Nile Valley. The lesser flamingo (*Phoeniconaias minor*) is somewhat broader in distribution throughout the southern half of Africa, but the greater flamingo (*Phoenicopterus ruber*) is resident along the entire east coast and all of the Nile. This large species has worldwide distribution: northwest Africa, southern Europe, India, Central and South America, the Caribbean, and the Galápagos.

A flamingo is an ancient bird, its fossils having been found dating back to the earliest days of bird evolution, long before there was much variety among birds. That it was a successful evolutionary "design" is evident in a form largely unchanged from those remote times. Presumably it has always had the same feeding habits that are indicated by its peculiar, highly specialized bill and attenuated form. Its food consists solely of aquatic organisms: the lesser flamingo relies chiefly on minute green and blue-green algae, and the greater flamingo feeds on crustaceans and other aquatic invertebrates. When feeding, the bird bends its neck downward until its angled bill is held upside-down in the water, opens its jaws, and sucks in water by retracting its tongue. Once water is in its mouth, the bill is closed and water is expelled by thrusting the tongue forward. Food particles, caught by a filtering mechanism in mouth and beak, are carried down the throat the next time the tongue moves back to take in water. Such elaborate beak structure and behavior means that the flamingo is a highly efficient plankton feeder, one of the very few in the bird world. Planktonic life, plant or animal, is abundant in tropical lakes and quiet streams; it reproduces rapidly and prolifically, ensuring these tall birds of a constant supply of nourishment, even if it consists of only a very few species. In fact, both species of flamingo live and nest in some of the highly saline lakes of the Rift Valley, where they feed almost exclusively on brine shrimp (*Artemia salina*), one of the few forms of life able to tolerate such hostile aquatic conditions.

Flamingos feed close to one another, at times almost obscuring the shallow end of a lake by their numbers. Their conical, truncated mud-pile nests, which rise above high-water level, are also grouped together in large colonies, but each is carefully spaced from those surrounding it. Probably no sight in Africa is more breathtaking than a flock of several thousand greater flamingos simultaneously rising into the air, their white bodies flashing in the setting sun, the long red legs trailing behind, and the outstretched sinuous necks gracefully undulating in rhythm with the powerfully beating wings, accented by an edge of dark primary feathers. Efficient but ungainly when standing in the water, few birds are more beautiful in flight.

The shoebill (*Balaeniceps rex*), a stork, has an equally unusual bill, one that is highly specialized for obtaining its own fare of catfish and lungfish embedded in the bottom mud. This unique bird is found only in dense papyrus throughout the northern half of Africa, where it deliberately and quietly stalks its prey. Despite spending much of its time on the ground, it flies vigorously, often soaring on thermal updrafts. When it is standing still, the weight of the massive bill obliges the bird to rest its head and bill against its neck and chest, creating a curiously dignified, "wise" expression. The huge beak, with its strong, curving pointed tip, is an efficient excavating tool, even in hardened mud as the river levels fall. The African lungfish (*Protopterus aethiopicus*), like its Southern American cousin, estivates within mucous cocoons deep in the mud of exposed river bottoms, breathing through a porous mud plug. It may be this plug, differing in appearance from the surrounding surface, which allows the shoebill to recognize its hidden prey. The electric catfish (*Malapterurus*), upon which it also feeds, usually is caught in shallow opaque pools, where it survives an oxygen deficiency by breathing air through respiratory branches in its gill chamber.

Who has heard of a 57-centimeter-tall bird building a 500-kilogram nest? This is the work of another river swamp dweller, the hammerhead (*Scopus umbretta*). Also a member of the stork family, this bird of uniform soft brown color derives its name from a thick, rear-pointing crest that appears to balance its long bill. It prefers to hunt its invertebrate food along the banks of slow rivers and streams, often dislodging prey from the bottom by kicking and scratching, causing burrowing forms to be exposed as they attempt to swim to safety.

The familiar European white stork (*Ciconia ciconia*) spends its winters in Africa, but for true magnificence among storks we must look to a purely African species, the saddle-billed stork (*Ephippiorhynchus senegalensis*). Its impressive size—120 centimeters tall with a wingspan of 240 centimeters—is set off by strongly contrasting colors. The white body supports dark wings and a jet-black neck rising to the crown of the head. The long, heavy, sharply pointed beak is tipped in red, has a black band midway, then is scarlet where it joins the head. Above the scarlet band is a massive bright yellow saddle overlying the bill itself. The bird hunts through the dense swamps like a heron, stalking slowly, pausing, then spearing fish with a javelin-like bill.

Bright colors are found among many birds associated with the Nile and other African rivers. Foremost among these is the brilliant little 12-centimeter-long malachite kingfisher (*Corythornis cristatus*), a common bird wherever there are rivers, lakes, and swamps. It prefers to fish along shores overgrown with reeds until breeding season, when it leaves for the earthen banks of streams in which it excavates nesting holes. When it is perched watchfully on a reed or papyrus stem, its bright red bill, rust-and-white plumage, and shining violet-and-cerulean head and back make it an unforgettable sight.

A quite different fishing bird is the nocturnal, rather mysterious Pel's fishing owl (*Scotopelia peli*), which finds river fish in the dark of night. How it locates its prey is unknown, but the means and method are effective, for two

other species of fishing owls, Bouvier's fishing owl (*S. bouvieri*) and the rufous fishing owl (*S. ussheri*) hunt in precisely the same way along forest streams and rivers. Their taloned feet are specially adapted for gripping slippery fish by means of rough, spiny soles. Furthermore, their long legs are bare, without feathers to get wet and add weight and resistance to their fishing efforts.

Waterfowl of many kinds are associated with African rivers, with the gregarious Egyptian goose (*Alopochen aegypticus*) being the best-known to men throughout the ages. Ancient tomb paintings clearly show this bird, which was a favorite of Egyptian fowlers two and three millennia ago. Despite its aggressive nature, it was domesticated by them as well. The Egyptian goose actually is a member of the somewhat primitive shelduck family and possesses distinctive patterns and colors in its plumage.

Reed Forests

Continents in the tropics have vast expanses of drainage basins and wetlands, channeled through by complex river systems, all the results of heavy rainfall and short dry seasons. Africa has thousands upon thousands of square kilometers of swamps and floodplains, the individual habitats determined by highly characteristic plants. None of these is more famous than papyrus (*Cyperus papyrus*), a tall, graceful member of the sedge family. It is a perennial plant with three-sided stems rising from long, thick rootstocks that grow horizontally within the bottom mud in shallows no more than a meter deep. The towering stems bear no leaves for about 3 meters from the base, then produce a brush-like crowning fan that nods in the breeze. A thick stand of several thousand hectares of papyrus creates a wetland "forest" impenetrable to all but the most specialized creatures, such as those already mentioned and others including the black crake (*Limnocorax flavirostra*), splay-footed lily-trotter (*Actophilornis africanus*, or jacana), squacco heron (*Ardeola ralloides*), and various snakes, turtles, and lesser animals.

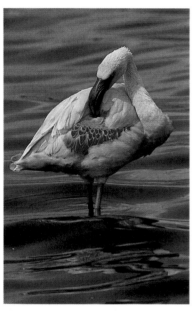

Above. *Like most flying birds, a lesser flamingo* (Phoeniconaias minor) *spends a certain amount of time each day preening its feathers with its beak to keep them in good condition.*

Ancient Egyptians cultivated papyrus in the delta region for a wider variety of uses than we today may realize: its tufted heads were used only for sacred purposes; the dense roots served as fuel and wood for making utensils; stems were lashed together to make rafts, boats, baskets, and other objects; stems were pounded and fibers separated for use in cloth and rope; but the most famous application of all helped to make this and all books possible, for the first paper was created by Egyptians from papyrus stems. The papyrus was used in other ways, too: as caulking and also as food, for its pith was eaten either raw or cooked. Apparently not a single part of this prolific plant went to waste, and it contributed significantly to the emergence and flourishing of this great ancient civilization.

A Multitude of Fishes

The mainstream of the Nile supports at least 112 species of fishes, 16 of which are found nowhere else. Possibly the most important inland fishes to Africans are the many species of cichlids (*Tilapia*). They reproduce

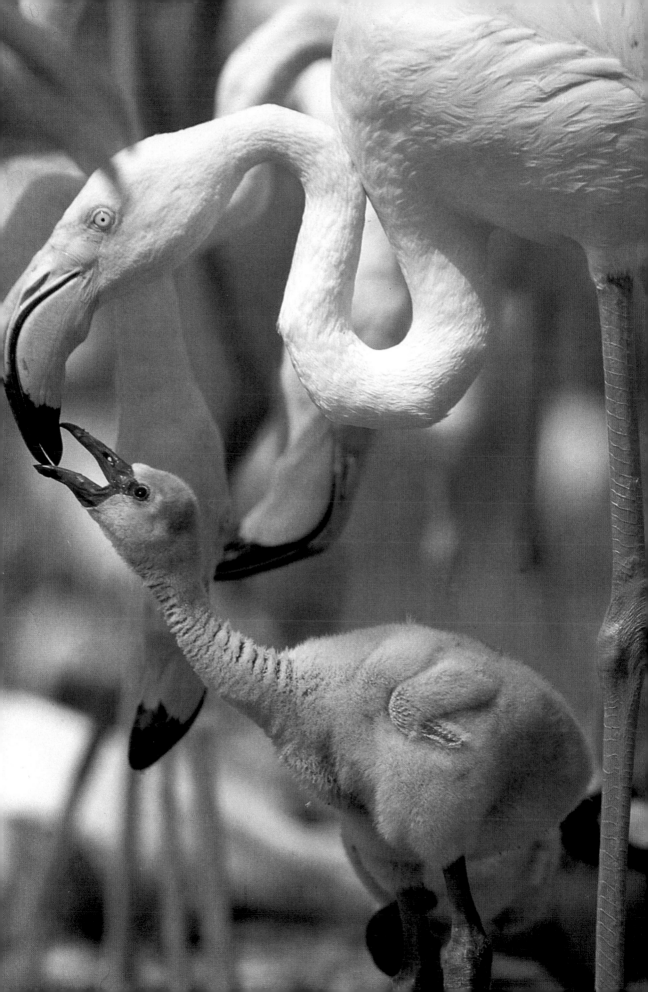

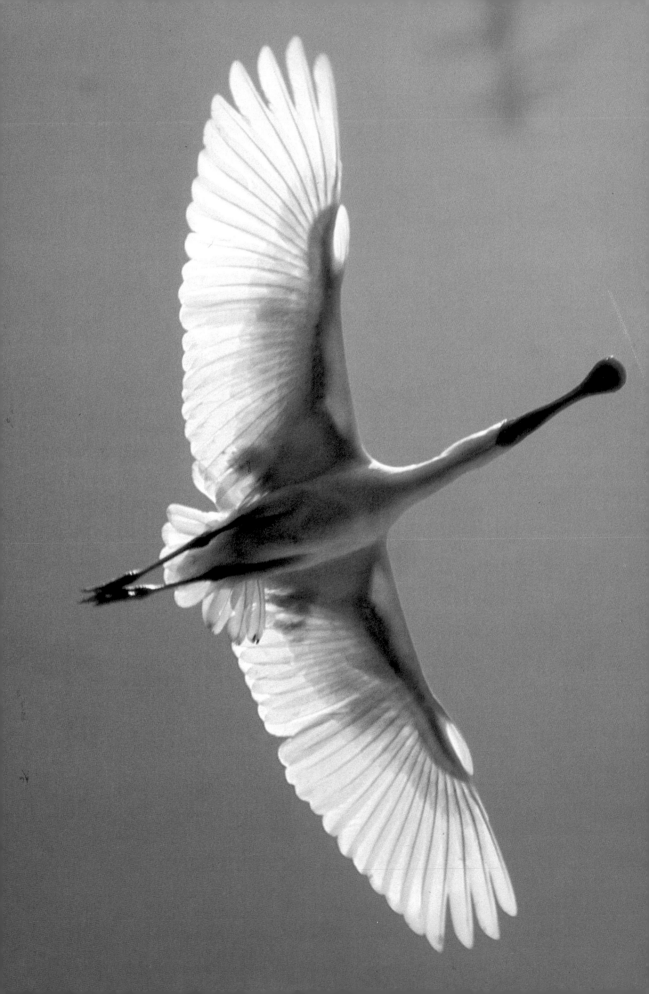

rapidly, grow quickly, occur in large numbers, are fit for human consumption, and live in almost every river, stream, and lake except those laden with mineral salts. Where they are cultivated intentionally, the annual yield may be as high as 4,000 kilograms per hectare; even in the wild state, some waters produce several hundred kilograms per hectare every year. *T. nilotica* is perch-like, but that name immediately brings to mind a much larger fish, the giant Nile perch (*Lates niloticus*). This huge member of the perch family, which can weigh up to 160 kilograms and be well over a meter long, is not restricted to the Nile; it has also been found in the Niger River, far to the west. In rivers where most other fishes are considerably smaller, the Nile perch is an immensely powerful predator.

African rivers can give rise to other aquatic giants as well. A very large member of the clariid catfish family, the African labyrinthic catfish (*Clarias*), may grow as long as a meter, but size is not its chief distinguishing characteristic. As a supplement to its gills, this catfish has a tree-like, labyrinthic organ that adds greatly to available surface area for absorption of dissolved oxygen. Such adaptation allows the fish to live in waters deficient in this vital gas and, more importantly, to wriggle overland at night from one body of water to another. Probably as a result of their breathing efforts while making a journey across dew-wet ground, they grunt as they move along in serpentine fashion. Coming upon two or three dozen large catfish wriggling along the ground in the dark of night, grunting as they go, must surely be one of life's odder experiences.

The ancients knew what they meant when they spoke of "Father Nile." Today this respectful epithet applies equally to our understanding of the river's part in the distribution and evolution of African wildlife.

African rivers, with cultivated lands extending to their very banks, are no longer populated by the immense throngs of wildlife that existed even a century ago. At the same time that Africa is becoming an infinitely better place to support a burgeoning twentieth-century population of humanity, it is rapidly losing its effectiveness and quality as a place in which lake, swamp, and river animals may safely dwell. Within little over a century, populations of some remarkable and unique species have so diminished, and their habitats been so reduced, that every effort must be made if they are to be kept from vanishing forever from the face of the Earth.

Opposite. *The African spoonbill* (Platalea alba) *is related to the ibises and storks. The wide, flattened tip of its unique bill facilitates capturing of such aquatic invertebrates as mollusks, insects, and crustacea. The birds' large nests, made of reeds and sticks, are built on low trees and marsh plants over water or close to the ground.*

Overleaf. *Because fishes are abundant in African rivers, African fish eagles* (Haliaeetus vocifer) *defend relatively small territories. With their powerful talons, they can snatch a fish weighing more than a kilogram out of the water. African fish eagles have wingspreads of 1²/₃ meters.*

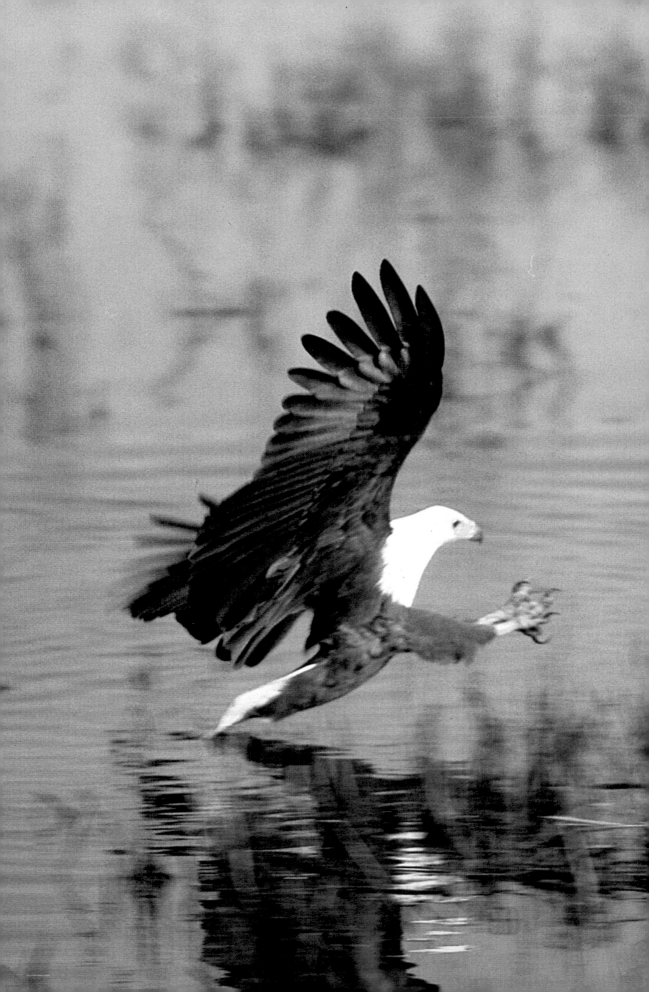

Asia: From Ice to the Tropics

Asia, one of the great landmasses of the Earth, extends eastward from Europe. Although its political boundaries may be defined, Eurasia is an enormous continent with a complex geological past. For example, the crustal plate carrying India was detached from Africa and moved northward as a huge island; then, 15 million years ago, this gigantic, slow-moving mass pushed into Asia, where it raised the Himalayas.

The continental landmass this book considers Asia extends eastward from the Volga River to the Pacific coast, and from the Gulf of Ob within the Arctic Circle to the Mekong Delta in the south. This vast area, approximately 10,500 kilometers by 8,000 kilometers, gives rise to many of the world's important rivers, which, because they flow through every kind of terrain and latitude—from high mountain to floodplain, from Arctic tundra to tropical rain forest—are very different from one another. Such large and familiar rivers as the Volga, Ob, Lena, Tigris, Euphrates, Indus, Mekong, and Amur will only be mentioned in passing here. We shall consider in greater detail three rivers: the Yenisei, Ganges, and Yangtze. These major rivers were selected primarily because they occupy three quite distinct positions in a huge triangle— one to the north, one to the south, and one far to the east.

At the Top of the World

The Yenisei of central Siberia, one of the world's mightiest rivers with a length of 5,940 kilometers, arises in the western Sayan Mountains as two torrential rivers, the Bei Kem and Khua Kem. The largest of all the Yenisei's tributaries is the Angara, flowing from Lake Baikal to the east, the lake being fed in turn by the Selenga River. Because Baikal is such an extraordinary lake, we shall look more closely at this branch than at the streams flowing from the western mountains. From the source of the Selenga, which is very close to rivers flowing eastward into the great Amur Basin, to the Kara Sea, the Yenisei is 4,130 kilometers long, or sizable enough for this branch to be one of the Earth's major rivers.

The entire river is strongly influenced by glacial and near-arctic conditions, past and present. Formed over 70 million years ago, the Yenisei is fed by meltwater from the mountains and the deepest lake in the world, Baikal. During the peak of glaciation, it found its way to the sea underneath the great ice sheets that covered western Siberia. Subsequent glaciations and interglacial periods did not substantially change the river's course. Once it leaves its highland sources, the Yenisei flows across the lowlands of northern Siberia, land that is locked in permafrost, which by melting along the river's margin adds to its volume. Because of the permafrost, erosion is negligible and a significant change in the riverbed almost impossible. Swamps and other wetlands are scarce in this region, and there are few lakes, Baikal being the one notable exception.

The Yenisei is a clean river, little affected by human development, although a number of dams have altered its flow patterns. The water is clear, with few dissolved minerals, and is rich in life-supporting dissolved oxygen. It is only moderately turbid in its lower reaches, where it begins to grow very deep yet allows light to penetrate further than do most other major rivers.

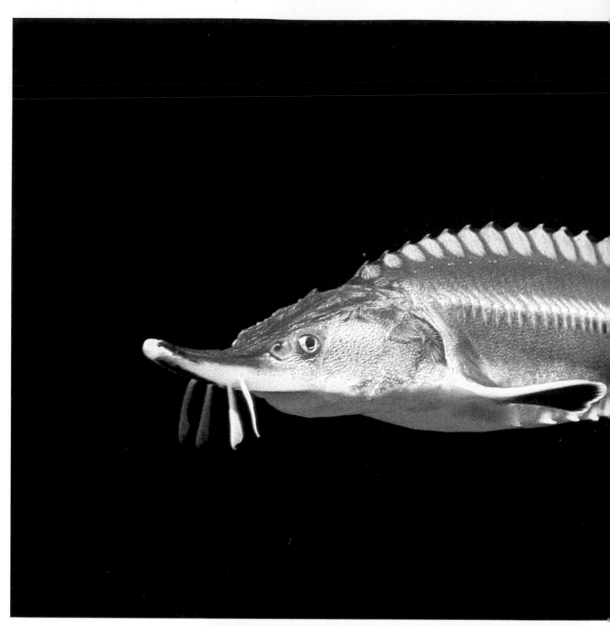

102. *The midnight sun hangs low over the Kolyma River in Siberia. Rivers flowing northward through Siberia to the Arctic Ocean have a reverse seasonal cycle. Their southern headwaters melt well before the thaw of lowland rivers, estuaries, and mouths. The result may be massive ice dams that finally give way with great violence and sometimes catastrophic effect.*

Above. *Russian belugas* (Huso huso) *may reach lengths up to 8½ meters and weigh over 1,300 kilograms. These ancient fishes have enormously heavy, pointed scales in rows along the sides of an otherwise scaleless body. Sensitive barbels hanging beneath their mouths are vitally important for feeding along the bottom. The beluga's eggs are prized as caviar. Belugas occur in tributaries to the Black Sea, in eastern Asia, Manchuria, and Siberia.*

Left. *Shallow Lake Seliger feeds the headwaters of the Volga River, one of the largest south-flowing rivers in Siberia.*

Above, opposite. *The painted stork* (Ibis leucocephalus), *a colorful bird of southern Asia, builds large stick nests high in trees. As many as 400 or 500 pairs of these storks may nest close together in only two or three dozen trees. They feed in shallow water, chiefly on small fishes.*

The Lake That Time Forgot

Baikal is the most remarkable lake on Earth, with a flora and fauna that is both unique and utterly extraordinary. Scientists, after studying Baikal for the past 150 years, continue to find it increasingly fascinating. In an aquatic sense, it is a "lost world."

Not only is it one of the largest lakes in the world, stretching 636 kilometers long and up to 80 kilometers wide, but at 1,620 meters it is by far the deepest. With the bottom of the lake lying 1,285 meters below sea level, it is deep even by ocean standards, and that in itself partly explains the uniqueness of its flora and fauna. Like the lakes of Africa's Great Rift Valley, Baikal is part of a major river system; yet it is its life that truly makes Baikal unique, for the lake supports more than 1,200 species of animals and 500 plant species. Of the 842 animal species inhabiting its open waters, 82 percent are not found anywhere else in the world.

For example, who would expect to find a seal in a mountain-locked lake 2,000 kilometers from the sea? Yet the Baikal seal (*Phoca sibirica*), a large, 1½-meter silvery gray mammal weighing up to 130 kilograms, shows a clear relationship to the Arctic seal (*P. hispida*). It is presumed that the seal penetrated into Baikal through the Yenisei and Angara during the last glacial epoch.

The Baikal seal differs noticeably from its marine relatives in having long, powerful claws on its large front flippers, excellent aids in crawling across rocky surfaces. All other seals possess shorter, weaker limbs with thin little claws. Armed with good teeth and strong jaws, it is a predator feeding primarily on different kinds of sculpins.

With such a prolonged ice cover on the lake, this air-breathing mammal must maintain contact with the atmosphere through holes in the frozen surface that are kept open throughout the severe winters. Not only are such holes used for breathing, but in February and March the female seals crawl through them onto the ice to give birth to their single pups. On sunny days in midspring before the ice melts, Baikal seals often are seen on the surface of the ice, basking in the warmth the meager light brings.

The variety of invertebrate animals endemic to Lake Baikal goes on and on. Flatworms in Baikal often are large, up to 15 centimeters long, and strikingly colored. Some are red and orange; others are greenish, striped, or handsomely speckled; a few have bumpy tubercles. *Graffiella lamellirostris* is pink with transverse red bars, and *Bdellocephala angarensis* has a dark body patterned with white stripes and round pinkish spots. The leaf-like *Sorocelis hepatizon* wears a dark banded collar below its "eared" head with white staring eyes. A segmented worm, the polychaete *Manayunkia baicalensis*, is a tube-dwelling creature whose closest relatives live either in the sea or around brackish river mouths elsewhere in the world. Apparently *Manayunkia* is a very ancient form for which time stood still in Lake Baikal.

Of the 84 known species of mollusks in Baikal, 54 are endemic but absent from all other bodies of fresh water. Most mollusks found in the lake have surprisingly thin-walled shells, probably because of the scarcity of mineral salts in the water.

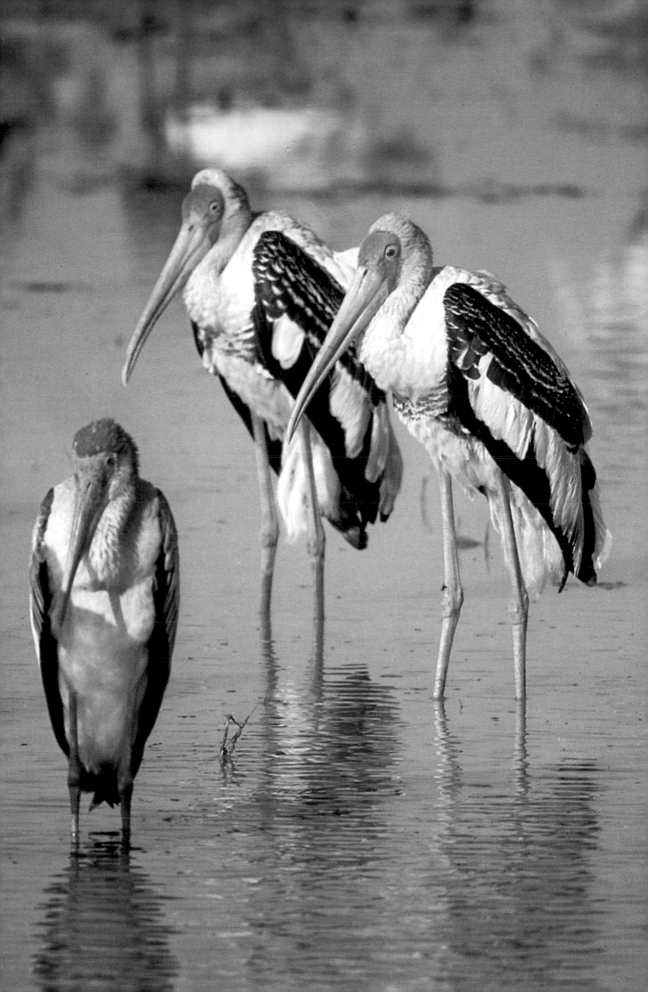

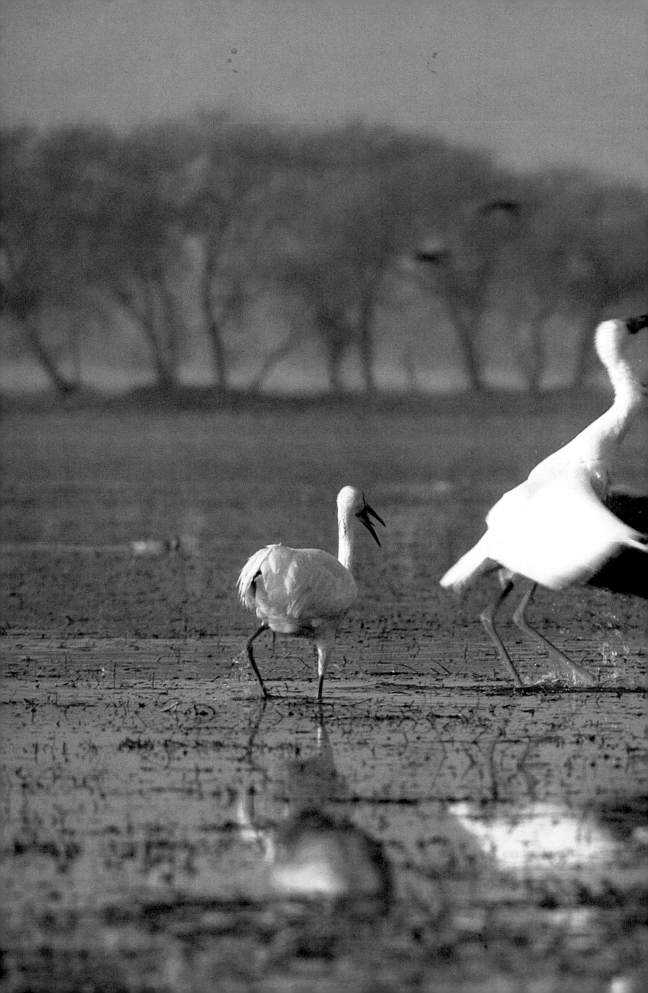

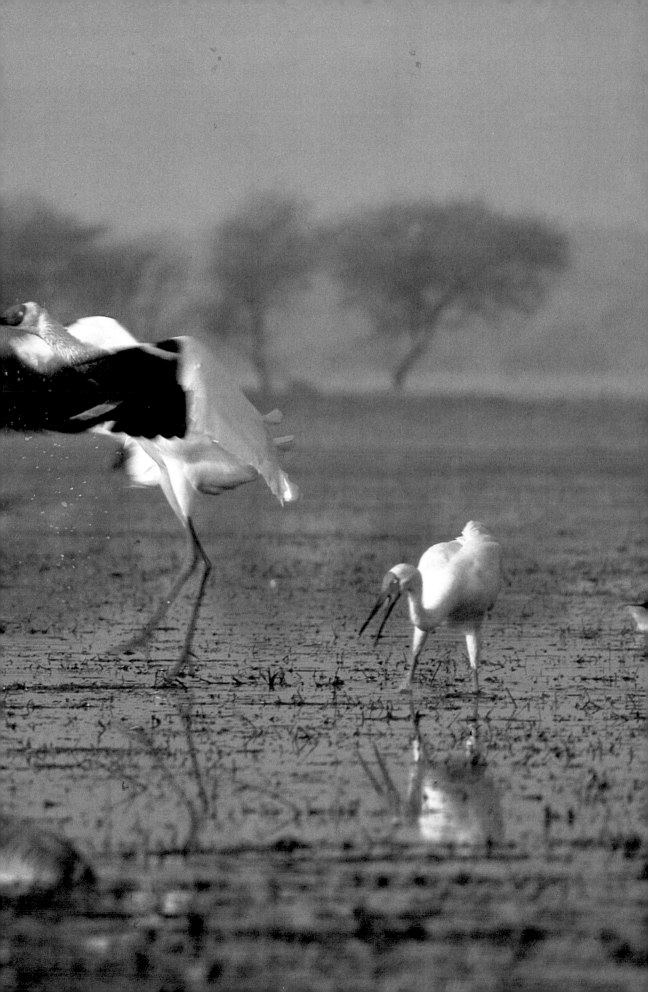

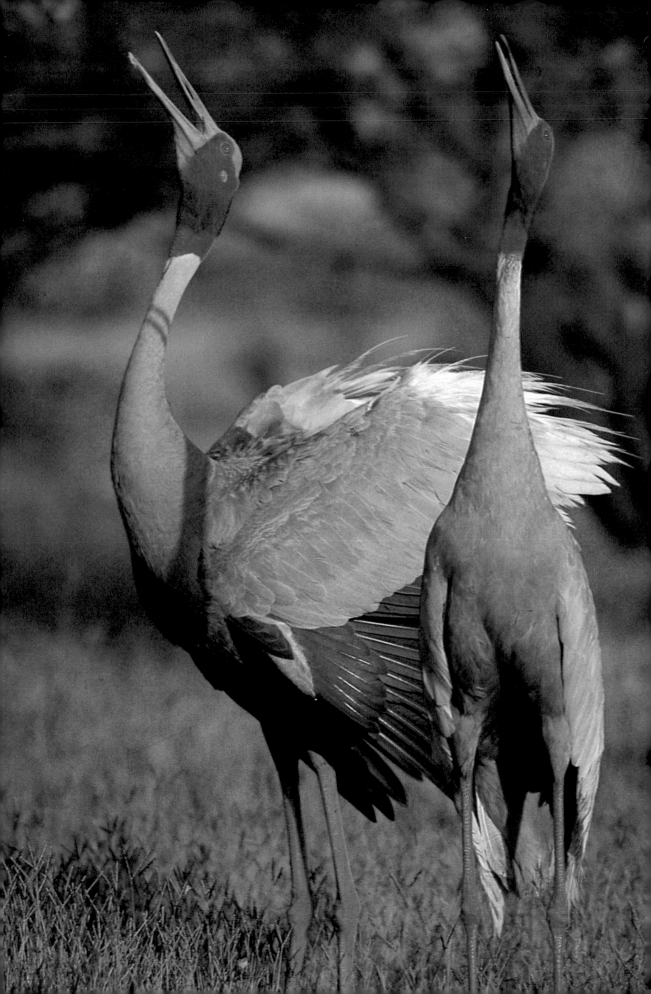

It is among crustaceans that the lake's most bizarre creatures are found. For example, in the depths of Baikal lives a slender, worm-like, eyeless shrimp (*Bathynella magna*) that is not only colorless but almost transparent. Its bland appearance contrasts sharply with other crustaceans in the lake, some of the most extravagantly decorated amphipods to be found anywhere. *Acanthogammarus flavus* has stout spines sticking up from its back; *Brandtia lata* is equipped with a double row of sharp spines protruding laterally; and *Pallasea bicornis* is a veritable miniature armored tank. At the opposite end of the scale, *Parapallasea puzylli* is a graceful, extremely attenuated creature with very long antennae; two sets of its ten pairs of legs are so long they seem to belong to a totally different animal.

How important is Lake Baikal to the Yenisei and Angara rivers? The upper reaches of these rivers are inhabited mainly by animal immigrants from the lake. Each year Baikal sends down the rivers thousands of tons of plant and animal plankton, the latter consisting chiefly of copepod crustaceans, hundreds of tons of bacteria suspended in the water, tens of tons of amphipods (mostly *Macrohaectopus branicki*), and several tons of fish larvae, bottom-dwellers, and plant and animal debris. Because the Yenisei, through the Angara, is the only outlet from the lake, some of these startling and singular creatures travel downstream to give the great river a special fauna not shared by other rivers flowing northward in the vastness of Siberia.

Sacred River of the South

From its source in the high Himalayas to its mouth at the Bay of Bengal, there is no more sacred river in the world than the Ganges—"Mother Ganga." For over 2,490 kilometers the banks of this fabled river provide a place of pilgrimage for devout Hindus, a place where sins may be washed away in its purifying waters. So great is the sanctity of this river that mythology has created underground connections with other Indian rivers to lend them some of its holiness.

Few rivers have so lofty a beginning. One source stream lies beyond Nanda Devi at about 7,690 meters, while the other emerges from an ice cave 3,090 meters high in the Himalayan snowfields. After leaving these towering peaks, the river, now enlarged by several headstream tributaries, begins to level out and descends gently at a rate of only 10 centimeters per kilometer. It then flows slowly and majestically eastward across the northern plains of India through a 1,000-square-kilometer drainage basin. It is in the lowlands and approaching the estuary that the characteristic and endemic life of the Ganges River merits our attention.

There is the 2½-meter, toothless giant catfish (*Pangasianodon gigas*) in which the young are as yet unknown to science. This very large, exclusively vegetarian fish is an important food item for Asians. Other unusual fishes living in the Ganges Basin include the Ganges gourami (*Colisa sota*), which creates a nest of bubbles and froth for its eggs; the Indian forehead brooder (*Kurtus indicus*), which carries its eggs tucked under a projection emerging from its forehead; and the odd snakehead (*Channa*), which breathes atmospheric

Opposite. *One of the world's largest cranes, the stately sarus crane* (Grus antigone) *stands 1½ meters tall. Its courtship display is a beautiful and memorable sight: it throws back its head while trumpeting its call, then bows and opens its wings wide. Because it mates for life, it is a symbol of marital fidelity in Asia.*

Above. *Many Asian rivers arise from snowfields and glaciers in the great Himalayan chain. As the Manas River of Bhutan shown here reaches toward the lowlands, it cuts deep gorges through the still-young mountains.*

oxygen by means of a special labyrinthine organ within the gill cavity.

Over 60 million years ago, one group of crocodilians diverged from the others, and to this day it resembles its long-nosed ancestors. The Indian gharial (*Gavialis gangeticus*), with relatively weak legs and a powerful flattened tail used in swimming, is one of the most distinctly aquatic of all crocodilians. It is capable of growing into a huge animal, perhaps as long as 10 meters. It is an odd-looking reptile, with a typically scaly thick-set body but jaws that, upon leaving the cranial part of the skull, abruptly narrow to a very long club-like structure armed with over a hundred sharp teeth. The gharial's diet is almost exclusively fish, especially those tending to move about in schools. When it sights a school, the gharial approaches quietly and, as the fish pass by, swings its bony snout out in a deadly arc more rapidly than the eye can follow. It usually catches two or three fish at a time. This effective feeding maneuver results from a radical evolutionary modification of its jaw structure.

Among the birds of the Ganges wetlands, none is more highly regarded and protected than the Sarus crane (*Grus antigone*), a symbol of happy marriage among Indians. No wonder, for it is a bird that mates for life and is almost never seen alone. Perhaps humans admire this great bird for its spectacular courtship displays as well as for its conjugal fidelity. When sarus cranes come of mating age, they carry on an elaborate ritual of leaping into the air, fanning their wings, bowing to one another, and trumpeting to the sky above, with head thrown back. Years ago on a misty morning beside a quiet stream, I witnessed this marvelous display, and the memory of it still haunts me. The strong rattling cry, the leaps and curtsies, and the great wings gathering in tendrils of mist will be ever vivid.

The Ganges, along with the Brahmaputra and the Indus, is the home of a remarkable mammal, the Ganges dolphin, or susu (*Platanista gangetica*). Like other river dolphins, it is a refugee from the sea which migrated to a freshwater habitat eons ago. As dolphins go, the Ganges variety is neither very streamlined nor powerful. It grubs along the soft bottom, where it seeks crustaceans and fishes, aided not only by its keen sense of echolocation but very likely by a sense of touch in its long, slender, toothed beak. Obviously sight is not an important sensory asset in this large turbid river, and the Ganges dolphin has such tiny eyes it is often referred to as "blind," but it is not.

Rivers and Mangrove Swamps

Where the Ganges meets the sea, a special world exists— a habitat that is neither fresh nor salt, lying somewhere between land and sea. This is the realm of the mangrove, a tree that completely alters the environs where it grows, to create a habitat unlike any other for wildlife. A mangrove's special characteristic among plants is its ability to tolerate flooding of its roots by salt water, a condition that kills most other trees. In the Ganges delta seawater is mixed with fresh water coming downriver to create especially favorable conditions for a number of mangrove species.

A mangrove swamp possesses distinct zones, each inhabited by certain specialized kinds of mangroves,

113 top. *No two Bewick's swans*
(Cygnus columbianus bewickii)
*have precisely the same
patterning on their yellow-and-
black bills. This great bird breeds
in northern Asia but winters in
northern Europe and the British
Isles.*

Bottom. *The whooper swan (C.*
cygnus cygnus) *is closely related
to Bewick's swan and has a
similar pattern of distribution,
but the whooper swan migrates in
smaller flocks. Scientists believe
whooper swans once bred in
Greenland, where they are still
seen frequently.*

Overleaf. *The increasingly rare
Indian one-horned rhinoceros*
(Rhinoceros unicornis) *often seeks
out rivers and streams, where it
wallows or swims beneath the
surface. On land the rhinoceros is
capable of a rapid galloping
charge if irritated; otherwise it is
a harmless, peaceful vegetarian.*

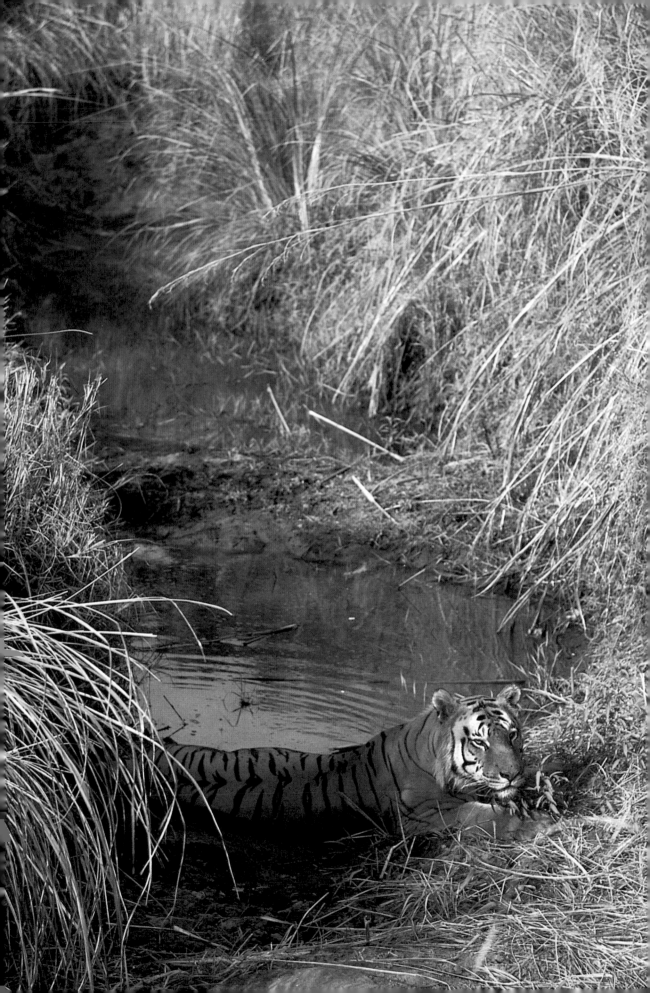

adapted to the degree of submersion in seawater brought in by the tides. Once mangroves become established, they spread prolifically along the shoreline, advancing over the years out into open water as trapped river and tidal sediment accumulates around the tangled mass of roots and pneumatophores. The trees seed abundantly, producing seeds that germinate while still attached. These grow a long, pointed root which, when the seed finally drops into the shallow water, often penetrates the soft mud and in effect plants itself.

As in lakes, ponds, and along riverbanks, wherever plant zones become established, they create habitats with varying characteristics for highly adapted animal life, which itself is then zoned. One of the best examples of animals distributing themselves according to the plants among which they live is found in the mudskippers, amusing creatures that live partly in and partly out of water, and sometimes even climb trees—at least the slanted prop roots of mangroves. *Boleophthalmus boddaerti* is a mudskipper that lives on the soft sediments beyond the outermost zone of mangroves, where it wanders back and forth across the wet surface to graze on algae. Another mudskipper, *Periophthalmus chrysopilos* has pelvic fins that form an efficient suction cup on the animal's underside that enables it to adhere to mangrove roots and trunks after climbing to escape a rising tide. A third species of carnivorous mudskipper, *Periopthalmodon schlosseri*, prefers to live on the firm mud of an even more heavily vegetated zone. Mudskippers are gobies that have acquired an amphibious specialization which enables them to crawl and hop about on the wet, exposed mud of mangrove shores. Some may actually drown if submerged too long, for they live for extended periods out of water if the air is humid enough. Oxygen is acquired through moist membranes in the mouth and gill cavities. The eyes of a mudskipper, which protrude well above its head, can be directed to focus on objects directly ahead of it, such as small crustaceans and other invertebrate prey inhabiting the rich mangrove community.

The "Long River"

The Ch'ang Chiang, or "Long River," better known to Westerners as the Yangtze, lives up to its Chinese name, for it flows over 5,494 kilometers from its source high in the Kunlun Mountains to the China Sea. With headstreams rising at an elevation of 5,100 meters in northern Tibet, the Yangtze has a wild and tumultuous beginning, slashing through deep gorges and often curving back on itself, for nearly 1,000 kilometers before leveling out into a navigable river. The gorges of its upper reaches are treacherous spots, with water levels varying as much as 60 meters, depending on flow and flood conditions. Many of these gorges are unbelievably spectacular, with vertical walls disappearing in mist-shrouded mountains and the confined flow of water gyrating in whirlpools or racing along at speeds of 21 kilometers an hour. At times the steep rocky walls collapse and plunge masses of rock debris into the churning river, causing even more violent currents. The spotted forktail (*Enicurus maculatus*), an attractive black-and-white spotted and striped bird, is a resident

The Indian tiger (Panthera tigris) seeks out streams in which to bathe and cool off from the searing heat of the Indian subcontinent. It is capable of swimming across rivers to reach new hunting grounds.

near high Himalayan streams at elevations up to 3,600 meters. It hunts snails and aquatic insects among the brookside stones, then swiftly flies low over the water to another likely spot. Its specialized way of life, adapted to turbulent mountain streams, assures it of a food supply uncontested by other predators of the region. The forktail's entire life cycle is spent here. It builds a camouflaged nest along a stream bank to rear its three or four young when sufficient warmth finally arrives in early summer.

Approximately 1,600 kilometers from the seacoast, the Yangtze leaves its tortured course and flows more quietly across broad plains that are subject to severe flooding. Possibly the most interesting stretch of this great river is that lying in mountainous Szechwan Province, an ancient habitat older than the mighty Himalayas. The wildlife of the province is characteristic of a cold climate and survives here when it has vanished elsewhere. Much of it is odd and often primitive. There are insectivores with an ancient lineage such as shrews that hunt in their frenetic fashion in or near the river's headstreams.

The true water shrews are closely adapted to their aquatic habitat in cold mountain streams. The Himalayan water shrew (*Chimarrogale playtycephala*) has such reduced external ears that folds of skin can close off the ear opening as the animal hunts underwater for crayfish, insect larvae, and small brook fishes. The Szechwan water shrew (*Nectogale elegans*) is unusual among its kind in having webbed feet for swimming and suction disks to aid in climbing over wet rocks. It braves even the swiftest currents, where it proves itself a strong swimmer and diver in the mountain torrents.

Creatures of the Lower Reaches

From the third century A.D., the Chinese have referred to the *tou lung* and *yow lung*, or dragon. Marco Polo saw this legendary creature and recognized it for what it is: a crocodilian. But he had no way of knowing how remarkable a member of its family it is. The Chinese alligator (*Alligator sinensis*) has only one close living relative in the world, namely, the American alligator. The distribution of the Chinese alligator in times past probably was extensive throughout eastern Asia, but today it is restricted to the lower Yangtze Valley, with its flooded wetlands and lakes. It survives in marshes uninhabitable by man, in deep lakes, and in the maze of streams forming a network through the marshes. By any standards it is not much of a "dragon"—little more than 1½ meters long, though ancient Chinese reports give it twice that size. It is generally believed, both in folklore and by biologists, that the Chinese alligator preys heavily upon the many turtles inhabiting the river. Undoubtedly it does not have a restrictive diet but feeds on a variety of game, including domestic fowl and small mammals.

Because seasonal temperatures and flood conditions vary greatly in the Yangtze Valley, the alligator hibernates in winter after digging burrows nearly 2 meters long into stream banks. In warm weather, it builds loose nests that it guards against intruders, but even its small size and reclusive habits appear not to allow a sufficient rate of reproduction to keep pace with man's hunt for it as a curio, alive or stuffed. Little is known about it in the

West, but it is possible that it may already be extinct. Of all the mammals living in the Yangtze or associated with it, none is more thoroughly adapted to an aquatic existence than is the Chinese river dolphin (*Lipotes vexillifer*), a 2-meter-long cetacean restricted to one large lake in Hunan Province, Tung-t'ing Hu. In this region the river fills several very large basins, creating lakes of great size. If the river dolphin once inhabited other lakes, it has left no trace of its presence there. This light gray animal, with a white underside, has broad front flippers and an erect flag-like dorsal fin that signals its presence in the broad waters of the lake. Like its distant relative in the Ganges, the Chinese river dolphin has small and weak eyes, therefore relying chiefly upon its extraordinary sense of echolocation to find its fish prey.

Resplendent River Birds

The white-breasted kingfisher (*Halcyon smyrnensis*), a large handsome bird with a rust-colored head, red beak, and brilliant refractive blue back and wings, is an active and successful predator, diving down from the sky like a shot to capture its fish, crab, frog, or reptilian victims. Once caught, the prey is carried back to the kingfisher's favorite perch and there battered into insensibility before being swallowed. A white-breasted kingfisher may hunt far inland, but it invariably nests in deep tunnels excavated into stream banks, where eggs are incubated and the young fed solicitously by both parents.

Eastern China and the Yangtze Valley harbor a candidate for the world's most beautiful bird: the mandarin duck (*Aix galericulata*). This spectacular waterfowl is known worldwide through its inclusion in aviaries and other captive animal collections, as well as from lovely portrayals in Oriental art. In flight the male and female resemble each other in contour if not in color, but once in the water the male's erect sail-like shoulder feathers are conspicuous. The rest of its dramatic coloring, its large crest, and the bold stripes and bands induce awe in human observers for the overall magnificence of this bird. Perhaps it is just as well that it is so popular in zoological collections, for this member of the wood duck family which breeds in virgin forests is becoming increasingly rare in its native habitats in eastern Asia as remaining woodlands are reduced.

The rivers of this vast region, like rivers everywhere, are constantly at work diminishing the continent across which they flow. Millions upon millions of tons of sediment are removed from aging highlands, carried downstream to enrich plains and build deltas, and finally cascade into submarine depths beyond the continental shorelines. Still, a human lifetime sees but small change in a river's course. The Tibetan highlands where the Yangtze, Yellow, Mekong, Brahmaputra, Ganges, and Indus rivers arise still are young mountains, jagged and unmarked by the work of flowing water. But there will come a day when even these mighty giants are humbled, turning into gently rounded hills.

Above, overleaf. *The mandarin duck* (Aix galericulata) *is unquestionably one of the world's most beautiful and ornate birds. During courtship display, the male makes use of its remarkable plumage, erecting its crest and shaking its body while showing off its exquisite sail-like flag feathers. Ritual drinking and stylized preening also are a part of its attempt to attract a female.*

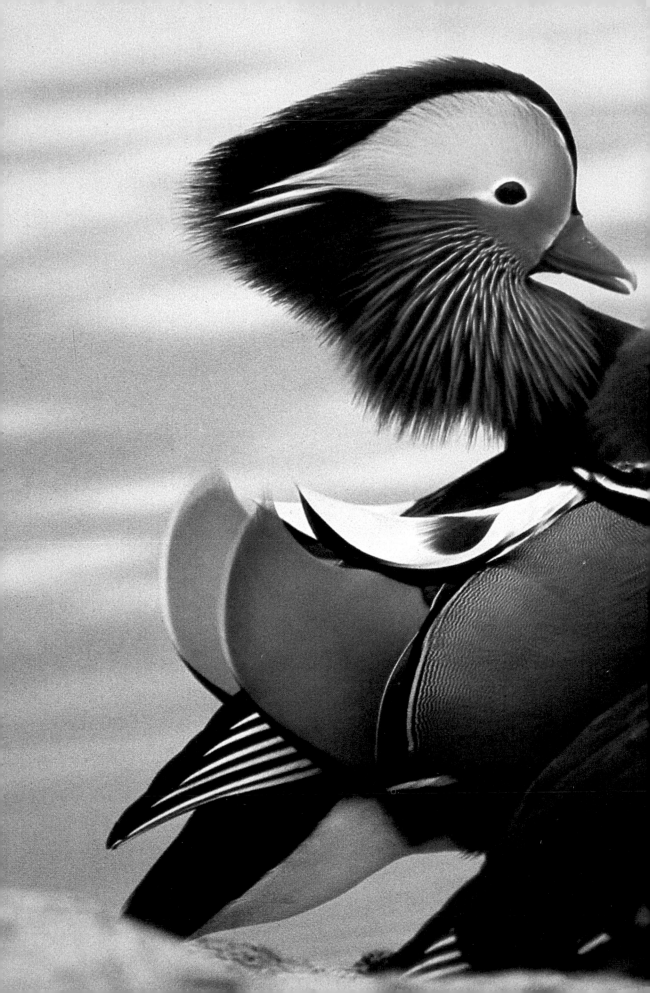

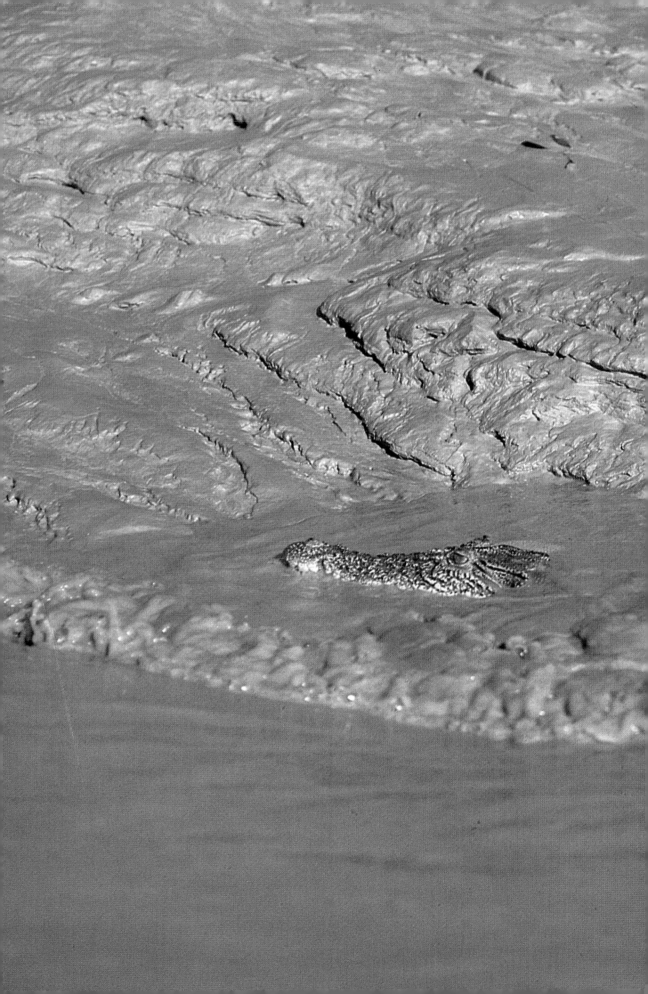

The Unpredictable Rivers of Australia

When one looks at a map of Australia that shows nothing but river systems, those of internal drainage basins usually are shown by dotted lines indicating their ephemeral nature, for they flow rarely, only after heavy rains. Along the margins of the island-continent, one sees a few rather short rivers in the far west, some in the north, and a cluster of small ones in the northeast. Only in the southeast do maps reveal rivers on a scale equal to those found elsewhere in the world, and these are all part of one system, the Murray-Darling.

The Great Dividing Range, which runs over 1,600 kilometers along the southeast coast, creates two kinds of rivers: those flowing eastward into the sea, and those collecting westward to form the Murray-Darling. The headwaters of the eastern slope are much like those of the European Alps, with clear, cold torrential waters. On the western side of the Australian Alps, the rivers combining to form the one great system are typically "Australian" in every sense: they are wide, muddy, sluggish, with extraordinary fluctuations in volume. They virtually disappear during periods of drought. Even by world standards, the Murray-Darling river system is very large, draining a watershed basin of over a million square kilometers. The combined length of the Murray, Darling, and Murrumbidgee (a major tributary) rivers is about 7,000 kilometers.

The snow-fed Murray rises close to Mt. Kosciusko, the highest mountain in Australia (2,195 meters). The river drains much of New South Wales, large parts of Victoria, and much of southern Queensland. Once the Snowy Mountains and Great Dividing Range are left behind, the Murray cuts into a narrow floodplain bordered by cliffs 30 meters high, eventually emerging through a region of gorges onto a great floodplain. After flowing for more than 640 kilometers through South Australia, it discharges its water—nearly 25 billion cubic meters a year—into shallow Lake Alexandrina, which is actually a coastal lagoon lying behind a long barrier island.

The importance of this large river system to the arid continent cannot be overestimated, for it is one of the major features that determines wildlife distribution. Consider that the Australian landmass of 7,716,563 square kilometers has an annual average of only 41 centimeters of rainfall, most of which is lost by evaporation. Less than 9 centimeters of this precipitation are carried off by *all* the rivers of Australia, and almost half of that volume is conducted by the Murray-Darling system. No wonder, then, that in the Murray-Darling Basin one finds not only concentrations of human settlement but also many of the strange and wonderful forms of aquatic life that have evolved in isolation on this ancient island-continent.

Fishes From Another World

Although Australian rivers contain only about 180 species of fishes in all, these include unique and remarkable forms found nowhere else, such as the lungfish (*Neoceratodus forsteri*) and the spotted barramundi (*Scleropages leichhardti*).

There is little doubt that the lungfish is one of the most fascinating of fishes. Its ancestors lived in Australia over 100 million years ago, and it has changed little since. The feature that gives the fish its name is a complex

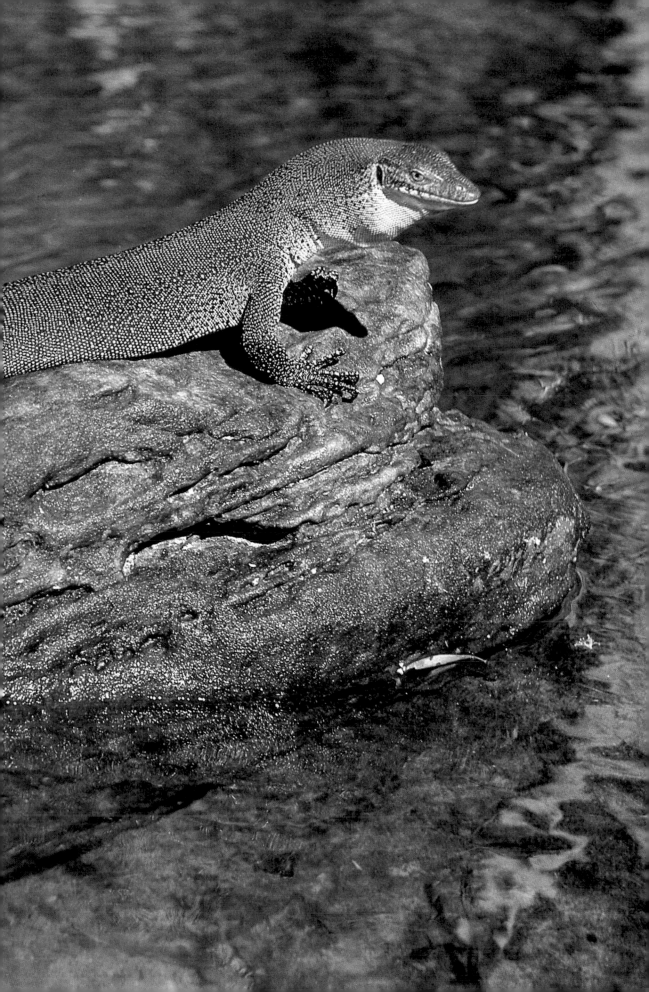

122. *The estuarine crocodile*
(Crocodylus porosus) *ranges from
river waters, through estuaries,
and even out to sea as it travels
from one island to the next in the
Malay Archipelago. Since river
flow in Australia is so variable,
the crocodile at times remains in
muddy pools to prevent
dessication. This is the only
crocodile that has preyed on man
with considerable frequency.*

124–125. *Merten's water monitor*
(Varanus mertensi) *is specially
adapted for survival in and near
water. While swimming, its broad
tail is used as a rudder and
sculling oar. Its nostrils open
upward on top of its snout; thus
breathing is easy even when the
monitor is virtually submerged.*

Opposite. *Its vocal sac inflated,
the red tree frog* (Litoria rubella)
*utters its deep, resonant call from
thick vegetation near stream
banks. It climbs up reeds and
shrubs, using opposable thumbs
and adhesive disks at the ends of
its toes.*

lung connected to the esophagus by a glottis-like opening. The fish also has the orthodox gill-breathing system of other fishes, which it uses much of the time to extract oxygen from the surrounding water. The problem, of course, is that Australian rivers are so variable and unpredictable in their flow. When their volume diminishes, the lungfish is forced to retreat to shallow pools left in the otherwise dry riverbed. Heat from the sun warms the water and gradually dissipates dissolved oxygen, causing many aquatic creatures to suffocate and die. Not the lungfish, however; it rises to the surface and gulps in air, which is swallowed, then enters the lung and is absorbed by the surrounding mesh of fine blood vessels. Oxygen is diffused across the lung membrane, and in this way the fish survives as long as enough water remains in the pool to cover it.

The spotted barramundi is a predatory fish equipped with strong teeth and a toothed bone on the floor of the mouth; hence the name "bonytongue." After spawning, which takes place in October, the female takes the fertile eggs in its capacious mouth, where the young later hatch and are sheltered as they grow. Even after the young fish begin to emerge to feed, they return to the safety of the mother's mouth if danger threatens. During this time, the male does not eat but relies on food reserves in its own body. Ichthyologists know the spotted barramundi as a member of the bonytongue family, a group of fishes that includes the famous giant arapaima of South America.

Strange Frogs in a Strange Land

There are over 100 species of frogs in Australia, all but seven species having some affinity for surface water. The continent's amphibian fauna is peculiar in that there are no salamanders or newts, no members of the *true* frogs (Ranidae), and no native true toads (Bufonidae), although a number of toads have been imported, ostensibly to assist in pest control.

The largest frog of the Australian continent, the great barred river frog (*Mixophyes fasciolatus*), with a head and body length of 10 centimeters, lives in eastern coastal regions of Queensland and New South Wales. One of the so-called nest-building frogs, it breeds near rapid streams. A nest typical of this family of frogs is constructed by *Limnodynastes dorsalis*. The female, while depositing eggs, paddles the surface water with her forelimbs, the digits of which have special flanges to create turbulence; this action produces a stream of bubbles that flow backward to be trapped in mucus used to hold the eggs together. The result is a foamy eggmass, which floats in shallow water trapped inside a stream bank burrow the frog has excavated. Such a hideaway protects the egg mass from the sun and also prevents it from being swept off downstream. Once the burrow is dug and the eggs are deposited, the male sits at the entrance, calling loudly from his guard post in the partly submerged tunnel.

Rivers and Reptiles

Australia is a continent of reptiles, including some of the most extraordinary in the world. But because it is such an arid land, not many of its reptiles are associated with water; on the contrary, most survive very well far removed from rarely available water.

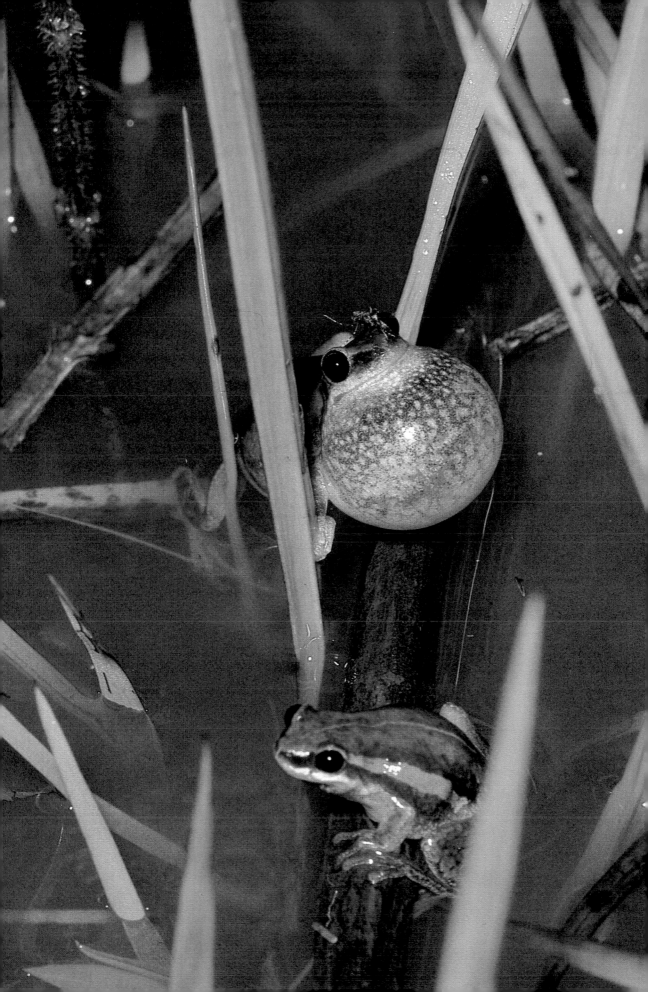

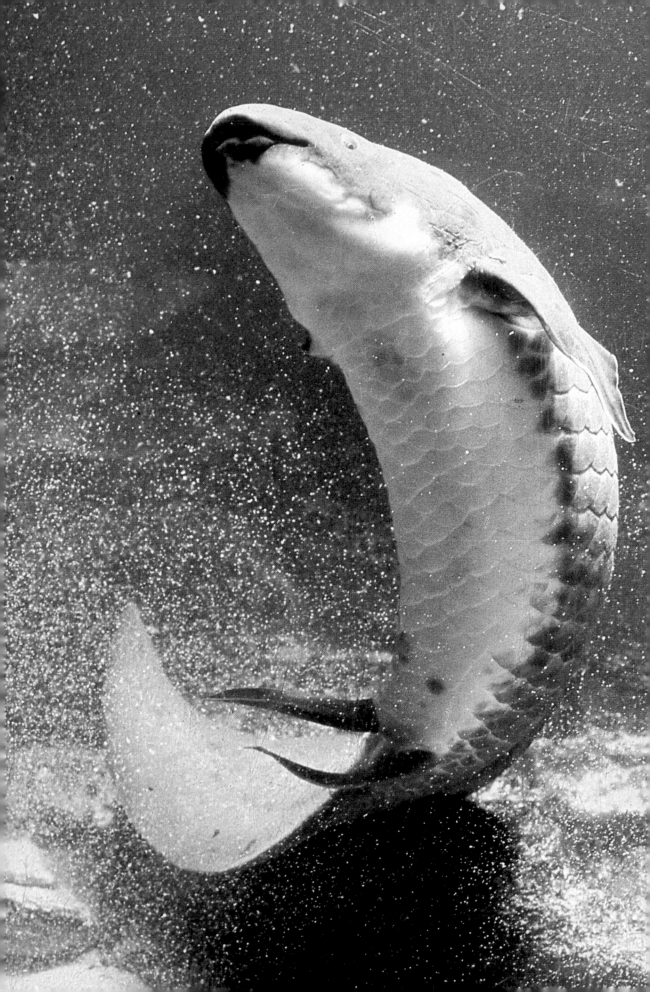

One exception is the snake-necked turtle (*Chelodina longicollis*), which lives throughout the Murray-Darling drainage area. An agile and irritable animal, it has a neck so long as to be almost unbelievable. Rather than retract its head straight back under the shell as most turtles do, it must bend its neck and fold it sideways. Despite its slenderness, the long, folded neck is a major adaptation for striking out at passing prey. The snake-necked turtle snaps readily, with great speed and accuracy. Its body appears well-suited to life in flowing water, for its large oval shell is shallow and only slightly convex, thus offering little resistance to the current. Its feet are broad and webbed, with long sharp claws capable of tearing apart its prey.

The Australian snapping turtle (*Elseya dentata*) is a river-dweller that is rarely seen. As its name implies, it too is an aggressive animal, quick to lunge at anything moving nearby in the stream. In contrast, the Macquarie short-necked turtle—found in the Macquarie River, a tributary of the Murray-Darling—is a shy, inoffensive little creature, usually brightly colored in reds, yellows, and browns. Its varied diet seems to include quite a bit of aquatic vegetation. While close relatives live in northern Australia and New Guinea, this species is restricted to the Macquarie River and its tributaries.

It is not usual to find lizards associated with rivers, though one, the Australian water dragon (*Physignathus lesverii*), suns itself on branches overhanging the water. When disturbed, it springs into the water and swims away rapidly with powerful undulations of its compressed tail. At other times water dragons can be found lying in shallow water along the river edge with just their nostrils protruding.

Australian Water Birds

Water birds are abundant in Australia. True waterfowl of the continent are varied and include some dramatic species, few of which are found elsewhere. The Australian radjah shelduck (*Tadorna radjah*) belongs to a large and puzzling group of birds possessing both duck- and goose-like features. Shelducks usually are considered not only intermediate between the two, but somewhat more primitive as well.

Among all the waterfowl of the world, there is no more majestic bird than the great black swan (*Cygnus atratus*), the only species of swan native to Australia. Its jet-black plumage is accented by a bright red beak, tipped in yellow or white, and pure white trailing wing quills that are seen clearly in flight. Once in the air, its powerful wings reach nearly 2 meters across and can carry the bird over vast distances, even though there is no particular pattern to its migrations. The nest of the black swan, a massive heap of dry grass and reeds about a meter in diameter, is guarded by both parents during incubation of the five or six eggs. When one of these birds swims, its relationship to the mute swan of Europe is obvious, for it also keeps its neck tucked back in a graceful S curve and holds its wings raised upright, like dark sails.

A Furry Egg-Layer

Few animals are more closely associated with Australia than the duck-billed platypus (*Ornithorhynchus*

Opposite. *The basic form of the Australian lungfish (Neoceratodus forsteri) has remained virtually unchanged for over 100 million years. The lungfish gulps air when the water level of Australian rivers lowers appreciably. It can then survive in small, shallow, oxygen-deficient pools as long as enough water remains to cover it.*

Above. *Although it is clumsy on land, the platypus (Ornithorhynchus anatinus) swims rapidly and with agility. Using its rubbery, sensitive bill, it probes for aquatic invertebrates along the river bottom. Its appetite is prodigious: a platypus may consume up to a thousand worms, insects, and crustaceans each day.*

Overleaf. *The red-backed radjah shelduck (Tadorna radjah rufitergum) is a strikingly marked bird of northern and eastern Australia. The female shelduck, somewhat excitable, often incites the male to attack an intruder by flicking water with her bill and lowering her head to indicate the direction of attack.*

129

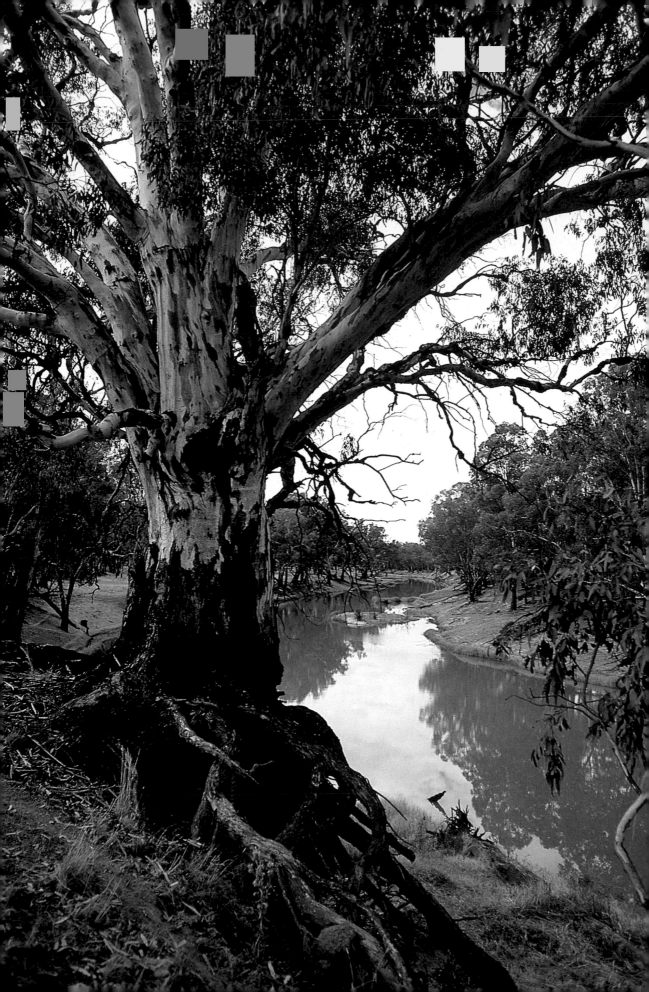

anatinus). Together with the spiny anteater, or echidna, which has no affinity for water, it is one of the two monotremes, or egg-laying mammals, in the world. Almost completely aquatic, the platypus crawls on land only with great difficulty. In water, it is another story, for its stubby, widespread legs are suddenly transformed by its large webbed toes into efficient paddles. The webbing on its front feet is so extensive it projects beyond the clawed toes; when struggling along on land, to prevent the claws from damaging the thin membrane, the platypus literally walks on its knuckles.

When it swims underwater, a platypus closes its eyes and nuzzles along the bottom with its rubbery bill in search of crayfish and other aquatic invertebrates. The sensitive bill probes and detects prey, and the animal's cheek pouches are soon filled with food. Then it rises to the surface, where it opens its eyes and consumes the delicacies. Its appetite is extraordinary: a single platypus may find and devour well over a thousand aquatic insects, worms, and crustaceans within one day.

After mating, the female retreats into a long burrow which she has constructed in a stream bank and which she plugs at intervals as she passes on her way to the brood chamber at the end. There she lays a pair of eggs, which she curls about to incubate with her body heat. After two weeks the eggs hatch, then lie within a simple fold of her skin—possibly a faint harbinger of what, during evolutionary time, ancient monotremes possessed before developing into pouched marsupials. The tiny, almost embryonic young "suckle" in primitive fashion, simply lapping milk from the fur on her abdomen as it is secreted from glands that open pore-like over an area of skin. There is no nipple, nor do the milk ducts join together as in more highly evolved mammals.

Why are monotremes so fascinating to the zoologist? Were it not for their presence on Earth, we might have a far poorer idea of our own remote ancestry. Both the structure and functioning of the platypus's reproductive system is much closer to the reptilian than to that of higher placental mammals. (Marsupials fall somewhere in between). Once mating has occurred, the egg takes on a leathery shell as it passes along the oviduct, then is laid quickly, with no further time spent in the mother's body. There is no womb whatsoever. In addition to this ancient form of reproduction, there are reptilian aspects to the platypus skeleton, structures that are much modified or nearly absent in more highly evolved placental mammals. Although it has a more complex internal hearing apparatus than any reptile, the platypus has no external ears, but only a hole leading into an auditory canal, as does a lizard.

The platypus regulates its body temperature, but less successfully than do higher mammals. In fact, it fluctuates rather widely, from 22° to 35.5°C, with no ability either to shiver (a warming process) or sweat (for cooling). So it is that Australian rivers and streams contain one of the strangest of all animals, a modern descendant that may reveal how mammals—of which we are one—came to be from a reptilian ancestry.

Above, overleaf. *The Australian black swan* (Cygnus atratus) *nests in wetlands, where it constructs broad, elevated nests of reeds and leaves. Both parents guard the nest during incubation and after the chicks hatch. Despite a difference in color, it is probable that the black swan and the mute swan* (Cygnus olor) *of the Northern Hemisphere share a common ancestry.*

Opposite. *Australia's Murray River is wide, slow, and laden with silt. This major river flows from its source near Mt. Kosciusko through portions of New South Wales, Victoria, and southern Queensland.*

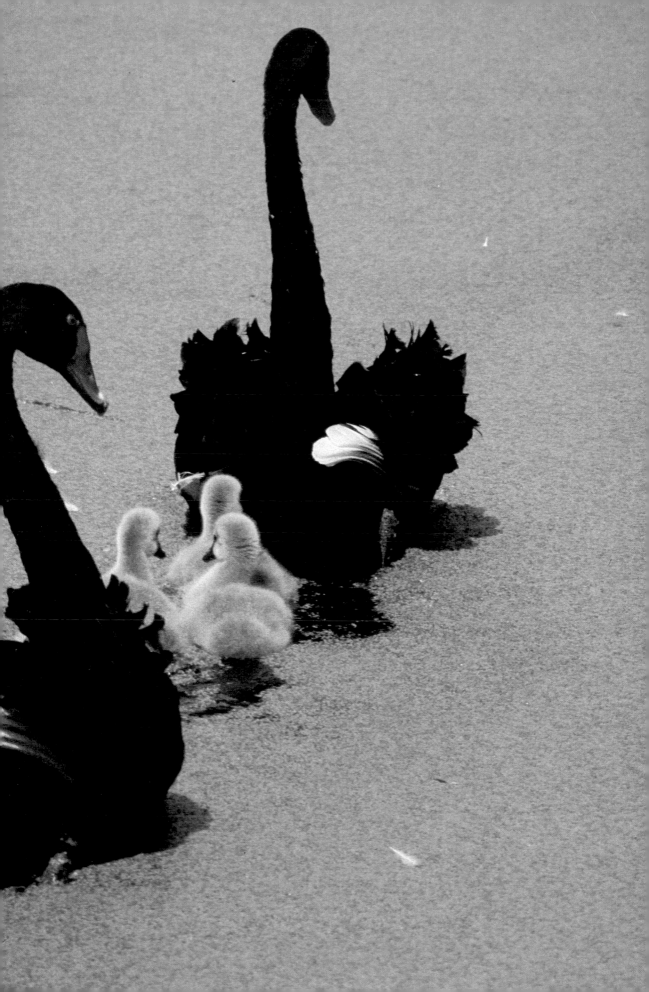

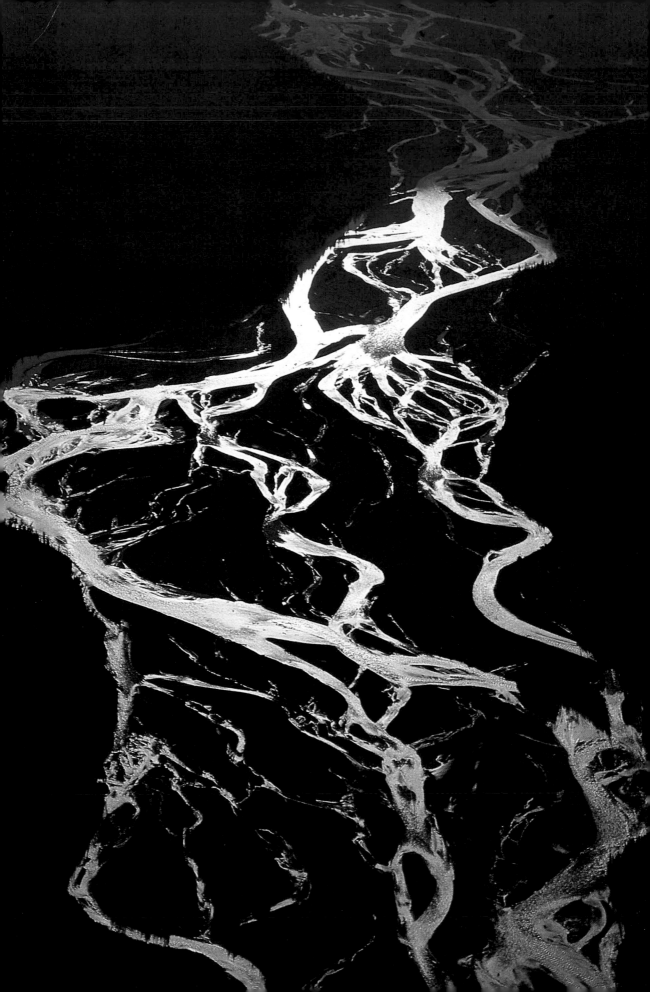

North America: Highways to the Sea

North America, bordered by two great oceans 4,800 kilometers apart, has a clear north-south orientation, from the subtropics to the Arctic. Inland from each coast run parallel mountain ranges—the Cascades, Rockies, and Sierra Madre in the west and the Appalachians in the east—which serve as major divides, sending water down river valleys to the Pacific or the Atlantic. Between the two divides is a huge basin drained by one of the world's mightiest rivers, the Mississippi and its great tributary the Missouri. In the west the Colorado and the Columbia are significant drainages, while the Yukon in Alaska and the Canadian Northwest is one of the largest, most untamed of all northern rivers. In the east, the St. Lawrence, with its interrupting chain of lakes, is a major river, and along the Atlantic coast are other smaller yet still important rivers.

The Journey of the Sockeye

Pacific salmon (*Oncorhynchus*) are true marine fishes for much of their lives; they eat nothing while ascending rivers to the spawning grounds, after which they die. The large (up to 45 kilograms) Chinook salmon, or king salmon (*Oncorhynchus tschawytscha*), migrates vast distances, perhaps as far as 4,000 kilometers up the Yukon River, but most salmon do not travel so far. Sometime before it is seven years old, the adult Chinook reaches maturity in the ocean and heads for continental shores. While all Pacific salmon species have much the same life history, I have chosen to consider the sockeye *O. nerka*, a somewhat smaller—but far more colorful—fish than the large Chinook.

No matter where they come from in the Pacific Ocean, sockeyes and their related species consistently find the headwater streams in which they were hatched. Within a matter of days after entering the main river that will eventually lead it to its birthplace, a male sockeye takes on a brilliant red color on its back and sides and another, even more dramatic, change commences. The male's jaws grow long and hooked, to the point where he can no longer close his mouth fully, and the teeth he bears outside his jaw lengthen. The female sockeye's reddish color intensifies, but her jaws do not change. Passing one tributary after the next in its journey, each salmon unerringly seeks its own home stream.

The great spawning runs are also signals to predators to come to the riverbanks to feed: gulls, birds of prey, bears, and other predatory or omnivorous mammals. The salmon's mortality rate is enormous but biologically normal, for only two survivors among the many thousands of eggs laid by each female and fertilized by a male are necessary to maintain the species.

In the ocean, the silvery streamlined salmon feed on small planktonic crustaceans and build up large reserves of fat and muscle. Once in fresh water and after metamorphosis has taken place, they do not feed. The humpbacked appearance of most male salmon comes from muscle and stored food. At first a salmon's muscle tissue is red and solid, but after weeks of strenuous swimming upstream, it turns pale and flabby. By then the fish is battered and scarred, its fins torn and perhaps an eye gone, but still struggling on. By the time spawning draws near, the transfer of fat and food reserves from flesh to

136. *Ice caps and glaciers cover one-tenth of the Earth's surface and continually melt along their advancing margins. In Alaska the rate of melting may be 150 meters every ten years. In this century alone, sea level has been raised 5 centimeters from meltwater.*

Below. *On reaching maturity, Pacific salmon* (Oncorhynchus) *head unerringly for the streams in which they were hatched. The salmon, which must readjust their tolerance to fresh water, now live on fat stored over years of feeding in the sea.*

139 top. *Before the journey upstream begins, the jaws of the male sockeye salmon* (Oncorhynchus nerka) *elongate and become so hooked that they can no longer close.*

Bottom. *Spawning beds are guarded aggressively by the males until all eggs are deposited and covered with loose gravel by the females.*

Overleaf. *The great salmon runs of Alaska rivers attract a variety of predators and scavengers. Gulls crowd in from the sea, and the world's largest terrestrial carnivore, the Kodiak brown bear* (Ursus arctos middendorffi), *gorges itself on the easy catches.*

reproductive organs is finally complete.

Once in the same spot where their lives began six or seven years earlier, the female sockeyes thrash about on the gravelly bottom and scoop out depressions with their body and tail. They then release a number of eggs, which are immediately fertilized by the males; the process is repeated many times until all their thousands of eggs have been laid and sink to the bottom, where they adhere to pebbles. The females then cover each batch after the males have deposited milt on them. Once the eggs are covered, the parents no longer tend them.

Embryonic development continues, with the growing young depending on bulbous yolk sacs. Within a few weeks after leaving the nest, the young begin their long migration downstream to the sea. The scent of their own individual headstream has by then been so firmly imprinted on their brains that they will be able to return to the precise spot years later. Because of a severe mortality rate, only 2 percent of the young arrive in the ocean, but by then their size, speed, and agility enable them to survive with increasing likelihood.

Mammals of the North

The Alaskan brown bear (*Ursus arctos*), is hardly an aquatic animal, but during the salmon run it spends days and weeks in the water, gorging itself and defending choice fishing spots. The moose (*Alces alces*) spends its summers near streams, lakes, and bogs, where it feeds on succulent vegetation. Its enormous, widespread hooves allow it to walk easily across saturated swampy soil and to swim powerfully, with its shoulders and head held high above the water, across even the widest of northern lakes. Its long prehensile upper lip can adeptly gather mouthfuls of aquatic vegetation while the huge animal stands up to its belly in water.

Although several subspecies of beaver live across northern Europe and into Asia, the animal is often most closely associated with North America, chiefly because of the extensive wilderness still available to it there. The Canadian beaver (*Castor fiber canadensis*), a stocky, heavy animal weighing up to 30 kilograms, is responsible for the presence of a great many natural ponds throughout the continent. Whether short or long, a beaver dam is constructed primarily to keep the entrance to the animal's lodge under water; but in creating such ponds, an easy method of transporting branches and small logs is provided both for construction materials and for food. The pond also offers security for a beaver.

A beaver scouts for a stream, then usually chooses an especially good site to commence its engineering work. Trees are felled with its chisel-like teeth, and the construction of a dam begins. Soon the stream is impounded, and the water level rises a meter or more above the downstream outlet. The beavers build their lodge out in the new pond, a great rounded dome of sticks and mud with several underwater access tunnels leading into the main living chamber. Nearby, large quantities of young branches still bearing leaves are placed in an underwater cache. Not only is there a plentiful winter food supply, but the large thick-walled lodge is well insulated, so that the body heat of the beavers keeps the interior warm.

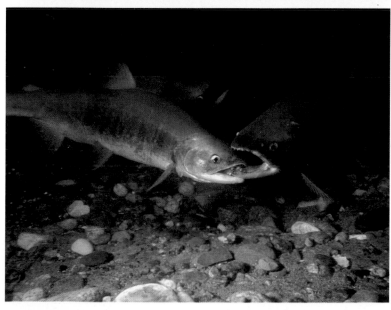

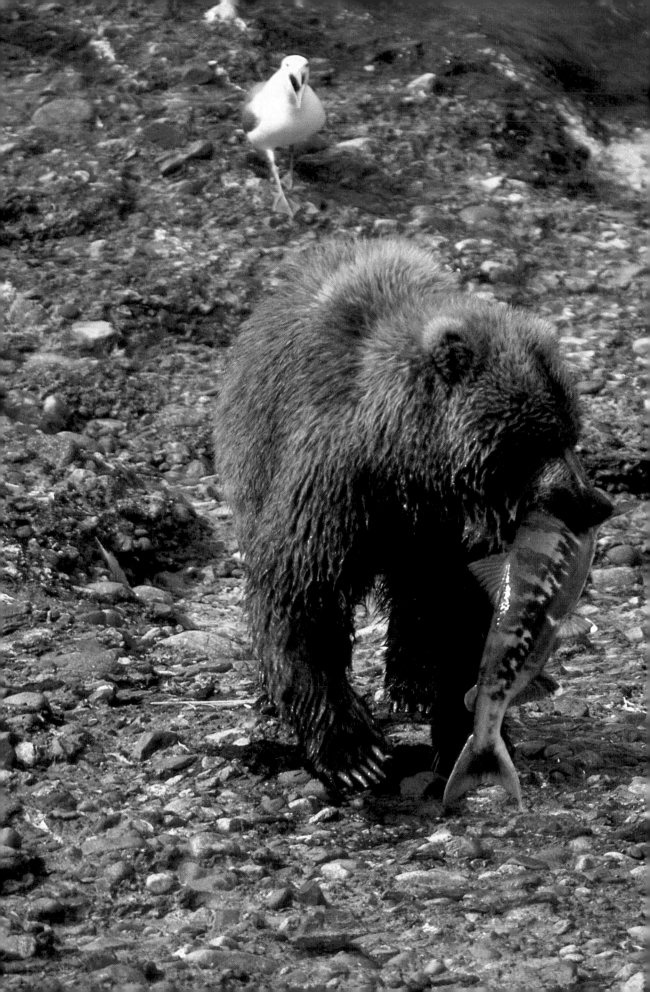

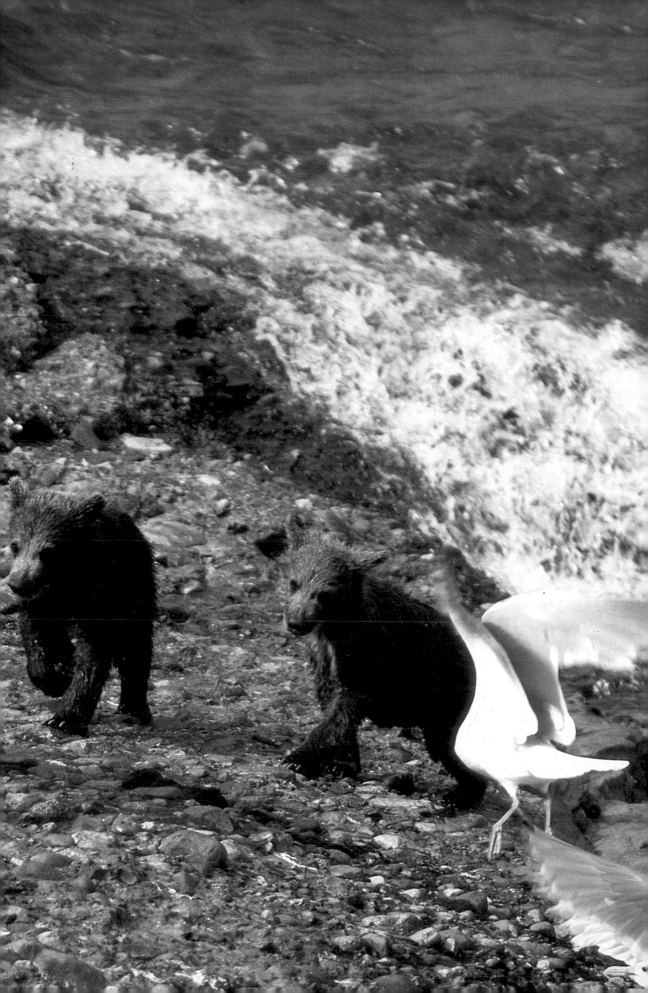

Right. *Kodiak brown bear cubs are dependent on their mothers for many months, but before winter arrives they will be capable of obtaining sufficient food in the form of berries, tubers, and other vegetation.*

Below. *Play is an important part of the Kodiak bear's existence. It sharpens reflexes and skills that will be needed in combat or to obtain food.*

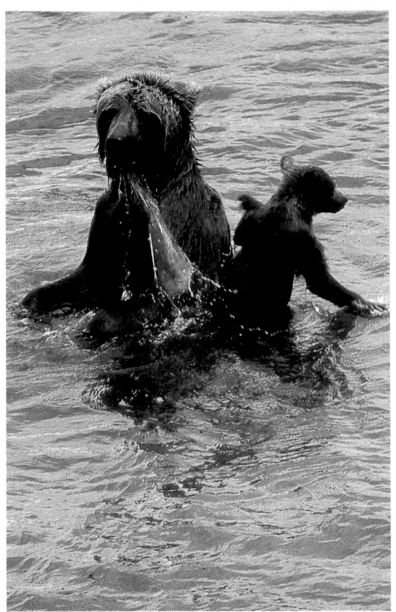

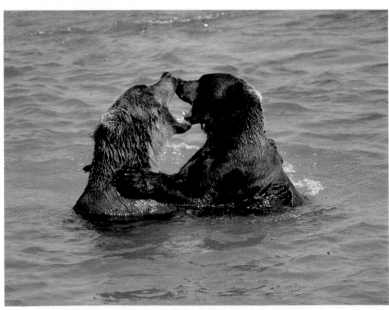

Beaver dams are in constant need of repair and control; the lodge may be enlarged or have chambers added; food needs to be stored; new canals must be excavated into surrounding bog to allow beavers to swim and transport vegetation. The beaver's life, then, is a round of constant activity.

Once a dam is built and a region flooded, some trees are felled and others die because their roots are submerged. What had been a woodland with a stream becomes an open area, rich in semiaquatic vegetation. A whole new community of plant and animal life appears, but the creation of this ecosystem is at best temporary. Someday the beavers will move on to a region possessing trees with easier access. The old pond begins to fill in with accumulated silt; a succession of plants appears and disappears. With each successive stage, appropriate animal forms appear. After some centuries, the area is as it once was: a stable climax northern forest—stable, that is, until another adventurous beaver discovers it is precisely the spot to build a dam.

The Father of Waters

The Mississippi watershed encompasses one-eighth of the entire North American continent, or over 3 million square kilometers; 22 billion cubic meters of water empty into the Gulf of Mexico each year, some of it traveling the entire 3,757 kilometers from the great river's source.

It is impossible to think of the Mississippi without considering the Missouri River, a tributary but in itself one of the world's great rivers. It arises 4,200 meters high in the Rockies and descends to a little over 100 meters above sea level where it joins the Mississippi, which then carries its waters to the Gulf. The magnitude of the Missouri is evident when one realizes that it constitutes 1⅓ million square kilometers of the total drainage for the immense river system.

Fishes and Other Aquatic Vestiges of the Past

Time runs backward in the Mississippi at least 80 million years when a huge paddlefish (*Polyodon spathula*) is found swimming slowly close to the surface, with its mighty mouth agape as it gathers quantities of plankton. Not only is it a fish of ancient origins, but there is nothing quite like it anywhere else in the world, although a relative of sorts, the Chinese paddlefish (*Psephurus gladius*), is found in the Yangtze. The paddlefish, like a shark, has a largely cartilaginous skeleton and an upturned tail fin. Once distributed throughout the entire Mississippi drainage basin, today its numbers have been reduced by human activity.

A fish that inhabits large bodies of water, the paddlefish is capable of living comfortably in murky rivers, where nutrients stirred from muddy bottoms nourish and enrich planktonic plants and the tiny animals feeding on them. The elongated flattened snout lifts its head as the capacious mouth opens to engulf the microscopic food, making the big fish a "living plankton net." Requiring an almost constant supply of food to sustain its bulk, the paddlefish is forever on the move, swimming lazily along close to the water surface.

The alligator gar (*Atractosteus spatula*), with a maximum length of 3 meters or more, diamond-shaped armored

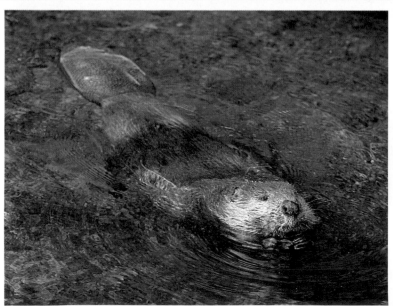

Above. *An excellent swimmer,
the muskrat* (Ondatra zibethica),
*has a laterally compressed,
rudder-like tail. It dives
frequently and, in so doing,
closes off its inner ears with a
fold of skin.*

Left. *Weighing as much as 30
kilograms, the Canadian beaver*
(Castor fiber canadensis) *is one of
the world's largest rodents. Its
wide, flat, scaled tail is used as a
rudder. When a beaver is
alarmed, it slaps the water with
its tail, to warn that danger is
near.*

147 top. Built of sticks, logs, and mud, beaver lodges are so stoutly constructed that few if any predators can tear them apart.

Bottom. The beaver's chisel-like incisors are effective in cutting down poplars, aspen, willows, and other trees, which then are towed to enlarge and strengthen its dam and lodge or are stuck in the bottom mud and stored for winter feeding.

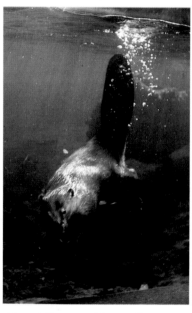

Above. Beavers dive easily to enter the underwater opening of their large lodges.

scales, and alligator-like jaws armed with close-set sharp teeth, is a dominant predator of the Mississippi. Its huge mouth is equipped with muscles so powerful that one of these fish has been known to crush a 2-meter-long alligator with a single bite. The mass of this 135-kilogram fish is so great that few other fishes in the river can withstand its attack. In addition to its size and its formidable armor and weaponry, it is a patient and stealthy predator, lying motionless until a victim comes, whereupon it attacks with a rapid lunge.

The hellbender (*Cryptobranchus alleganiensis alleganiensis*) is a giant salamander living in the upper Mississippi west of Lakes Michigan and Superior. A six-year-old hellbender, which lives its entire life as an aquatic creature, may reach a size of 60 centimeters. The only major change that occurs during its growth is the loss of gills; otherwise all its bodily characteristics are those of an amphibian larva, even after it reaches sexual maturity.

Resting quietly on the river bottom, the alligator snapping turtle (*Macroclemys temminckii*) nevertheless conveys an impression of pure and terrible power. With a weight of 100 kilograms, it is one of the largest freshwater turtles on Earth, and one of the most formidable. Unlike other snapping turtles, it does not stalk its prey but entices it to its huge beaked mouth with a deceptive lure. It lies there on the bottom, with its mouth opened to form a large dark cavity. On the upper side of the tongue a red, worm-like projection wriggles and waves, sometimes briskly, then languidly. No other part of this stealthy creature moves: the enormous rough shell, or carapace, jagged with projecting plates, is dull-colored and covered with silt and algae; the heavy tail with its protuberances and the scaly, clawed legs remain completely still. The great animal waits, the red "worm" in its mouth twitching invitingly. A fish sees the bright object and moves in close to investigate such a tempting available morsel. The turtle instantly snaps its cleaver-like jaws together, and the fish is sheared in two or gulped down whole.

Birds of the Wetlands

The Mississippi River valley supports a large variety of bird life: from the sooty-colored dipper (*Cinclus mexicanus*), thrusting its way upstream along the bottom of torrential brooks in the Rockies, to the stately great blue heron (*Ardea herodias*), stalking its fish and amphibian prey along the banks.

One of the most adaptable and successful of all North American birds, the red-winged blackbird (*Agelaius phoeniceus*) is a common and vivid inhabitant of river marshlands. The male's scarlet wing patches, with thin light-colored borders, and its incessant trilling call are familiar everywhere east of the Rockies. When the male sings, it partly opens its wings to display the brilliant red shoulder patches, thereby establishing territory not only to its competitors but also to the quieter females. Deep, sturdily woven nests are built in marsh grasses, suspended well above the wet soil or shallow water below. Only in the northwestern part of its range does it suffer competition from its larger cousin, the yellow-headed blackbird (*Xanthocephalus xanthocephalus*), which takes the choice nesting areas over deeper water, forcing the

147

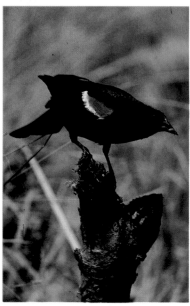

Top. *The yellow-headed blackbird* (Xanthocephalus xanthocephalus) *is a North American bird common in cattail and tule marshes west of the Mississippi. It builds a nest in aquatic vegetation protruding above deep water, thus making it difficult for predators to reach.*

Bottom. *The red-winged blackbird* (Agelaius phoeniceus) *is one of North America's most abundant birds. River marshes and wetlands ring with its trilling, squeaky call.*

red-wing farther in toward shore, to a zone more hazardous because of land-based predators.

If one has a vantage point overlooking extensive river marshlands, sooner or later a powerful, low-flying bird comes into view—the marsh hawk (*Circus cyaneus*), actually a harrier and the only member of its clan in North America. Occasionally it rises to circle high in the air; the rest of the time it speeds silently along just over the reed tops, then drops without warning to snatch up mice, frogs, and other inhabitants of the grassy wetlands. It nests directly on the marsh, building a large mound of sticks and vegetation.

The pied-billed grebe (*Podilymbus podiceps*), a small solitary grebe with a heavy bill adapted for crushing stout-bodied crayfish, inhabits river marshes on the western side of the Mississippi-Missouri Basin. Although it flies well and follows seasonal migratory routes, it is otherwise a thoroughly aquatic bird, preferring to escape by diving rather than taking wing. Even its nest is a mass of wet floating grass, bunched together well out of reach of shoreline marauders.

The River Without a Name

In the southeastern United States a great river flows southward from Lake Okeechobee for more than 160 kilometers to Florida Bay, an arm of the Gulf of Mexico tucked between the mainland and the Florida Keys. It is difficult to comprehend as a river. Though in places the river may be 80 kilometers wide, it averages no more than 15 centimeters in depth. Since Lake Okeechobee is only 4½ meters above sea level, the descent over the river's length is minimal and the flow of water almost imperceptible. The highest rises in the Everglades region, which are little more than 2 meters above sea level, are known as *hammocks* and are covered with South Florida slash pine (*Pinus elliotti densa*), live oak (*Quercus virginiana*), gumbo-limbo (*Bursera simaruba*), and other trees that avoid wet soil.

Water level in the Everglades fluctuates with the seasons, partly because of high rates of evaporation both on the lake and on the extensive stretches of quiet open water in the river portion. When the level falls, aquatic animal life seeks the deeper spots popularly called alligator holes, not only because the American alligator (*Alligator mississipiensis*) takes refuge there but also because its activity in part serves to keep such basins open and relatively deep. Such pools also contain a number of species of turtles, including the pugnacious Florida soft-shelled turtle (*Trionyx ferox*), with its sensitive soft oval back and long snorkel-like nostrils. In any season, wet or dry, these pools are filled with fishes, such as mosquito fish (*Gambusia*), killifish (*Fundulus*), and the big predatory largemouth bass (*Micropterus salmoides*). The Florida gar (*Lepisosteus platyrhincus*) is a ferocious creature that consumes nearly all other kinds of fish as the bulk of its diet but also captures frogs, crayfish, and aquatic insects.

The American alligator, perhaps the most famous denizen of the Everglades, is innocuous with respect to man. It is purely a freshwater animal and seldom ventures out into brackish water where its range can overlap with a lesser-known Floridian reptile, the American crocodile

(*Crocodylus acutus*). The crocodile is less abundant and, because of its shy and secretive nature, seldom seen. Once seen, it is easily distinguished by a lighter gray color, narrower snout, and the manner in which its teeth are exposed.

Despite tales to the contrary, the loud bellowing of an alligator is not an indication of courtship but is carried on throughout the year. Actual courtship is quiet and almost gentle, with the two animals lying side by side in shallow water, the male stroking the female from time to time with his front leg. Later he lowers his head beneath hers, to rub her throat while blowing bubbles upward past her head. Mating occurs not long after, and the two separate, although both may inhabit the same general territory. About two months later, the female begins to construct a nest by scraping up mud and vegetation with her body and tail. Once the nest is completed—a matter of a few days' activity—the female carefully excavates a hole in the top with one hind leg. She then positions herself over the hole and deposits from 30 to 50 leathery eggs in the depression, slowing their fall with her hind feet. When all have been laid, she edges over to the side of the nest, keeping her weight off the batch of eggs, and gently covers the cavity with plant material and mud. Once this is done, she remains near the nest as the embryos develop, hissing and charging at intruders but making no attempt to bite.

The Long and Slender

Of the 27 species of snakes known in the Everglades, only three are venomous—two of which are varieties of rattlesnake not associated with wet areas. The venomous Eastern cottonmouth, or water moccasin (*Agkistrodon piscivorus piscivorus*), commonly remains close to water along the banks or lies in wait on overhanging limbs. This snake swims easily and readily but is not truly aquatic, nor does it hunt its prey while in the water. When disturbed, it makes a threatening gesture by opening wide its mouth, to reveal the puffy white interior that gives the snake its name.

One of the most curious animals living in the Everglades region is the two-toed amphiuma or Congo "eel" (*Amphiuma means means*), which at a quick glance might be thought a thick-bodied snake or an eel. It is neither, but instead an amphibian, a highly modified salamander almost a meter in length. Its widely separated legs are so tiny and feeble they are completely useless. Normal salamanders go through an aquatic larval stage complete with gills before metamorphosing into lunged adults. The amphiuma seems to hover partway between, with gill arches and gill openings but no actual gills; it breathes air with lungs. It never develops eyelids, which adult amphibians possess. Thus it appears to have retained certain larval characteristics while attaining others which are those of an adult.

The amphiuma is a nocturnal animal that seldom ventures far from its burrow. When it does, it moves slowly across the bottom in search of insect and crustacean prey but is quick to return to its shelter if alarmed. When the Everglades are flooded and the peat is soggy, amphiumas may emerge and wriggle slowly across wet land away from open water in search of prey.

151 top. *Basswood Lake lies in the heartland of the Boundary Waters area. This complex system of thousands of rivers, lakes, and streams was fed by melting glacial ice. Each autumn the waters receive an enormous amount of organic matter as leaves fall from surrounding trees. Decay quickly sets in and creates a rich organic mud in which multitudes of small creatures live.*

Bottom. *The Boundary Waters area is a feeding ground for a wide variety of visitors, such as the female mallard ducks* (Anas platyrhynchos) *shown here.*

Above. *Autumn foliage is reflected in the water of Basswood Lake in Northern Minnesota.*

A River of Birds

This great grassy Florida river, with its tree-crowned hammocks, is a haven for one of the largest assemblages of birds in North America. The region is subtropical and supports an exceptionally wide variety of plant communities. The larger and more popular birds for visitors to look for include the roseate spoonbill (*Ajaia ajaja*), white ibis (*Eudocimus albus*), wood ibis (*Mycteria americana*), great white heron (*Ardea occidentalis*), yellow-crowned night heron (*Nyctanassa violacea*), anhinga (*Anhinga anhinga*), snowy egret (*Leucophyx thula*), and the rare Everglade kite (*Rostrhamus sociabilis*). A total of 237 species of birds are known in the Everglades, some of them only seasonal visitors.

Some of the birds are specialized to a high degree. The Everglade kite, for example, feeds on nothing but a snail (*Pomacea*) that is equipped to breathe both underwater and in the open air. When the snail crawls about on exposed vegetation, it is picked off by the kite.

Ibises and spoonbills are closely related, and both tend to roost in large numbers in mangroves and other trees at the southern end of the Everglades. While the white ibis and its near relative the glossy ibis (*Plegadis falcinellus*) probe in the mud for food, the roseate spoonbill holds its oddly shaped bill straight down in shallow water and, swinging it from side to side, traps small aquatic prey with apparent ease.

One of the strangest birds in the Everglades is the anhinga, or darter (*Anhinga anhinga*)—also known as the snakebird. While it swims, only its long neck and head extend above the water, quite clearly suggesting a reptile. When the anhinga dives beneath the surface, it partly opens its wings and swims slowly, its neck bent and the stiletto beak poised. As fishes are attracted by the drifting shadow of the bird's wings, its head shoots out with blinding speed and a fish is speared. If the victim is large, it is brought to the surface, tossed in the air, and caught head-first in the anhinga's open beak.

The anhinga's feathers are not water-repellent, so when the bird emerges from the water, it shakes itself vigorously, then climbs to a low perch above the river and sits quietly, wings outstretched to the sun as its plumage dries. This characteristic is shared by a close relative, the double-crested cormorant (*Phalacrocorax auritus*), another diving, fish-eating bird common to the Everglades.

The only member of its family, the limpkin (*Aramus guarauna*) resembles a crane or rail and is believed to be a rather primitive bird possessing ancestral traits of these more modern birds. It has a highly specialized diet, feeding on, among other things, the same snails (*Pomacea*) as the Everglade kite; freshwater clams, crayfish, insects, and frogs may be captured as well. Frequenting heavily vegetated marshland, where it moves about easily, it prefers to slip away through the underbrush rather than take flight when disturbed.

"Mermaids" of the Everglades

The Florida manatee (*Trichechus manatus latirostris*), like other sirenians, is a huge, cylindrical, completely aquatic mammal weighing upward of 600 kilograms (some

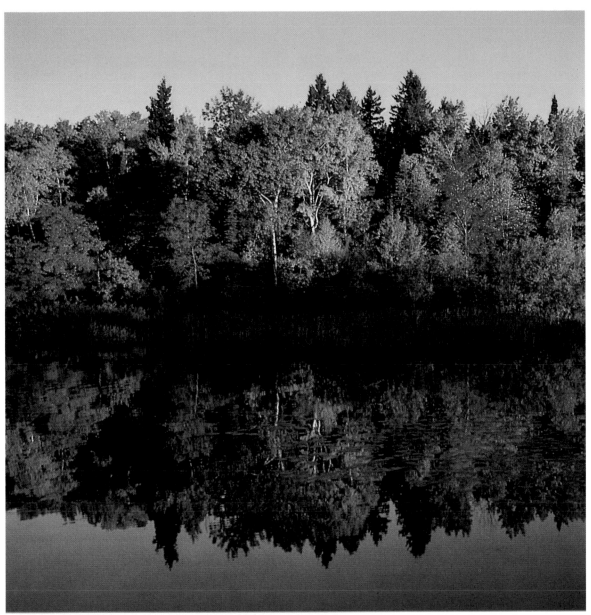

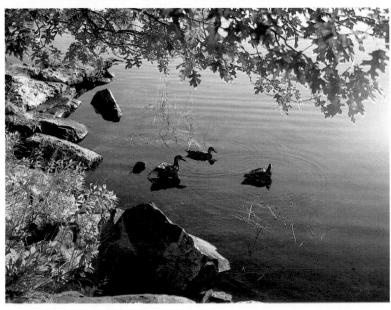

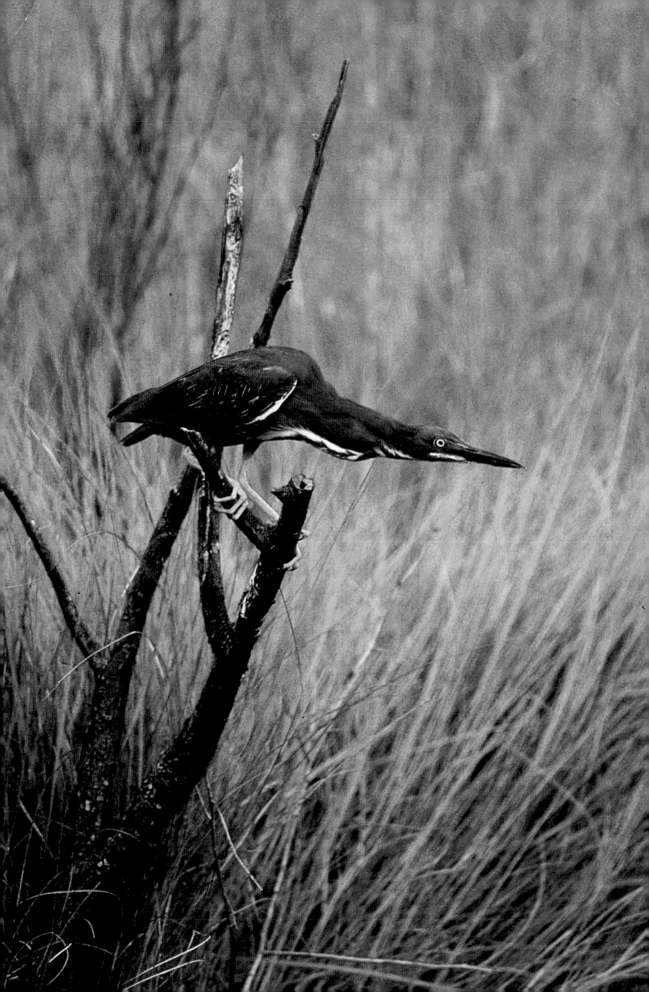

say as much as 900 kilograms) and stretching 4 meters in length. Manatees are slow-moving, peaceful vegetarians; their great bulk and rounded bodies give a somewhat bovine impression. The body of a manatee places it somewhere between a whale and a seal in appearance: its propelling tail is rounded rather than formed in a pair of flukes, and its pelvic girdle consists of nothing but a broad flat bone deeply buried in the body. Its forelimbs are more mobile than a whale's flippers and can be used to gather vegetation for food as well as to cradle its young, especially when nursing.

The manatee has a prodigious appetite, consuming as much as 30 kilograms of food a day and digesting it in intestines that may stretch over 20 meters. Its feeding habits make it desirable in weed-choked waterways that would otherwise become impassable.

The head of a manatee is grotesque, yet with great mobility of expression. Its bristly lips can be extended or widened when gathering food in large quantities, or can be tucked underneath each other in rubbery fashion. The animal's eyes are small and placid, there are no external ears, and its nostrils can be closed off completely when it is submerged. Because the vegetable food of the manatee requires constant chewing, there is considerable wear on its teeth, with the result that the flat grinding molars are constantly being formed at the back of the jaw. These then move forward as older teeth in front are damaged and lost.

Portals to the Sea

Any river that undergoes the effects of the tidal rise and fall of the sea is called an *estuary*. Coastal formations present almost endless variations of an estuary, from a deep fjord to a wide lagoon behind a barrier island. In the Mid-Atlantic states of North America, there is an almost classic example of what an estuary should be: a river widening into a broad bell-shaped bay, then flowing out across a continental shelf into the ocean.

The Delaware River has two sources, both in mid-central New York state. For a great many miles thereafter it is a typical river, differing little from others in the Northern Hemisphere. Finally it reaches a place of transition, a spot where the water flow leaves the ancient rocky Piedmont and strikes the newer, softer sediments of the coastal plain. These are more easily eroded by flowing water than was the rocky substrate, so gurgling rapids and falls mark the region where the two come in contact. Appropriately enough, such a geological location is called the *fall line*. From there to the sea, the river is tidal—its flow being alternately accelerated and retarded by the twice-a-day rise and fall of the ocean tides. For many kilometers below the fall line the water is still essentially fresh, although a few hardy and tolerant creatures from the bay 160 kilometers downstream may survive for a while if carried so far upriver.

An estuary probably presents the most profound changes for aquatic organisms of any watery environment in the world. At one end there are the freshwater creatures, all of them having evolved from either sea or land ancestors long ago. At the other end are the animals of the ocean, penetrating the increasingly brackish bay only so far as their body chemistry permits. The region in between is

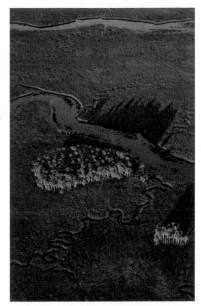

153 top. *Although tidal marsh creeks, such as that shown here in the Big Bend section of Florida, may fill and empty with the tides, the overall rate of flow, especially across the grassy expanse, is extremely slow, thus allowing the accumulation of rich organic nutrients from decomposing plant material.*

Bottom. *Although the Everglades may appear to be a wet grassland with elevated hummocks of trees, it is in fact an enormous, shallow, slow-flowing river.*

Opposite. *The green heron (Butorides striatus) prefers secluded areas, where it poises, immobile, along wooded streams to wait for fish or frog prey.*

153

Opposite. *The broad spatulate bill of the roseate spoonbill (Ajaia ajaja) is used to filter tiny crustaceans and plankton from the warm turbid water. This bird is no longer common in the Everglades.*

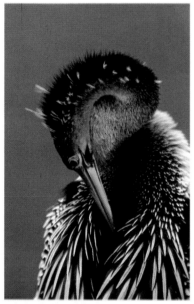

Above. *The subtropical Everglades support an enormous assemblage of birds, such as the anhinga (Anhinga anhinga), or snakebird. Unlike the plumage of many water birds, that of the anhinga is water-permeable, an adaptation which makes the bird less buoyant and more able to swim low in the water. When it swims, only the anhinga's sinuous neck and head appear above the surface, until it dives to "fly" underwater to spear fish prey. After swimming, the anhinga preens its feathers, shakes the water out of its wings, and spreads them in the sun to dry.*

populated by some of the most resistant and tolerant creatures known. They are adapted to continuing environmental change, and have found in their evolution a form of security. They live neither in fresh water nor in water filled with salts from the sea.

What lives in the Delaware estuary? Microscopic rotifers, planktonic crustaceans, worms, and fishes from fresh waters upstream exist as far down the river portion as they can before the ocean salts make it impossible for them to survive. Frogs and salamanders quickly disappear from the river's shores as the first tinge of salt occurs. On the other hand, marine creatures invade the estuary. The first, and the least tolerant of lessened salt content—sea stars, sea urchins, and their relatives—disappear just inside the bay mouth. Certain crustaceans, mollusks, worms, and fish are able to venture farther upstream, depending upon the season. This last point is important, for it too increases the variability of an estuary, since spring brings an increased flow from inland as snows melt, and often in autumn less fresh water enters the estuary. The result is a fluctuating *salt front* that may vary many miles up and down the estuary.

Finally, there are the creatures that live in estuaries and nowhere else—or at least they thrive there better than in other places. The oyster (*Crassostrea virginica*) is such an animal. In an unpolluted estuary, huge bars or reefs of oysters grow along the shallow bottom where they filter out vast quantities of nutrients and plankton. An oyster community is just that: it establishes a bottom habitat for a great many other organisms that otherwise could not exist there, for the hard shells of oysters provide a marked contrast to the soft sediments of a bay. Certain kinds of sea anemones, segmented worms, and crustaceans occupy every niche. Other mollusks are present, too—including the predatory oyster drill (*Urosalpinx cinerea*).

One of the most persistent and abundant denizens of an estuary is the blue crab (*Callinectes sapidus*), which goes so far upstream it startles some observers who think it is entering purely fresh water. This is not possible, but the remaining tinge of salt is so slight it is hardly perceptible to a human.

The Rich Meadows

Estuaries possess an ecological importance beyond all relation to their size. Conditions along their shores permit the luxuriant growth of salt-marsh cordgrass (*Spartina*). This grass, which grows so well in salt-saturated tidal mud flats, produces abundant nutrients that not only feed plant plankton in the bay but are also the base for food webs or nutritional relationships up and down the adjoining coast.

The clapper rail (*Rallus longirostris*) is a characteristic bird of the salt marsh, where it slips effortlessly through the dense cordgrass. When wetlands are extensive, the clapper rail remains in brackish or salty tidewater creeks, while the similar king rail (*R. elegans*) establishes its territory farther inland along freshwater creeks emptying into the marsh. The small, shy seaside sparrow (*Ammospiza maritima*) is another resident of marsh grasslands, where it is difficult to see because of its modest grayish coloration. Unlike its inland seed-

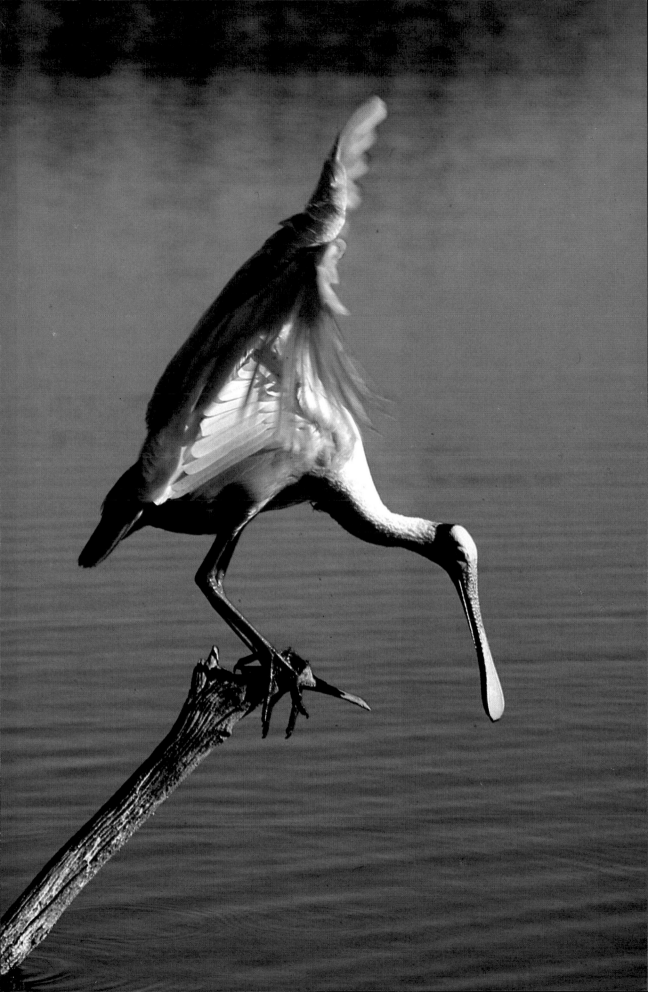

eating relatives, the seaside sparrow devours more insects and marsh crustaceans than plant material. Territorial long-billed marsh wrens (*Telmatodytes palustris*) also seek marsh insects, but they prefer frequenting the inner margin of salt meadows where the tall reed *Phragmites* grows as a border.

Along the mudbanks of tidal creeks live fiddler crabs (*Uca pugnax* and *U. minax*), the former often in huge swarms that sweep through the cordgrass sounding like a breeze. A fiddler crab is strictly a marsh dweller, feeding on the rich detritus that makes up the muddy floor. The male has one greatly enlarged claw that it waves back and forth in territorial display and in courtship ritual. The disproportionate claw is virtually useless in defense and impossible to use in feeding. The male's other claw is the only means by which food is conveyed to its mouth. The purple marsh crab (*Sesarma reticulatum*), living a little farther inland on the marsh floor, builds a deeper burrow than those of fiddler crabs, often protecting its entrance with a mud "porch." This crab harvests cordgrass and cuts it into short lengths before eating it. The wastes that pass through its body and decaying marsh grass that lies in windrows in fall and winter, help enrich the thick marsh mud.

The bay and salt-marsh creeks serve as essential nurseries for a number of oceanic fishes, such as the oily menhaden (*Brevoortia tyrannus*). While diving in the turbid waters of salt-marsh creeks, I have seen young barracuda (*Sphyraena*), lookdowns (*Selene vomer*), summer flounder (*Paralichthys dentatus*), and a host of other small fishes finding sustenance and security in these rich waters. The bottoms of such creeks often harbor tube-building worms, sponges, sea anemones, hydrozoans, and other refugees from the ocean. Crabs of several species crawl about in search of tidbits; and ribbed mussels (Mytilidae), anchored on strong silken threads, jostle one another in the swift currents.

Beyond the two capes forming the mouth of the Delaware River estuary, the river continues to flow—in a fashion. River water, still a little fresher than that of the sea, rides atop the more dense salt water, before slowly mixing into it. But a river is not water alone, for it transports enormous volumes of sediment. The heavy particles drop out as soon as a river loses sufficient velocity, but finer suspended material is carried far. No matter how small the particles, they and the water transporting them constitute a mass heavier than seawater, and this mass flows rapidly along the bottom as a *turbidity current*, which cuts into the continental shelf and erodes submarine canyons that plunge deeply into the continental slope. Far out at sea, these turbidity currents spread across the plains of the ocean floor, adding to their finely graded substance. In this fashion, the great rivers of the world continue to flow far beyond what appear to be their geographical limits, performing work and transforming the ocean floor. Someday the water molecules descending in a current to the ocean depths will rise once again from the surface as evaporation, completing the endless cycle that has been at work on Planet Earth since the seas were first formed. Only because of this cycle and the properties of that miraculous substance, water, does life exist at all in the rivers and on the landmasses of the world.

Above. *Barnacles* (Balanus) *may travel a great many kilometers upstream in a river estuary. They feed by using fringed legs that sweep planktonic food into their mouths.*

Opposite. *The edible blue mussel* (Mytilus edulis) *lives in bays of rivers that empty into the ocean. These small bivalve mollusks are held in place against vigorous tidal flows by strong threads cemented to the substrate.*

Overleaf. *Well up into Delaware Bay, at the mouth of its river, three species of marine fishes find food and security in the turbid waters: a lookdown (Selene vomer), a pair of pompano (Trachinotus carolinus), and a barracuda (Sphyraena).*

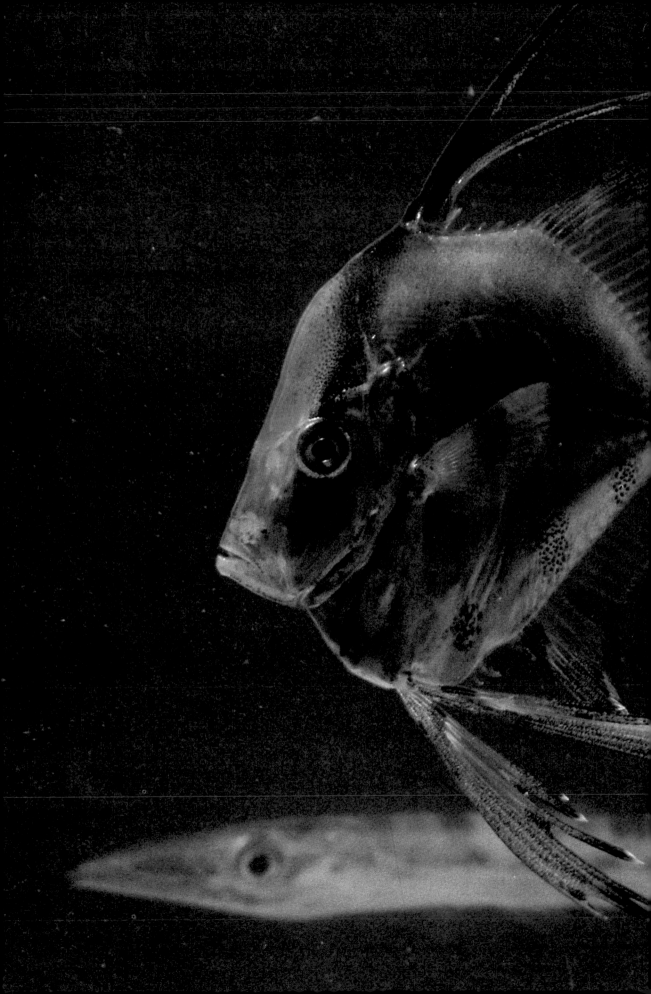

South America: The World's Greatest River

Sprawling over 6 million square kilometers, the Amazon is a world in itself. It is, quite simply, the world's largest river. Disputes arise over its exact length, more than 6,712 kilometers—but it would appear to be about 80 kilometers longer than the Nile. Yet it is not its length that makes it great: it is the volume of water discharged, amounting to one-fifth of all river water in the world. During rainy seasons, the Amazon's discharge of over 200,000 cubic meters a second is eleven times that of the Mississippi. The Zaire, which ranks second in volume in the world, is exceeded not only by the Amazon but by two of its tributaries, the Madeira and the Rio Negro, each delivering more water from its mouth into the main stream than the African river does into the Atlantic.

A total of 1,100 tributaries throughout the Amazon Basin fetch water from six different countries. In its lower 400 kilometers, the river may spread up to 56 kilometers in width and often be more than 90 meters deep. The depth, width, and generally placid nature of much of the lower river make it possible for oceangoing vessels to sail nearly 3,700 kilometers upstream.

After arising in the high Andes far to the west, just 190 kilometers inland from the Pacific coast, the river drops steeply—as much as 4,800 meters within only 950 kilometers. Beyond this rapid descent, it and its tributaries sprawl across a huge flat expanse with a slope so gentle—less than half a centimeter per kilometer—that water seeps out onto the surrounding land, creating a vast wet forest many kilometers wide. This is not only twice as large as any other river basin; it forms the world's largest uninterrupted tropical rain forest.

As one traces the river upstream, it acquires other names: Solimões, Ucayali, Tambo, Ene, Apurímac, Santiago, Toro, and finally the tiny Huaraco. A traveler attempting to navigate the maze of huge tributaries—the Negro, Madeira, Tapajós, and Xingú—would find each of them as majestic and awesome as the main channel itself. Early explorers referred to the enormous river basin as a "green hell," primarily because it was difficult, if not impossible, to emerge from it unscathed.

Of Waterfalls and Ducks

The source of the Amazon is the Huaraco, the Apurímac's headwater extension, which arises as a spring in the tundra on the slopes of Mt. Huagra at 5,100 meters. Moss grows in the spring pool; reindeer moss (a lichen) and dwarf shrubs prove this is an alpine world. The cold little brook descends rapidly (2,400 meters in less than 50 kilometers), gathering more water as other springs and brooks contribute to its volume.

All up and down the Andean range are more such brooks, some flowing into the Amazon watershed, some lying on the other side of the mountainous divide and heading straight to the nearby Pacific. In steep mountain valleys, rimmed by fog-shrouded forests, water roars down from cataract to cataract. Where erosion has cut into softer sediments, white waterfalls gleam.

Hardly the place for ducks, it would seem; yet throughout the entire Andean chain, running from Venezuela to Tierra del Fuego, torrent ducks (*Merganetta armata*) live, through their behavior tied intricately to the most tumultuous of streams. Although there is only one species,

160. The Amazon arises high on the eastern slopes of the Andes and flows across an entire continent, on its way creating the largest rain forest on Earth. Close to its source the Amazon is swift and turbulent. As this photograph reveals, its descent is steep.

162–163. One of the most highly specialized of all waterfowl, the torrent duck (Merganetta armata) has long, extremely stiff tail feathers and a hard spur on its wrist joint with which it braces itself against rocks in the torrents of Andean rapids. Using its unusually large, webbed feet, it swims upstream either on the surface or submerged. These are accomplishments unequalled by any other bird. This diving bird feeds exclusively on bottom-dwelling aquatic insects, such as stonefly and mayfly nymphs—creatures found only in the swiftest currents.

it is subdivided into six clearly defined subspecies. Such fragmentation of species, not found in other waterfowl around the world, reflects the near isolation their way of life has forced upon them. Torrent ducks are confined to fast-flowing streams and rivers at elevations up to 3,500 meters, but they are never abundant and do not occur in flocks. A torrent duck is a slimly built bird, dark in plumage, rusty underneath, with light vertical bands running up its neck. Its bill is slender and bright red; its feet are nearly the same color. Two features make it unusual, both of importance to the way the duck makes its way through rushing water. First, it has a hard spur on the wrist joint of its wing that may help it hold onto rock surfaces. Next, its tail feathers are long, greatly stiffened, and bent downward to balance, and possibly to brace, the bird as it climbs up slippery rocks. The tail also serves as a rudder, propellor, and brake.

When an adult male torrent duck stands on a rounded rock jutting above the rapids, he inspects the area briefly, sticks his neck out, teeters on the edge and, with a great leap and splash, disappears beneath the surface. A female in a similar position eases herself into the water without a fuss. Once submerged, using their enormous webbed feet as their only means of propulsion, both forage along the turbulent rocky bottom, wings folded tightly against their streamlined, torpedo-shaped bodies.

In rapids and waterfalls they find their food: aquatic insects, such as caddisfly larvae and stonefly nymphs, that require cold, much-aerated waters. They work their way upstream for 15 or 20 meters before surfacing for three or four seconds, then dive again and remain out of sight for 40 seconds or more. Sometimes one torrent duck will use a single rock as its base of operations, returning to it again and again. At other times, one will forage upstream for half a kilometer or more, taking half an hour to do so, then enjoy an extraordinarily swift and tumultuous ride back to where it began, with the current buffeting and twisting it, sideways or backward, but the duck is always in command of its fate and somehow misses crashing into rocks or being caught up in whirlpools. When it returns to home territory, it stops abruptly in the swift current, with its broad, stiff tail serving as a "sea anchor," and quickly skitters to the bank or its favorite rock, in the lee of which it may forage for a bit before climbing out. Watching one of these birds in what appears to be an overpowering current, one is sure time and again it has at last been destroyed, only to find that it has temporarily disappeared in spray and froth. If a torrent duck is alarmed by an intruder, it may seek refuge behind a waterfall rather than take wing. Flight is only a last resort.

A torrent duck is highly territorial and feeds repeatedly in the same stretch of cold, highly oxygenated water. It nests in rocky crevices 15 or 20 meters above the river; shoreline vegetation is unimportant to it. When the young hatch, each duckling in turn topples off the ledge, tumbling head over heels as it bounces from one jagged rocky outcrop to the next before finally landing on the stony shore or in the water. That they arrive uninjured is due to their extremely light weight (only 35 grams) and the fluffy, downy coat that slows their descent and provides a buffering protection. Once in the water, the chicks are so light they can even ride on the frothy spume.

When a torrent duck takes wing, it gives a single, high-pitched "Wheek, wheek" as it flies low over the watercourse, following every twist and turn of the rapid stream. Since they are so closely restricted to their individual streams and watershed basins, it is no wonder that such marked local differentiation has set in between subspecies.

Because torrent ducks are widely dispersed and difficult to see, their presence may often be indicated by another bird with precisely the same preference for habitat and food, the white-capped dipper (*Cinclus leucocephalus*). This starling-sized bird, with its short tail, strong stubby wings, and compact body, is equally at home in swiftly flowing water. Its habits beneath the surface are different from the torrent duck, however, for it "flies" with its short wings through the water, its unwebbed feet drawn up close to its body. Repeatedly, it dives headfirst into the rushing stream, the current pushing it to the bottom, where it then proceeds to walk about and briefly hunt for insect food. The active, whirring flight of the dipper calls attention to birdlife around a torrential stream and suggests that the elusive ducks may also be present.

The Green World

One of the great panoramas of our planet begins where the Andean foothills level out: a rain forest of such dimensions there is no other to equal it. In the west it is nearly 2,000 kilometers wide and interrupted only by countless rivers and streams. Its luxuriance is due to the high rainfall, which maintains a constant humidity, often steaming in the prevailing high temperatures. Unlike temperate forests, there are no stands of dominant trees, for one of the "rules" of plant and animal distribution requires a multiplicity of species in tropical latitudes, without great populations of any one kind, whereas in temperate regions species are fewer, but their individual populations may be great. In the Amazon Basin, one hectare can contain over 40 different kinds of full-sized trees, compared with only 5 or 6 species per hectare in North American forests. For this reason, even a huge tropical rain forest is a fragile ecosystem; once cut, it may take centuries for normal vegetation to return, so widely scattered are the individual trees. Some species may even fail to reappear.

Why speak of rain forests in a book on rivers? Because in the Amazon the two features are indivisible; both are the products of an enormous quantity of water that falls into the basin or is wrung out of the atmosphere against the bulwark of the Andes, only to flow back down into the rain forest basin again. The wildlife found both in the river and the steamy forest is inextricably linked.

The Amazon rain forest, like all such forests, has characteristics that separate it from forests in higher latitudes. Lacking seasons, there is no periodic leaf fall or time of flowering. Trees are mostly hardwoods, with props and buttresses and light-colored trunks. There is relatively little vegetation on the forest floor, because so little light penetrates through the thick foliage far above. Most of all, the determining feature of a rain forest is its vertical division into layers, or *canopies*. Where one walks in the gloom of the *forest floor*, through the thick leaf mold, a sparse herb layer is inhabited by such creatures as

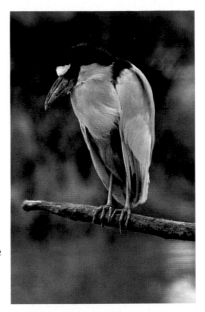

Top. *The boat-billed heron* (Cochlearius cochlearius) *walks slowly through shallow water along stream banks, scooping up small fish and crustaceans or digging aquatic invertebrates out of the mud. These wary birds rest quietly by day and hunt only after dark.*

Bottom. *The banded tiger heron* (Tigrisoma fasciatum) *is an inhabitant of forested river shores, where it is active during the day. These solitary birds become motionless when danger threatens and are almost impossible to see in the light and shade of shoreline vegetation. A banded tiger heron's call resembles the sound of lowing cattle.*

army ants (Dorylinae) and the black-crowned ant pitta (*Pittasoma michleri*), an erect, short-tailed bird that constantly turns over leaves to capture insects and other prey. Pittas tend to fly only for short distances above the forest floor and seldom emerge into open sky.

Next comes the *shrub layer*, the habitat of some large ground-dwelling animals: grazing and predatory mammals and giant snakes. Above the shrub layer is the *understory*, consisting of medium-sized trees 10 to 15 meters tall and occupied by a variety of small birds, tree-dwelling amphibians, reptiles, and such mammals as the rare bushy-tailed opossum (*Glironia*).

The *canopy layer*, higher still, swarms with birds of astonishing variety. Here live the ornate umbrella bird (*Cephalopterus ornatus*), the silver-throated tanager (*Tangara icterocephala*), and the swift collared forest falcon (*Micrastur semitorquatus*). The canopy is also home to a multitude of monkeys and sloths.

Emerging above the overall canopy are certain towering trees that push toward the tropical sunlight and provide a final vertical zone for arboreal animals. The Toco toucan (*Ramphastos toco*), with its huge, brightly colored bill, lives here, as do various members of the parrot and parakeet tribes. The lovely blue hyacinth macaw (*Anodorhynchus hyacinthinus*) glides across openings among the trees, perhaps pursued by the great crested eagle (*Morphnus guianensis*). This uppermost zone, which is not so contiguous as the canopy just below, is subject to great heat, light, and the buffeting of heavy storms. Animals living up here frequently descend to the more protected canopy.

All these layers can be seen from the river, for its mighty flow bisects forests as cleanly as a giant knife, with little evidence of transition. The river leaves its mark on the trees, with their trunks stained as much as 15 meters above the ground by river sediments deposited there during floods.

The Hunters and the Hunted

Fifty million years ago tapirs were widely distributed over the Earth, but in those days the configuration and placement of the continents was very different from what we find today. The dynamics of plate tectonics have shifted crustal formations in such a way (and continue to do so) that populations of many land-dwelling animals were separated, with further migratory access denied them. In other words, they became isolated. Tapirs entered South America about a million years ago when the Panamanian land bridge formed. They disappeared from North America, as they did in Europe, but managed to survive in Malaysia and in Central and South America. There one finds a total of five species, hardly changed from their ancient past. Despite differences in habitat, all are strikingly similar.

The lowland tapir (*Tapirus terrestris*) is a timid, nonagressive creature, given to remaining solitary except for pairing during the few weeks of its mating season. Almost totally nocturnal, it spends its days amid dense foliage, asleep or at rest. In the early evening, it emerges from thickets to browse in marshy backwaters or swim in the rivers from one feeding spot to another. Its diet consists of a wide variety of aquatic vegetation, as well as

The outsized beak of the Toco toucan (Ramphastos toco) is not heavy; rather it consists of an open network of bony structures that provide strength without weight. Toucans use their bills to manipulate objects with great skill: with them they can seize fruit, small animals, and even eggs from another bird's nest.

Above, right. *Brilliant scarlet ibises* (Eudocimus ruber) *wade through floating duckweed, one of the world's smallest flowering plants. They probe deep into bottom mud in search of fishes, mollusks, and other invertebrate prey. These gregarious birds gather by the thousands and often fly together, beating their wings and then gliding in unison.*

fruit and leaves onshore. A powerful swimmer, the tapir is capable of covering long distances in the water. It also can run with surprising speed when alerted by the approach of a predator, its massive bulk slipping easily through the underbrush toward a watery haven. Although a relative of the rhinoceros, it has little means of defense other than its elusiveness and escape by way of water. As a result, it seldom roams far from the web of rivers and pools and is a true denizen of that world.

What preys upon a tapir? The attractive, spotted and striped young may become the victims of a number of river-associated predators, but the adults probably have only one major enemy, the jaguar (*Panthera onca*). This magnificent cat, superficially resembling a leopard, is also nocturnal and a hunter of the river shores. The jaguar is more massive than the lithe leopard; a large specimen is only a little smaller than a lion or tiger. Because of its stocky, powerful build, it hunts primarily on the ground, rather than in trees like its African and Asian cousins. It is one of the few cats in the world to take readily to water, where it swims easily and swiftly, not only to cover territory but also in pursuit of prey. A jaguar is an immensely strong animal, capable of pulling a large adult tapir weighing 150 kilograms several hundred meters through the jungle and then swimming across a broad river with it. The jaguar is not at all restricted in its diet, for a tapir, while it might supply enough food for days, is not always easy to find or catch. The big cat also hunts other mammals, such as monkeys, a sloth that has descended to the ground, wild pigs or peccaries, caimans (which are crocodilians), fishes, and anything else it comes across.

Among the jaguar's favorite prey are two large rodents. The orange-rumped agouti (*Dasyprocta aguti*), one of a number of South American agouti species, commonly lives in wet forests along river shores. It is active in the daytime and retreats to burrows at night, so its encounters with jaguars are usually by chance. A more likely, far more rewarding victim from the jaguar's point of view is the world's largest rodent, the carpincho or capybara (*Hydrochoerus hydrochaeris*), a creature weighing up to 54 kilograms. Resembling a gigantic guinea pig, the capybara is almost exclusively aquatic and gathers in small herds in rivers, backwaters, and swamps. It is most active during twilight hours, in the half-light of morning and evening, although it may continue feeding on its preferred aquatic plants well after dark.

A capybara is an attractive, but not easy, item of prey for the jaguar. On land it seems to walk slowly but, when startled, can dash with great speed and take long leaps toward the nearest water, where it is most at home and secure. Obviously it is a good swimmer, but so is the jaguar. Safety for the capybara lies in diving and remaining submerged for several minutes while swimming away from danger. It then surfaces cautiously, allowing only ears, nostrils, and eyes to protrude above the water, often amid a stand of aquatic vegetation. The jaguar, unable to follow underwater, is usually left hunting many meters away.

The capybara, like other peaceful animals, is sought by more than one predator. The aquatic environment of the river is not always sanctuary, for here lurk two other

Above. *The ornate, or long-wattled, umbrella bird* (Cephalopterus ornatus) *is a shy inhabitant of the middle and upper canopies of the Amazon rain forest. It feeds on berries, tropical fruit, and occasionally insects.*

The king vulture (Sarcorhamphus papa) possesses remarkably keen eyesight. Soaring high above the forest, it spots carcasses or weakened animals along riverbanks. The king vulture inhabits much of tropical America.

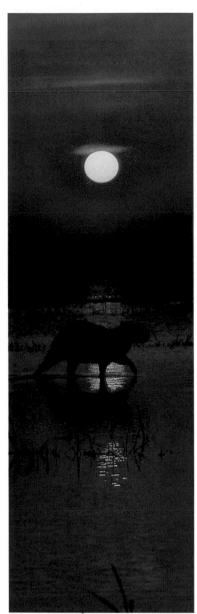

Above, opposite. *The capybara* (Hydrochoerus hydrochaeris), *the world's largest rodent, is a peaceful, gregarious animal. It is almost completely aquatic and grazes predominantly on plants growing in water—although it may eat grass and other land plants as well.*
Normally capybaras walk slowly on land, but they are capable of long leaps toward water. Their rapid swimming and prolonged dives baffle predators. When a capybara surfaces, it is almost invisible, with only its eyes, ears, and nostrils protruding.

dangerous hunters, both giant reptiles. The black caiman (*Melanosuchus niger*), close to 5 meters long, is the largest of the South American alligators and a formidable foe of any creature that happens into its aquatic domain. Lying quietly at the surface, with little more exposed than nostrils, eyes, and the rows of scales along its back, the caiman's log-like inertia belies its formidable nature and great strength. The rows of massive conical teeth in its jaws are used not for chewing but only for seizing and holding a struggling victim while it is dragged below the water surface and drowned or crushed by the powerful jaw muscles. The caiman must then return to the surface to swallow its victim.

Young tapirs, agoutis, capybaras, birds, and even small caimans are all potential victims of the world's largest snake, the aquatic anaconda (*Eunectes murinus*). Even if most specimens are smaller than the record length of 11¼ meters, anacondas are definitely reptiles to be reckoned with. A large anaconda with a girth of over 90 centimeters is capable of swallowing a 70-kilogram victim, usually a mammal caught in shallow water along the riverbank. Often the snake lies submerged except for its broad, sledgehammer head. At other times, one may coil on the bank or drape itself on overhanging limbs, ready to drop into the water below. Like all the great constrictors, anacondas do not squeeze to break bones but to suffocate prey, which is then swallowed whole, headfirst.

A large anaconda, for all its 225 kilograms of muscle, is a curiously dignified and beautiful snake. Its colors—green, brown, black, and gold—give it the luster and magnificence of an Oriental tapestry. Its calm demeanor between its biweekly meals is ample evidence of the freedom it enjoys from being molested by any other creature in the Amazon Basin. Its presence along the banks of the river is as natural as the towering green forest canopy or the fish in the water. As part of the ecosystem, it is an extraordinary product of a long evolutionary past.

The Amazon is filled with superlatives: the largest rodent, the largest snake, and also the largest otter and largest freshwater turtle. The giant otter (*Pteronura brasiliensis*), except for its size, is not unlike otters elsewhere in the world; it can be as much as 2 meters from nose to the tip of its tail. It is thoroughly aquatic, with a tail that is almost completely flat for the last two-thirds of its length—an adaptation that greatly assists its skillful manuevering in the water. Furthermore, its forefeet are thoroughly webbed, from the tip of one toe to the next, a specialization that is seen only on the hind feet of other freshwater otters. The giant otter is so at home in the river that at times it may rear up vertically above the surface almost to its midsection, as it treads water. In this position it scans the river scene, sometimes calling out loudly. Otters elsewhere are usually nocturnal, but the Amazon giant otter is strictly diurnal, hunting the waterways vigorously from dawn to dusk and occasionally taking time out to cavort and play.

The largest turtle is the arrau (*Podocnemis expansa*), a giant that can weigh well over 70 kilograms. Without including the tail or head and neck, its shell alone may measure a meter in length, and two-thirds of that in width. Despite its size, this monster is no predator but

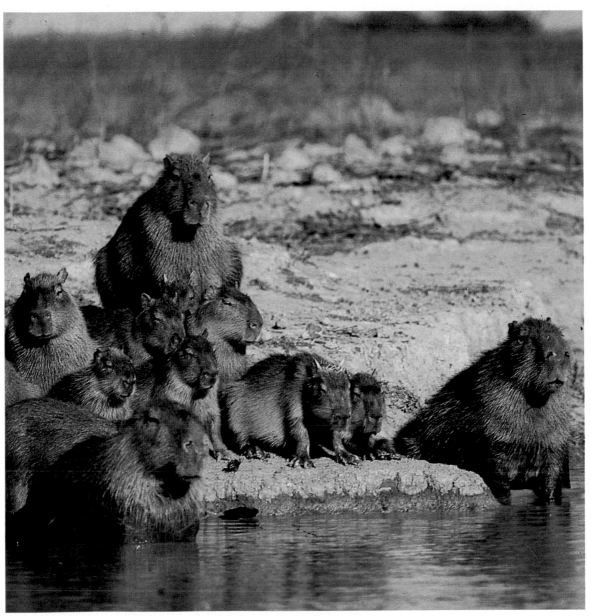

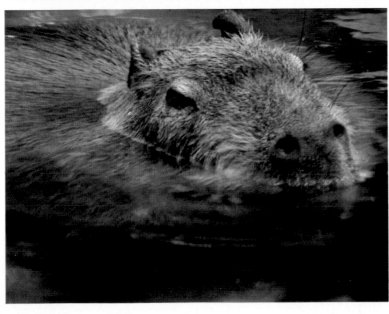

eats aquatic vegetation and fruit fallen into the river from shoreline trees. It uses its size and strength to advantage, however, in migrating long distances during mating season—over 150 kilometers.

If the arrau is the world's largest freshwater turtle, the matamata (*Chelus fimbriatus*) is the strangest. Its shell appears unusually bumpy with large blunt conical plates protruding upward, yet it is its neck and head that make it unique. The very long wrinkled neck is fringed by foliose outward growths, almost like rows of stubby bushes. Then there is the head, with large triangular flaps sticking out laterally like fleshy fins or wings. The whole front end terminates in a flexible nostril which, like a snorkel, can penetrate the surface without any other part of the turtle appearing. The wrinkles, folds, and fleshy outgrowths so camouflage the Matamata underwater that it is nearly impossible to see. A fish swims by and the turtle instantly opens wide its enormous mouth; water rushes in to fill the gaping cavity, carrying the fish with it, the powerful jaws snap shut, and the victim is swallowed. Hidden from the rest of the aquatic world, the Matamata does not have to seek food; food comes to it, carelessly and unaware.

Solicitous Toads

The Amazon Basin is home to a bewildering variety of frogs and toads, many of which live high in the rain forest and have life cycles that omit the usual tadpole stage. But among those directly associated with water, none is more remarkable than the Surinam "toad" (*Pipa pipa*). In the water this stout, soft-looking frog with a pointed snout is a marvel of aquatic adaptation. All swimming frogs have webbed hind feet, but those of the Surinam toad are special, so outsized they appear not to belong to the animal. The amphibian, of course, derives enormous thrust from these enlarged flippers, which make it possible for it not only to swim rapidly but to perform astonishing underwater acrobatics. This last ability is highly important to the survival of the species, for frog eggs are eagerly sought by fishes lurking in the shallows, and the behavior of the Surinam toad helps eliminate this hazard.

The intricate mating ritual of the animal has been studied for nearly three centuries, but only in recent years have its details been clearly observed. When the male clasps the female with his front legs, the skin on her back begins to swell outward into a spongy mass. Then both toads, kicking with their large webbed hind feet, swim upward off the bottom, turn upside-down at the top of an arc, and the female lays several eggs, which slide into folds of skin on the belly of the male. They continue their swimming somersault until they are right side up again, whereupon the male presses the eggs into the spongy tissue of the female's back, fertilizing them as he does so. This somersaulting continues fifteen or more times, after which up to 200 eggs have been fertilized and embedded in the female's swollen back. The process completed, the male departs.

Within the next few days, the fertilized eggs sink more deeply into the spongy mass until all that protrudes is a small bit of egg membrane. There the young undergo development, bypassing the free-living tadpole stage,

Opposite. The anaconda (Eunectes murinus) is the world's largest snake and, at over 9 meters, the longest reptile. These great constrictors feed only periodically and spend much of their time basking in shallow water or on banks and overhanging limbs.

Below. The grotesque Surinam "toad" (Pipa pipa)—actually a frog—inhabits slow-moving streams in the Amazon Basin. Its dark color and irregular outline make it difficult to spot as it rests on the muddy bottom. Its long, slender fingers are equipped with sensitive tactile organs, so that it can locate food even when the water is so murky it cannot see.

Overleaf. The completely aquatic Surinam toads perform an extraordinary mating ritual, in which the male clasps the female, whereupon the skin of her back swells into a spongy mass. Locked together, both toads kick themselves off the river bottom, turning upside-down as the female lays her eggs. The eggs slip into skin folds on the male's underside, but as the pair swim upright again, the male presses the eggs into the back of the female, fertilizing them as he does so. The eggs sink into the spongy skin and remain almost hidden as they develop. In about 2½ months the heads of the young begin to protrude. Finally the tiny but fully developed froglets break free and swim off.

although close inspection reveals a vestige of the more familiar life cycle: a tiny tail used as a respiratory organ rather than for propulsion. After two and a half months of being embedded in their mother's back, the young begin to stick out their heads and arms and legs. Even while they are still not entirely free, they feed on aquatic life in the water about them. Eventually they pop out as completely formed froglets and swim to the surface.

A Multitude of Fishes

It has been estimated the Amazon contains up to 2,000 species of fishes, far more than any other river system in the world. No one knows how many different kinds live there, for most of this enormous flow has not been studied in detail, and new forms of life are continually being brought to light.

Home aquarium enthusiasts have become thoroughly familiar with one member of a very large group of brilliant little fishes, the tetras, through the popular neon tetra (*Hyphessobrycon innesi*), which surprisingly belongs to the same family, Characidae, as the notorious piranha (*Serrasalmus nattereri*). Seen underwater, a piranha is an attractive, deep-bodied fish, silvery and greenish-blue on top, shading to a rusty orange on the chin and belly. With its mouth closed, it seems innocuous enough. What cannot be immediately appreciated are the heavily built jaws and fearsome array of stout triangular teeth. Although their common victims are other fishes, because they are one of the very few examples of bony fishes that go into a feeding frenzy of mass predation, myths and exaggerations of every sort have sprung up about them. There is no question that a school of piranha can strip a mammal the size of a tapir to its skeleton in short order, with each fish taking repeated bites with razor-sharp teeth. But the truth is, more often than not they feed on weakened, bleeding, or dead animals. In most stretches of the Amazon, Indians living along the shores swim regularly in piranha-infested waters with impunity. Piranha attacks on people seem to occur mostly in the vicinity of slaughterhouses, where blood and offal keep them in a state of constant agitation. The piranha is a valuable natural predator and scavenger, much maligned by humans.

Among the many characid fishes of the Amazon is the world's only fish which truly *flies*. The other "flying" fishes, both in fresh water and in the ocean, merely glide for considerable distances on outstretched pectoral fins. But the Amazon hatchetfishes (*Carnegiella strigata* and *Gasteropelecus sternicla*) actually flap their long pointed pectoral fins with great rapidity. The deep-keeled body that gives them their common name is an extraordinary parallel to the sternum, or keeled breastbone, of birds. Each serves as a base of attachment for powerful flight muscles that activate either wing-like fins or, in the case of birds, feathered wings. True flight serves the hatchetfish in two ways: it is a life-saving means of escape from predators, and it enables it to capture low-flying insects above the water's surface.

Lungs, Roars, and High Voltage

Knowledge of plate tectonics, the theory that explains the change in position of continents, allows us to understand

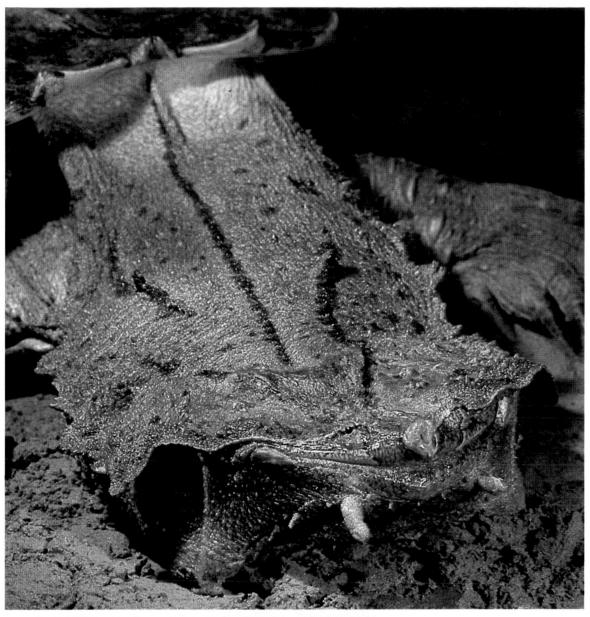

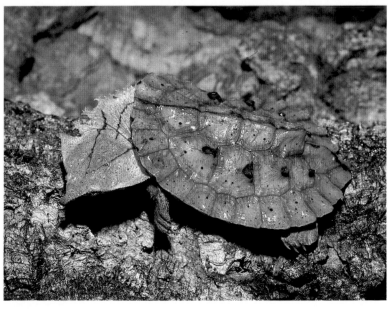

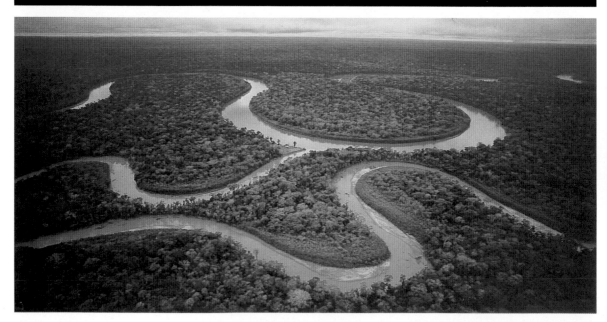

why the South American lungfish (*Lepidosiren paradoxa*) so closely resembles its African cousin yet is so different from the more ancient and primitive Australian lungfish. The South American lungfish has a thick eel-like body, with a pair of lungs branching off the front part of the esophagus. It must use these lungs exclusively during adult life, for the bushy external gills it had as a juvenile disappear as the fish grows. Its long slender paired fins, more like flexible stilts than paddles, serve to keep the fish propped above the muddy bottom.

Given the amount of water in the Amazon Basin, it seems unlikely that drought could ever set in; but this is not so, at least in river backwaters, especially those which become isolated as pools when the river level drops. As the water recedes, a lungfish excavates a burrow at least half a meter deep into the still-soft mud, curls up in the bottom, and secretes a slime capsule as protection against drying out. A small hole in the cocoon near the fish's mouth allows it to continue breathing air from the open shaft leading to the surface. A lungfish can survive in such a state of estivation for several years—at least four, and in one experimental procedure, seven.

Holes in bottom mud are also constructed for spawning purposes. Lungfish eggs are rather large and, when clustered in the nest, resemble those of amphibians. They are protected by the male, who develops on his hind fins a veritable tree of branching filaments, bright red with the oxygenated blood they contain. While it is not certain, it is possible these serve to bring oxygen to the developing embryos when inserted among the eggs.

In keeping with other superlatives, the Amazon is host to one of the largest freshwater fishes in the world, the arapaima (*Arapaima gigas*), also known as the pirarucu, paiche, or giant redfish. Some have said it is the largest of all inland fishes, but the largest specimens have now been fished out. Nevertheless, there is a record a century and a half old that tells of one measuring 4.5 meters long and weighing 180 kilograms.

As a giant predator, the arapaima lives in shallow, flooded areas thickly grown over with aquatic plants. Here it finds an abundance of fishes on which to feed, as well as other aquatic animals. The presence of these huge fishes does not go unnoticed, for they create resounding splashes as they leap into the air and are said to make a roaring sound when inhaling air. (They often find it necessary to obtain oxygen from the atmosphere if the shallow warm water is deficient in this essential gas; otherwise, they use gills.) They do not have as elaborate a lung as the lungfish, but the air bladder typical of most fishes is in the arapaima well provided with blood vessels and opens directly into the pharynx.

Glandular secretions from the head of the arapaima are not yet understood. Some observers believe they serve to mark the giant fish's territory; others say these secretions enable the young to remain close to the head of the male who guards them. While it is true the young fishes do hover close above his head, what actually keeps them there, other than their sense of sight and a special sense enabling the young to perceive the pressure caused by nearby objects, is not certain.

Every living animal, from jellyfish to man, produces measurable quanta of electrical energy. In higher animals,

182 top. The Amazon carries enormous quantities of water that floods out into the jungle. Continual evaporation from the whole wet region results in frequent rain, which in turn falls back upon the forest, inducing even more luxuriant growth.

Center. Where the Amazon and its huge tributary the Rio Negro merge, their waters flow side by side for a considerable distance without mingling. Areas of light-colored sand deposited in the Rio Negro appear red because the deeper, darker water does not allow as much sunlight to reflect back.

Bottom. Many of the Amazon's tributaries, such as the Manú River, flow slowly over flat land and twist into serpentine meanders.

Above. *The notorious piranha* (Serrasalmus nattereri) *is one of the most feared freshwater fishes. It normally feeds on carrion or weakened animals, but if an entire school goes into a feeding frenzy, they can strip a large animal down to its skeleton in a matter of minutes with their large, razor-sharp triangular teeth.*

this is most noticeable in the nervous system, both in the brain and in nerves leading to muscles. In the oceans and in fresh water, certain fishes have magnified this ability in order to provide a measure of defense or possibly to be used in other ways. Nowhere has such adaptation been carried to a greater degree than in the electric eel (*Electrophorus electricus*) of South America, and nowhere is an electric fish more feared. What makes this fish (it is not truly an eel) so remarkable is its ability to release a powerful electric charge into the surrounding water.

If a juvenile electric eel 2 or 3 centimeters long produces an uncomfortable tingling sensation when held, what of a 2-meter-long, 27-kilogram adult? With a full blast of 550 volts and a little less than 2 amps, a horse will be stunned and knocked off its feet, and a man possibly killed.

Four-fifths of the body of an electric eel consists of little but modified tail muscles, with all the essential organs of the creature being crowded into the front fifth. The muscles have lost their original appearance and are soft, white, and rather gelatinous "batteries" arranged along either side of the nearly cylindrical tail, with only a little room left for normal propulsive muscles. The electric organs are of three different kinds, each composed of small electroplates, about half a million in all, "wired" in series by nerves.

One of the electric organs, called the *bundles of Sachs*, generates a weak electric field around the fish, with the positive pole at the head and the negative pole at the tail. Small discharges are sent out constantly at a rate of about 30 per second; anything entering this field fairly close to the fish disrupts the symmetry of the field and thus stimulates the main electric organ to discharge a full jolt of direct current. The main power surge of hundreds of volts can be repeated up to 150 times in an hour without showing signs of fatigue. A formidable creature!

It is probable that weaker discharges may serve as a means of communication, or at least orientation, between these remarkable fishes, since their eyes are tiny and weak, but sensory pits of a special nature pockmark their head and jaws. Because they often live in very murky water, locating one another by ordinary means might be difficult. Are perhaps the pits receptors of electrical signals?

Shallow, turbid, warm water usually is deficient in oxygen, so the electric eel is also an air-breather. The tissues of its highly corrugated mouth and tongue are richly supplied with blood vessels for absorbing oxygen. Every 10 or 15 minutes one of these creatures rises slowly and quietly to the surface, gulps in a mouthful of air, then sinks back to the muddy bottom, where it waits patiently for prey to enter its force field.

Oddities of the South American fish world, which are endless, may be summed up by mentioning a few members of the catfish family. There are giant catfishes similar to those found in India; catfishes that climb up sheer rock faces under a waterfall by means of a suction-cup mouth; heavily armored catfishes that patrol the bottom; parasitic catfishes that inhabit the gill chambers of larger river fishes and are apt to penetrate the orifices of mammals swimming in the water; blind catfishes that live completely buried in bottom sediments. The list goes on and on.

Above. *The red-nosed tetra* (Hemigrammas rhodostomus) *has a striking banded tail. Such conspicuous markings distinguish many tetras and make them more easily recognizable in murky South American rivers.*

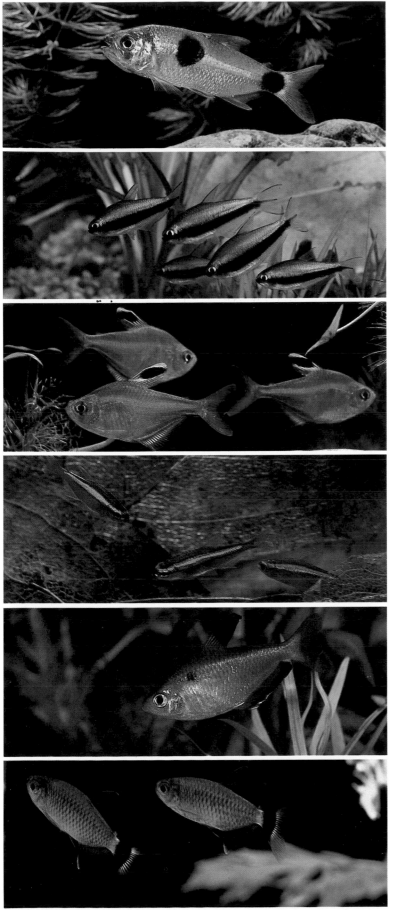

Left. *Numerous species of brilliantly colored little tetras occur throughout the entire Amazon Basin. Among the most popular of aquarium fishes, they display an overwhelming diversity of color. Some of the most beautiful tetras include (from top to bottom): rainbow characin* (Exodon paradoxus); *Andean tetra* (Nematobrycon palmeri); *bleeding-heart tetra* (Hyphessobrycon rubrostigma); *cardinal tetra* (Cheirodon axelrodi); *serpa tetra* (Hyphessobrycon serpae); *and glass tetra* (Moenkhausia oligolepis).

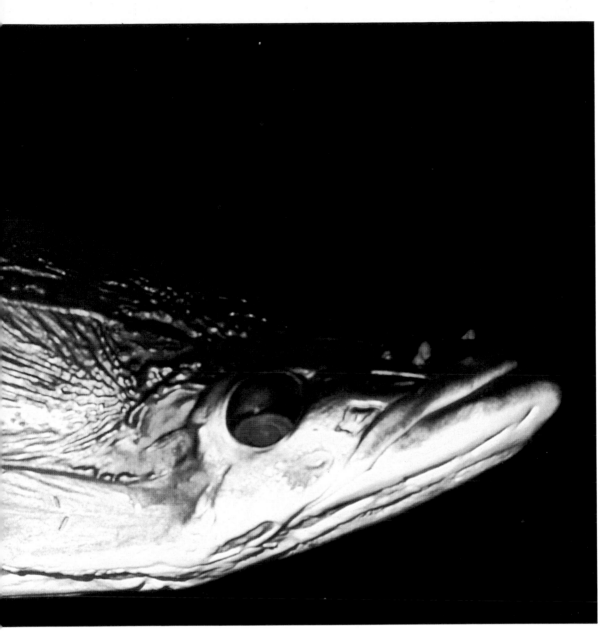

The arapaima (Arapaima gigas) is one of the world's largest freshwater fishes. When the Amazon floods, the arapaima may swim inland and inhabit shallow pools choked with vegetation. Here the smaller fish on which it feeds are available. The great fish is able to survive in oxygen-poor shallows because it has, in addition to gills, a primitive lung in the form of its swim bladder.

This organ is plentifully supplied with blood vessels, and by swallowing air into this bladder the lungfish obtains sufficient oxygen.

Top. *The Amazon is also home to the world's largest otter, the giant otter* (Pteronura brasiliensis). *Unlike otters elsewhere, this 2-meter-long giant hunts during the day. These formidable animals are not easily intimidated and prey on fishes, birds and their eggs, and even other mammals.*

Bottom. *The coypu* (Myocastor coypus) *is well adapted to life in South American rivers. Coypus have webbed hind feet, are excellent swimmers, and can remain submerged for up to 5 minutes. A coypu usually digs a burrow in a riverbank, but it may also gather reeds and build itself a nest.*

A Mind in the River

We now know that humans are not unique in the animal world in having a highly developed brain. In recent years we have learned that the brain of a dolphin is fully equal to ours in complexity, although we have no clear idea of how it is used. Two quite different kinds of dolphins live in the fresh waters of the Amazon; both appear to have an ancient lineage and are not to be confused with the more familiar marine dolphins, which belong to an entirely separate family.

One of these, a member of the white dolphins, is known as the buffeo negro (*Sotalia fluviatilis*), a mammal that ranges from cream-colored to nearly black. This species and the Amazon dolphin (*Inia geoffrensis*)—pink, gray, or black—range throughout the enormous river system, as far north and south as tributaries allow and westward to the Andes foothills. The Amazon dolphin is a curiously lumpy-looking creature, with very large front flippers, short whiskers on its face, and a long, narrow, toothed beak. Over long years of isolation in turbid river water, natural selection has allowed the sense of vision to diminish somewhat, with the result that its eyes are smaller than those of its distant marine relatives. Its skin is not as tough as that of saltwater forms but is soft and wrinkles easily.

Both river dolphin species are fish eaters, and both undoubtedly find and capture their prey by echolocation. Like the more familiar marine dolphins described in history and most contemporary accounts, river dolphins are friendly to man and give evidence of a high degree of intelligence.

Dolphins are not the only completely aquatic mammals in the Amazon. The Brazilian manatee (*Trichechus inunguis*), a slow-moving amiable vegetarian, makes mournful sighing noises in quiet stretches of the river where it is found, as far as 3,000 kilometers from the mouth.

The entire huge Amazon Basin—forest, swamp, and stream—owes its existence and constancy to the world's greatest river, which has created an ecosystem unparalleled elsewhere. Seldom in the Earth's history has there been such a coming together of unfailing high temperatures and ample rainfall with an enormous river system. Together they have formed a region in which some of the most remarkable wildlife ever to exist has developed astonishing specialties. But we must not forget that this area, despite its size, is fragile and easily affected by man. If enlightened citizens preserve it, this great river basin will endure as a treasure for all mankind.

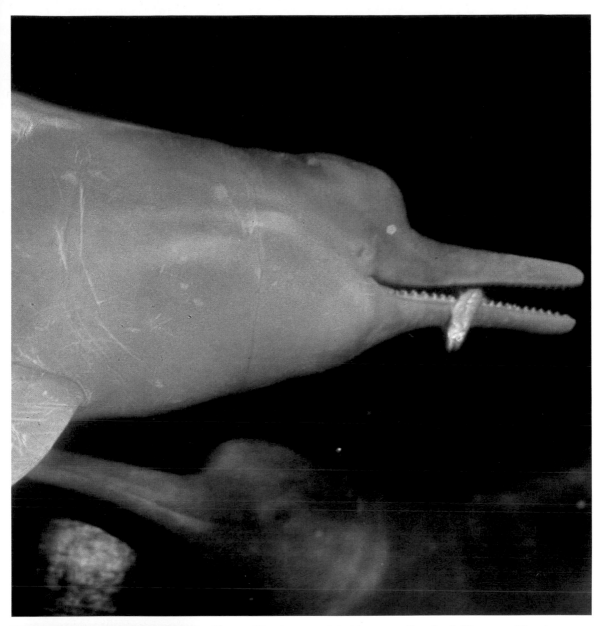

Above. *The Amazon dolphin, or boutu* (Inia geoffrensis), *has been isolated for millennia in the turbid water of the Amazon and other South American rivers. Its eyesight is much weaker than that of marine dolphins and porpoises, but it compensates for this with a keen sense of echolocation and a large number of sensory bristles on its snout. When full grown, the dolphins reach a length of 8½ meters.*

Left. *Although its ancestors were land dwellers, the Brazilian manatee* (Trichechus inunguis) *is completely aquatic. This quiet, peaceful vegetarian prefers the still Amazon backwaters, where it can lazily swim along and gather copious quantities of aquatic plants with its unusually mobile lips.*

Overleaf. *The magnificent Iguassu Falls, on the border of Brazil and Argentina, epitomize the flow and energy of water as it rushes from a highland source toward its final destination in the sea.*

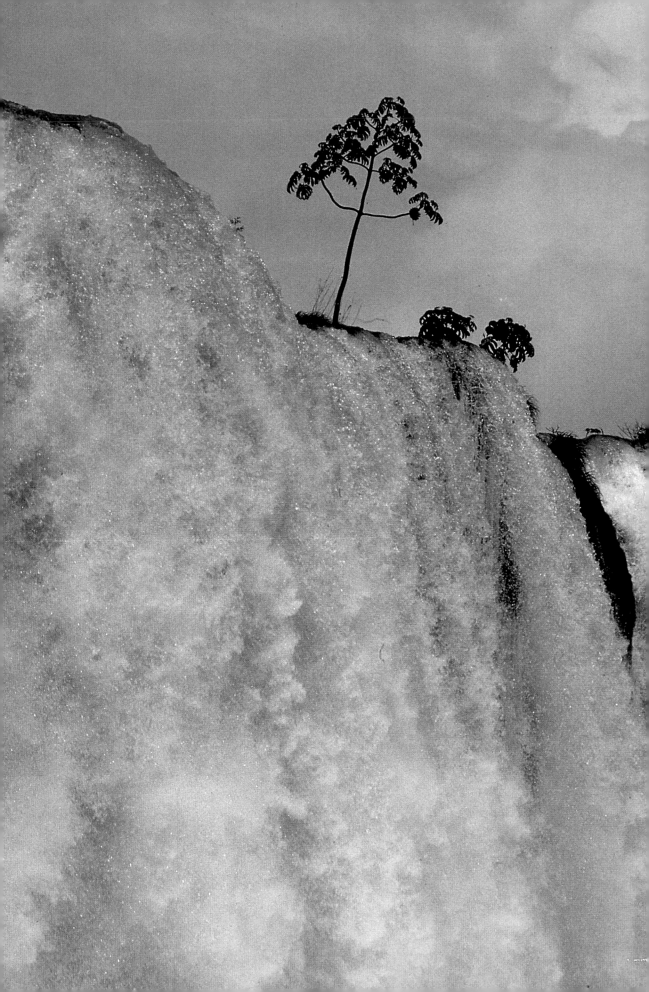

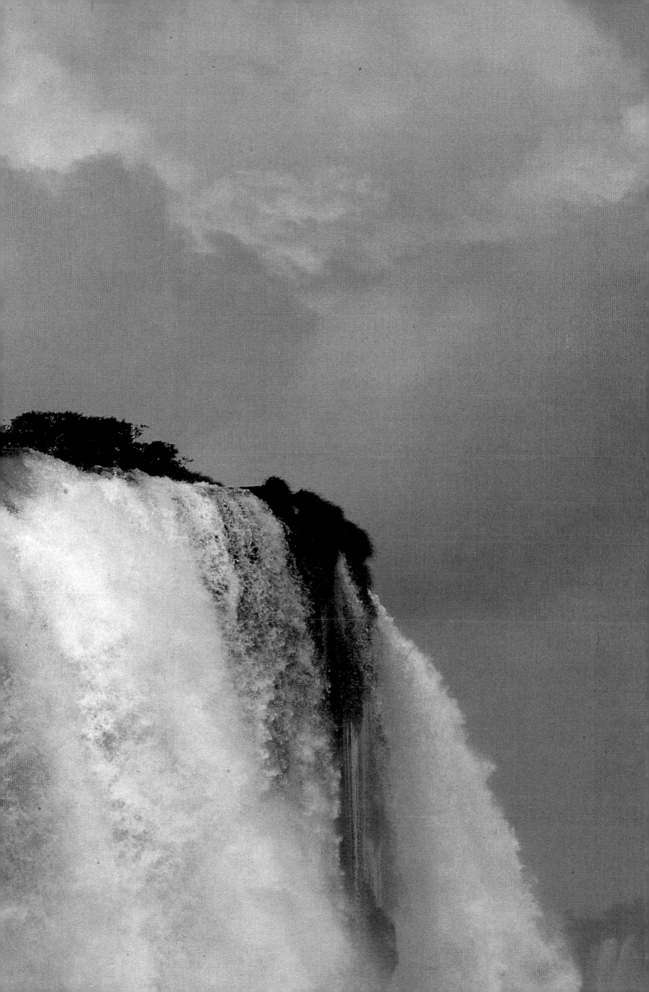

Picture Credits

Numbers correspond to page numbers.

1 Fritz Polking/Bruce Coleman, Ltd.; 2–3 ANIMALS ANIMALS/© Stouffer Productions; 4–5, 8–9 Jeff Foott; 12, 14–15, 17 National Aeronautics and Space Administration; 20 Steven C. Wilson/Entheos; 23 David Cavagnaro; 25 William H. Amos; 26 Hans Reinhard; 27, 28–29, 30 Dwight R. Kuhn; 31 James H. Carmichael/Bruce Coleman, Inc.; 32–33 J. P. Champroux/Jacana; 32 bottom Stephen Dalton/Natural History Photographic Agency; 34 Jeff Foott; 35 Hans D. Dossenbach; 36–37 Angelo Lomeo; 38 Bob and Ira Spring; 40–41 Sonja Bullaty; 43 top left Russ Kinne/National Audubon Society Collection/Photo Researchers, Inc., right I. R. Beames/Ardea London; center Hans Reinhard; bottom left E. A. James/Natural History Photographic Agency, right Douglas Botting; 44 top Collection Varin-Visage/Jacana, bottom Hervé Chaumeton/Jacana; 46–47 top row left and center Hans Reinhard, right Klaus Paysan; center row left Hans Reinhard, center Jane Burton/Bruce Coleman, Inc., right and 46 bottom Hans Reinhard/Bruce Coleman, Inc.; 49 Heather Angel; 50 Hans Reinhard; 52 top Hans Reinhard, bottom Stephen Dalton/Bruce Coleman, Ltd.; 53 Hans Reinhard; 55, 56–57 Hans D. Dossenbach; 59 Douglas Botting; 60 D. N. Dalton/Natural History Photographic Agency; 61, 62–63 Arthur Christiansen; 64 Hans D. Dossenbach; 65 Pissavini/Jacana; 66 Jane Burton/Bruce Coleman, Inc.; 68–69, 71 Hans Reinhard; 72–73 Jane Burton/Bruce Coleman, Ltd.; 74 Bob and Ira Spring; 77 top Douglas Botting, center Chris Bonington/Bruce Coleman, Ltd., bottom R. I. M. Campbell/Bruce Coleman, Ltd.; 78–79 Peter Johnson/Natural History Photographic Agency; 80 Edward S. Ross; 81 Anthony Bannister/Natural History Photographic Agency; 83 top Edward S. Ross, bottom Edward R. Degginger; 84–85 J. P. Hervy/Jacana; 84 bottom Simon Trevor/Bruce Coleman, Ltd.; 87 Erwin and Peggy Bauer; 88–89 Gary Milburn/TOM STACK & ASSOCIATES; 90 top Wolfgang Bayer/Bruce Coleman, Inc., bottom Jen and Des Bartlett/Bruce Coleman, Ltd.; 91 Peter Johnson/Natural History Photographic Agency; 92–93 F. S. Mitchell/TOM STACK & ASSOCIATES; 95 Hans D. Dossenbach; 96 ANIMALS ANIMALS/© Fran Allen; 97, 98 M. Philip Kahl/Verda International Photos; 100–101 F. S. Mitchell/TOM STACK & ASSOCIATES; 102 Douglas Botting; 104–105 Tom McHugh/National Audubon Society Collection/Photo Researchers, Inc.; 104 bottom Jonathan T. Wright; 106 Mike Price/Bruce Coleman, Ltd.; 107, 108–109 Jean-Paul Ferrero; 110, 111 Stanley Breeden; 113 top Joseph Van Wormer/Bruce Coleman, Inc., bottom Lynn M. Stone/Bruce Coleman, Inc; 114–115 François Gohier; 116 Jean-Paul Ferrero; 119 Su Gooders/Ardea London; 120–121 Frank S. Todd; 122, 124–125, 127 Stanley Breeden; 128 Jean-Paul Ferrero/Ardea London; 129 Tom McHugh at Taronga Zoo, Sydney/Photo Researchers, Inc.; 130–131 Joe B. Blossom/National Audubon Society Collection/Photo Researchers, Inc.; 132 Carl Purcell/National Audubon Society Collection/Photo Researchers, Inc.; 133 top ANIMALS ANIMALS/© Margaret Conte, bottom O. S. Pettingill/National Audubon Society Collection/Photo Researchers, Inc.; 134–135 Frank S. Todd; 136, 138 Jim Brandenburg; 139, 140–141, 142 top Jeff Foott; 142 bottom Jeff Foott/Bruce Coleman, Inc.; 144–145 Harry Engels; 144 bottom, 146 Thase Daniel; 147 top Steven C. Wilson/Entheos, bottom Stephen J. Krasemann/DRK Photo; 148 top ANIMALS ANIMALS/© Harry Engels, bottom Gregory K. Scott/National Audubon Society Collection/Photo Researchers, Inc.; 150, 151 Sam Abell; 152 Warren Martin Hern; 153 Wendell Metzen; 154 William A. Paff/TOM STACK & ASSOCIATES; 155 Edward R. Degginger; 156, 157, 158–159 William H. Amos; 160 Loren McIntyre; 162–163 G. Ziesler/Bruce Coleman, Ltd.; 165 top Hans D. Dossenbach, bottom Loren McIntyre; 166 François Gohier/National Audubon Society Collection/Photo Researchers, Inc.; 168 top Harold Schultz/Bruce Coleman, Ltd., bottom Horst Schäfer/Amwest; 169 Bruce Coleman/Bruce Coleman, Ltd.; 170–171 Loren McIntyre; 172 Sven-Olof Lindblad/National Audubon Society Collection/Photo Researchers, Inc.; 173 top Jan Lindblad/National Audubon Society Collection/Photo Researchers, Inc., bottom Dave Norris/National Audubon Society Collection/Photo Researchers, Inc.; 174 Tom McHugh at Steinhart Aquarium/Photo Researchers, Inc.; 175 Loren McIntyre; 176–177 Heather Angel; 179 top L. and D. Klein/National Audubon Society Collection/Photo Researchers, Inc., bottom Joseph T. Collins/National Audubon Society Collection/Photo Researchers, Inc.; 180–181 Tony Morrison; 182 Loren McIntyre; 183 Tom McHugh at Steinhart Aquarium/Photo Researchers, Inc.; 184 Hans Reinhard/Bruce Coleman, Inc.; 185 top to bottom: Jane Burton/Bruce Coleman, Ltd.; Hans Reinhard/Bruce Coleman, Ltd.; Jane Burton/Bruce Coleman, Ltd. (2); Serge Pecolatto/Jacana; Mero/Jacana; 186–187 Klaus Paysan; 186 bottom M. Freeman/Bruce Coleman, Inc.; 188 Loren McIntyre; 189 top Collection Varin-Visage/Jacana, bottom Tony Morrison; 190–191 Michael P. L. Fogden.

Patterns of River Drainage

Trellis. *The three major factors that determine how a stream pattern will develop are the slope of the land, its physical nature or composition, and its previous history. Water obviously lingers longer on gentle slopes than steep ones. Soft sediments are more rapidly eroded than hard rocks. And contours may have been created by glaciation or accumulation of sediments in previous ages. When the surface of the earth becomes folded and tilted, long valleys are created, each becoming a major stream-carrying conduit. Short tributaries at right angles to the main rivers feed water down the steep-walled slopes.*

Dendritic. *The tree-like dendritic pattern is very common, being frequently seen across plains, plateaus, and other flat land surfaces. Tributaries descend slowly, eventually converging to form a great river which in turn carries all the water toward a final destination.*

Parallel. *If a slope is long and steep, rain falling along the summit tends to descend directly downward, establishing a series of parallel streams. Such a pattern is most often seen on the slopes of steep, geologically new mountains, or along great rift systems.*

Centripetal. *In some parts of the world, huge basins draw rivers inward to a single lake or marsh. Small-scale examples are volcanic calderas. On a larger scale, centripetal patterns occur in arid regions where the collected water either evaporates or percolates downward into soft sediments. Often the lakes in such basins contain concentrated minerals.*

Rectangular. *When river drainage assumes a more or less rectangular pattern, it is because major cracks or faults in the earth's surface have formed ready-made channels that water flows through, often joining repeatedly. Such topography is usually made up of quite resistant rocks; otherwise the pattern would quickly alter to a more conventional one.*

Radial. *When rain falls on the summit of a single large elevation —such as a volcanic dome thrust up from flat surrounding land— the water cascades downslope in all directions, forming radii around a central point. The streams may have differing characteristics. For example, some may be dendritic in pattern while others may be nearly parallel. These streams do not necessarily empty into a common river.*

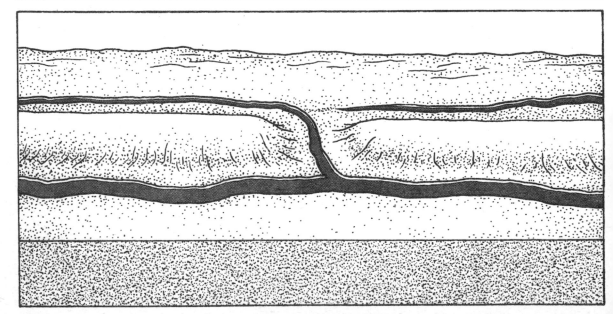

196 top. Consequent, Subsequent. *Just as there are different types of drainage patterns, so are there distinct kinds of streams. The flow of streams developing on surfaces underlain by flat strata is under the control of the slope of the land alone. Such streams are called consequent streams. Where strata are folded, streams develop between strata of resistant rock. Such streams, whose courses are determined, in addition to the slope, by the structure of the land surface, are called subsequent streams.*

196 center. Antecedent. *Sometimes, despite folding of the Earth's crust, a stream will pursue its original course, cutting directly through the uplifted obstacle.*

196 bottom. Pirated. *Often a stream will erode and reduce the divide separating it from a neighboring stream to such an extent that the latter is "captured" by the first, or diverted into it. The newly diverted stream adds volume to its captor, usually creating a major river, especially if the enlarged river continues to capture other streams. The old upper streambed of the captured stream, now beheaded, may form a watergap in the divide and begin again as a tributary.*

197. Superimposed. *Like antecedent streams, superimposed streams continue along their original courses, but a superimposed stream, after cutting through younger, softer layers, maintains its channel as it erodes through resistant strata far below its original bed.*

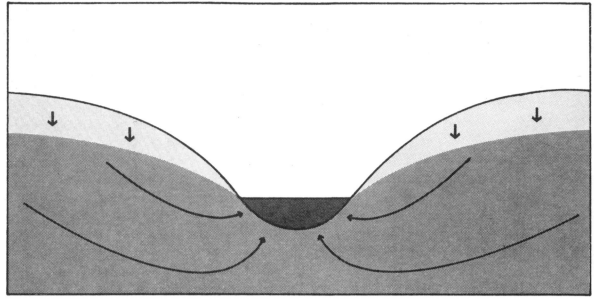

Top. **Water Table.** *Only a certain, sometimes small, percentage of water runs off in stream channels. Usually water percolates downward through the soil until it reaches a point of complete saturation. Above this level (known as the water table), soil is filled with air. Water tables fluctuate considerably according to the amount of water received and absorbed. Some soils hold water for a long time, but others lose it rather quickly. As on the surface, soilwater deep within the earth flows "downhill," attracted by gravity to an exit which may be very close by, or thousands of kilometers away. When the land surface is flat, so is the water table beneath it, but if the topography is hilly, the water table flows out at the level of valley streams, yet rises high*

beneath the dome of a hill as it slowly percolates downward through the soil. A well dug near the crest of a large hill does not have to be as deep as the hill is high, or reach to the level of a stream far below.

Bottom. **Springs.** *After water percolates freely downward to the water table, it then begins to flow laterally, often rather slowly. If water emerges from the ground lower down the slope, a spring, which may flow continuously or intermittently, is born. Often the source of water in a spring is unknown; it may be very far away. A simple spring (left) is one in which the water table merely emerges at its normal level on a slope; but others are more complex, with water bubbling forth from cavernous*

rock (center) or even spurting outward from fissures in extremely hard, unyielding rock (right). Subterranean water, especially that which, as it seeps along, has been trapped deep under layers of rock, is cold and clear. Often it may be "hard" due to dissolved minerals, but almost any spring, anywhere, gives forth pure and delicious water. Contamination occurs at the surface; bacteria vanish quickly as water percolates downward.

Above. **Waterfalls.** *When a river flows across the face of the Earth, it encounters rocks and substrates of varying hardness. The power of flowing water, intensified by an abrasive force when it carries suspended grains of sand, clearly affects certain surfaces more quickly and dramatically than others. In some places, where coastal sediments butt against the ancient rocky continent, a river flowing seaward over shallow rock basins suddenly encounters a softer substrate, and immediately begins to cut it away. Erosion continues until there is a precipitous drop, and water plunges straight down in what we know as a waterfall. Some of these are dramatic; others are new and only beginning to show as rapids.*

When a waterfall is old and well established, and cuts out softer underlying sediments leaving a cap or tabletop at the lip, the uppermost layers become unstable and collapse, leaving a pile of rubble in what had been a pool at the bottom of the falls. Niagara Falls, for example, has migrated over eleven kilometers in less than 10,000 years as a result of this continuing collapse. Other waterfalls erode the upper level more quickly and simply decrease their angle of drop, proceeding from a waterfall to a steeply angled series of rapids.

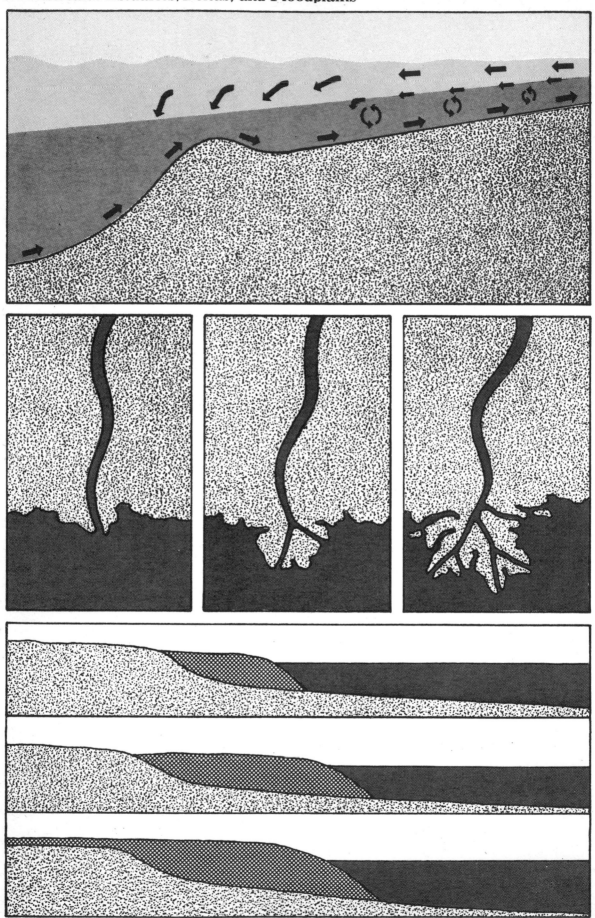

200 top. **Estuary.** *An estuary is the lower portion of a river that experiences the tidal effects of the sea, and its pattern of circulation and flow is complex. Fresh water (shown as lighter area) is less dense than salt, so river water tends to ride over the intruding heavier sea water (shown as darker area) that twice daily works its way upstream in the form of a sloping wedge. The interface between fresh and salt water is one of mixing and dispersion. Eventually the fresh water, well beyond the mouth of an estuary or bay, mingles with the ocean and is no longer traceable.*

200 center and bottom. **Deltas.** *A river loses almost all its velocity and power as it empties into the ocean, and the finest of silty particles descend to carpet the shore in a soft, gentle rain of particulate material. This accumulation slowly but inexorably fans out into a delta, through which the river and its branches, created during times of flood, must continue to run. If the drop-off into the sea (or lake) is steep, then the extent of the delta is necessarily limited, but in many places where the rivers enter shallow coastal waters, or continental shelves, deltas grow enormously in extent. Despite their size, deltas represent only a minute fraction of the sediment transported by rivers, for most sediment continues outward and downward, building continental shelves and carpeting the bottom of the deep ocean.*

201. **Floodplains and Meanders.** *A valley cut by a river in recent geological time is surrounded by sharply angled walls. But in time, a less angular, wider valley is created, and eventually the river flows across a flat valley floor known as a* floodplain. *Once a floodplain is built and the river runs over its flattened surface, the stream channel never proceeds in a straight line. Even the most minor interruption of its flow, on one side or the other, causes the river to be deflected toward the opposite bank. There it erodes soil, creating a comparatively steep wall, against which the water flows and then ricochets back toward the other shore. This progresses until the river snakes back and forth, each outer curve steep and deep, and each inner curve gently sloped and shallow with sediment deposited by a lessened current. Such curves are known as* meanders.

Above. **Oxbow Lakes.**
Meandering rivers are constantly on the move across floodplains, their loops often growing more and more tightly curved. During a time of flood or high flow, water may cut through the narrowed neck of such a loop. The old loop then becomes isolated as a still-water pond or lake. Aerial inspection of a floodplain usually reveals either open water oxbow lakes or numerous faint scars. The latter, usually marked by luxuriant vegetation or old riverbank stands of trees, tells us oxbow lakes were created, existed for a while, and then filled in and vanished in the rest of the floodplain.

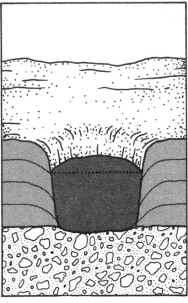
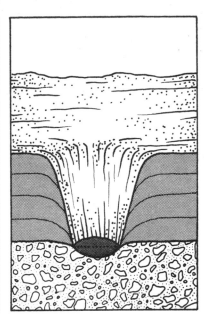

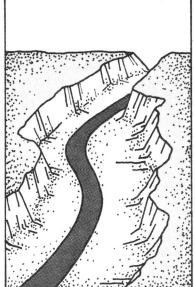
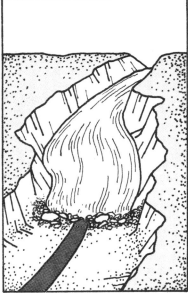

Top. **Kettles.** *The Northern Hemisphere has been subjected to repeated invasions of glacial ice from the north. At least four times, major glacial sheets have advanced and retreated over the continents. The enormity of some of these glaciers defies imagination, often being several kilometers thick, to say nothing of their extent. When the glaciers retreated, huge chunks were occasionally isolated, insulated by soil and rock. Eventually the enormous chunks melted, leaving depressions in the now-consolidated soil. These depressions, or kettles, became filled with water, forming lakes or swamps of varying sizes.*

Bottom. **Glacial Lakes.** *Almost without exception, lakes in mountainous country are the result of past glacial action in a previously eroded river valley. In river valleys, where glacial ice once spread, large, deep lakes are the result of rivers dammed by terminal moraines, or accumulations of rocks and earth that had been carried by a glacier, and deposited when the ice retreated.*

Adapting to Currents: Immature Insects

Prosopistoma foliacea

Blepharicera

Stenonema

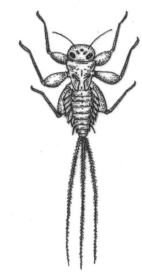

Simulium

Sisyra

Psephenus

Above. *Rivers provide homes for myriad insects. As larvae, the species pictured here are completely aquatic, living entirely underwater in swiftly flowing streams.*

Running water contains more dissolved oxygen than still water, and because these insects require highly oxygenated water for survival, it is not surprising that they have evolved ingenious methods of anchoring themselves against strong currents. If swept downstream into calmer waters, they would die from lack of oxygen. Being well anchored also enables many insects to catch bits of food that flow downstream past them. Some insects even anchor themselves to the very substances on which they feed.

The ventral surface of the mayfly naiad Prosopistoma foliacea *is* flat, and its smooth arched back is curved. The naiad secures its body on rocky beds of mountain brooks, and flowing currents press the animal even more closely to the stones. The net-winged midge larva* Blepharicera *is unique among river insects in possessing six suckers on its underside. Each funnel-shaped sucker has a piston at its base which can be pulled up, making it possible for the larva to grip smooth rocks. Like many current-dwelling insects, the nymph of another mayfly,* Stenonema, *has an extremely flattened body, providing little resistance to water. Its legs are also flattened, with extremely sharp edges and claws, and its plate-like gills overlap, making a suction disc of its abdomen. The blackfly larva* Simulium *can live in the swiftest* water. It weaves a silken mat onto a rock and latches onto this mat with the tiny barbed hooks on its hind end. With its body secured, the larva is able to feed: the fan-like fringed appendages on the animal's head strain food from the current. The spongillafly larva,* Sisyra, *parasitizes freshwater sponges. After it hatches, the larva inserts its mouthparts into the sponge tissue and draws out the sponge's cell fluids. The spongillafly larva also obtains oxygen from the water currents created by the sponge's respiration and its bristles catch passing bits of debris, which serve as camouflage. Flexible plates shielding the body of the larval torrent beetle* Psephenus *are edged with movable spines which seal the larva to the substrate.*

Glossosoma

Molanna

Leptoceridae

Oecetis

Helicopsyche

Polycentropus

Above. *Caddisflies are widely distributed over the Northern Hemisphere. They undergo complete metamorphosis, which makes them unique among the four orders of aquatic insects. In their larval period, most caddisflies build the ingenious cases and nets which also distinguish them from other aquatic insects. These cases and nets conform to the shape of the larvae. They are constructed of different materials, depending on the turbulence of the water in which the larvae live. Those insects living in the swiftest waters build the heaviest cases, which weigh the insects down and protect them as they are roughly tumbled in the rapid water. The Glossosoma larva builds a stone case in the shape of a turtle's shell. A column of* smaller stones bridges the case's opening. When it prepares to pupate, the larva removes the stone bridge and fastens the rim of its case to a rock. Glossosoma larvae are found in cold, fast-running waters. More fragile cases can be built in calmer waters. The Molanna larva, for example, builds a shield-shaped case made only of sand. Many larvae in the family Leptoceridae build cases from plant material— scraps of bark or leaves—bitten into equal pieces and arranged end-to-end in a spiral pattern. Oecetis *cases, found in cool mountain regions, are also made from plant material, often small sticks. One of the most striking cases is that of the* Helicopsyche *larva. This case, shaped like a snail's shell, is made of tiny pebbles and sand.* Polycentropus *larvae make long silken tubes under stones in swift brooks. These nets act like sieves, filtering food from the water as it flows through them.*

205

Representative Freshwater Fishes: The Amazon

Arapaima gigas (2–3 m)

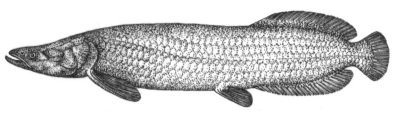

Osteoglossum bicirrhosum (1 m)

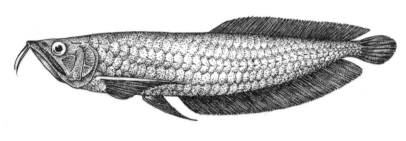

Serrasalmus nattereri (30–60 cm)

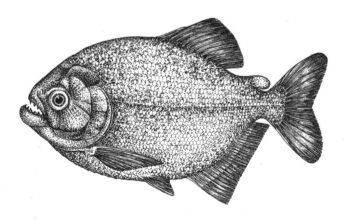

When we think of rivers and the creatures that they support, we are apt to think first of fishes. There are about 20,000 different species of fishes presently known to science. About half live in fresh water and are most likely to be found in rivers at one time or another in their life-cycle.

The most varied of the world's freshwater fish faunas is the Amazon's. Every area has a staple food fish, and the Amazon's is the pirarucú—the Brazilian Indians' "red fish." Its scientific name, however, derives from the Guiana Indians' name, arapaima. Scientists call it Arapaima gigas—"the giant"—and classify it among teleostean fishes of the family Osteoglossidae—the bonytongues. The arapaima is one of the largest of freshwater fishes, perhaps reaching a length of 2–3 meters or more and attaining a weight of 200 kilograms or more. Intensive fishing, helped along by modern methods, has eliminated most large specimens.

Living with the arapaima throughout its vast range in Amazonia (and being part of its normal diet) is another bony-tongue—the arawana (Osteoglossum bicirrhosum). Arawanas grow to a meter or so in length, but most individuals are smaller—just the right-sized meal for their larger relative, the arapaima. Arawanas are mouthbrooders. The male gathers in his mouth the cherry-sized eggs after they are fertilized and incubates them for about three weeks, at which time the little arawanas swim out, ready for life on their own.

Not all fishes are harmless to humans, and the piranhas (Serrasalmus) of the Amazon are among the fishes infamous for their occasional—though much exaggerated—habit of feeding upon humans, as well as other larger animals. Piranhas are not very large, the various species reaching a maximum size of 30 to 60 centimeters. However, they are schooling fishes and even a school of small piranhas is a potential hazard to waders and swimmers. A piranha possesses cutting teeth, with which it bites just the right-sized morsel for one swallow. A piranha normally takes bites out of other fishes, and sometimes other piranhas, as is evident in aquarium specimens, which more than occasionally lose an eye or a fin to the feeding enthusiasm of a tankmate. The name piranha is Indian, and evidently means "toothed fish," although an early writer stated that the name means

Electrophorus electricus (2–3 m)

Gymnotus carapo (60 cm)

Potamotrygon circularis (diameter 30 cm)

"scissors." Actually, "piranha" probably is the name Indians gave to scissors when they first saw one, appreciating its ability to cut as cleanly as the fish jaws that the Indians had used for trimming and snipping long before scissors were introduced by Europeans. There are about four species of dangerous piranhas. Of these, the red piranha (Serrasalmus nattereri) *has the largest distribution.*

Actually more dangerous to human life than piranhas is the electric eel, aptly named Electrophorus electricus. *Large eels, as long as 2–3 meters, are powerful generators (1,000 volts), dangerous to all animals, including humans. Electricity in the water has a paralyzing effect that is proportional to the size of the animal affected. Electric eels themselves are immune to their own discharges, but humans, cattle, and horses, among other animals, are apt to be stunned, and eventually drowned, if they trespass too near larger eels. The eels do not bite or eat the larger animals that might accidentally, as it were, be stunned by the electricity. Electric eels eat fishes, and fairly small ones at that. There are many species of electric eels in the Amazon, but all except* Electrophorus *are only weakly electric (1 volt or less). These electrically weak fishes are also known as knifefishes. The weak electricity is used by the fish as a kind of radar system to navigate at night, when the fish is active, and to some extent, perhaps, to communicate with others of its kind. The banded knifefish* (Gymnotus carapo) *was the first of its kind to become known to science.*

The Amazon also features many other fishes dangerous to humans. The most feared, perhaps, are the freshwater stingrays of the family Potamotrygonidae (genus Potamotrygon). *Related more closely to sharks than to bony fishes, stingrays are well camouflaged bottom-dwelling animals that are difficult to see as they rest motionless, half-buried in the sediment. If trod upon, a stingray lashes its long tail, and may inflict injury upon the unwary by means of a serrated spine located near the middle of the tail. The spine has a lengthwise groove on its undersurface, filled with venom-producing tissue that adds intense pain to what would otherwise be merely a severe laceration.*

Representative Freshwater Fishes: The Zaire

Citharinus congicus (40 cm)

Campylomormyrus rhynchophorus (20 cm)

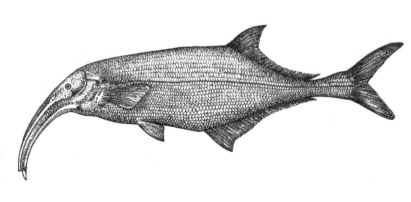

Malapterurus electricus (1 m)

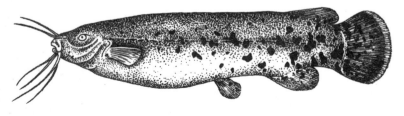

The large rivers of western Africa, such as the Niger and the Zaire, are the counterparts of the Amazon. Although they are now separated by the Atlantic Ocean, in an earlier time, some 100 million years ago, these rivers of South America and Africa may have been represented by a single river system with a single fish fauna. Today there are no freshwater fish species common to the two continents. Related species, however, are common to the two and occur nowhere else on Earth. A close relative of the arapaima, for example—the bonytongue Heterotis niloticus—*occurs in the Niger. And the characoids or characins, the major group of fishes that includes the piranhas, is otherwise known only in Africa. Characoids number about 1,000 species, most of which are South American. A distinctive group of African characoids includes several species of the genus* Citharinus, *silvery deep-bodied fishes that feed on microscopic plants and small crustaceans of the river bottom.* Citharinus congicus *of the Zaire was named when this river was known as the Congo. Although the names of rivers may change with fashion, the scientific names of fishes, once established, may not.*

Electric eels are unknown except in South America, but Africa features a large (100 species) family of fishes, the Mormyridae, that produce weak (1 volt) electric signals. Mormyrids are sometimes called elephant fishes, not only because they are exclusively African, but because many of them have a trunk-like snout. Campylomormyrus rhynchophorus *is an extreme example. Most mormyrids are smallish fishes, up to 20 centimeters long, that probe the bottom, feeding on small insect larvae. Like electric eels, mormyrids are active at night. They have a very highly developed brain, which functions in relation to their keen electric sense. Whereas electric eels are thought to be close relatives of characoids, mormyrids are thought to be close relatives of bonytongues.*

Bichirs are very primitive bony fishes known only from Africa. There are 10 species with pelvic fins (Polypterus) *and one eel-like species* (Calamoichthys), *otherwise known as the reedfish. Among their primitive characteristics are paired lungs and heavy, enamel-covered scales. Bichirs haunt the weedy margins of lakes and rivers in search of small fishes and*

Polypterus ornatipinnis (40 cm)

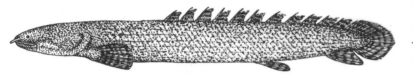

Mastacembelus congicus (30 cm)

Protopterus dolloi (1 m)

amphibians, the principal items of their diet. Young bichirs resemble young salamanders. Polypterus ornatipinnis *is so named for its pretty fins.*

Fifty species of spiny eels (Mastacembelidae), are variously distributed throughout Africa and tropical Asia. These fishes are unrelated to electric eels nor are they related to "true" eels (such as freshwater eels of the genus Anguilla). *Spiny eels are easily distinguishable by numerous sharp spines that precede the dorsal fin. These eels have a fleshy proboscis, used for probing the bottom of swamps and weed-choked areas in search of small food items.* Mastacembelus congicus *is said to grow to about 30 centimeters, but other species of spiny eels grow to twice that size. They are eaten by humans in some areas.*

Strongly electric fishes are represented in Africa by one species of catfish, Malapterurus electricus, *which reaches a size of over 100 centimeters. Like most catfishes, it has whiskers (barbels) around the mouth and lacks scales. It is a sluggish creature and were it incapable of stunning its prey of small fishes it would probably be incapable of catching them. Electric fishes produce their shocks with specialized muscles that have enhanced electrical properties, and the catfish is no exception. It is not a hazard to humans except when caught by fishermen. It is commonly fished for food, and when handled or stepped upon it can stun a person into unconsciousness.*

True lungfishes include only a few species living today: one in Australia (Neoceratodus), *one in South America* (Lepidosiren), *and four in Africa* (Protopterus). *Dollo's lungfish,* Protopterus dolloi, *occurs in the Zaire. Most of the African species regularly estivate—the equivalent of hibernation—when and if the ponds and streams in which they live dry up during the rainless season of the year. Then the lungfish digs a burrow into the ground, coats the walls with a mucus cocoon, and leaves a small breathing tube open at the top. As the water level falls, the fish becomes inactive, curls its tail over its head, and, taking only an occasional breath of air, persists in a sleep-like state until the next rainy season. An estivating lungfish may survive without water for up to four years.*

Megalops cyprinoides (1 m)

Oloplotosus luteus (15 cm)

Nematocentris rubrostriatus (10 cm)

The largest river in the Australian tropics is the Fly, which arises in the central highlands of New Guinea and flows south to the Gulf of Papua. Because of abundant rainfall at its source—as much as 9 meters annually—its volume of flow is perhaps the third largest of the rivers of the world, behind only the Amazon and Zaire. Its known fish fauna numbers over 100 species, far fewer than that of the Amazon (1,300 species) and the Zaire (560 species).

A conspicuous fish of the Fly is the ox-eye herring (Megalops cyprinoides), also called the Pacific tarpon. If the oxygen concentration of the water is low, as it frequently is in tropical swamps and other freshwater areas, the ox-eye comes to the surface to breathe air. This species is widespread along the coasts of the Indian and Western Pacific oceans. Tarpon larvae are ribbon-like forms similar to the larvae of true eels, and it is thought that this similarity of larval structure indicates a close relationship among the fishes.

A newly discovered species of freshwater catfish, Oloplotosus luteus, is unique to the highlands of the upper Fly. It is a member of the family Plotosidae, which includes the venomous marine catfishes of the Indian and western Pacific oceans. In New Guinea and Australia there are a number of freshwater species of this family in the genera Tandanus, Neosilurus, and Anodontiglanis, but the nearest relatives of Oloplotosus seem to be marine forms of the genera Plotosus, Paraplotosus, and others. This relationship is evidenced by a peculiar dendritic organ that hangs between the pelvic fins and vent. The dendritic organ occurs in all marine species, but in no freshwater ones except Oloplotosus luteus. This seems to be an example of a species that was once marine but has become isolated in fresh water. The history of New Guinea is geologically complex. Apparently its northern and southern parts, once separate, collided some millions of years ago; this peculiar catfish of the Fly may have originated when its ancestors were caught in the middle, so to speak, and isolated in fresh water with the uplift of the land.

Other freshwater fishes common to New Guinea and tropical Australia are the rainbowfishes (Melanotaeniidae), so named because of their many subtle colors. They are small, deep-

Toxotes chatareus (40 cm)

Scleropages jardini (1 m)

Kurtus gulliveri (60 cm)

bodied relatives of silversides (Atherinidae), found the world over along temperate and tropical coasts. Rainbowfishes of the genus Nematocentris *are very deep-bodied. Eggs of rainbowfishes have tiny threads that entangle among the leaves of aquatic plants where they are laid. Since predators are attracted by freely floating objects, such anchorage is indeed an advantage.*

Among the many peculiarities of the fish world are the archerfishes, a group of four closely related species of the genus Toxotes *(family Toxotidae). Typically, they grow to about 25 centimeters.* Toxotes chatareus *occurs in the Fly—where it grows to the exceptionally large size of 40 centimeters—and also in coastal rivers from India to Australia and the Philippines.*

Archerfishes cruise just below the water surface, on the lookout for insect prey. They shoot down the insects by squirting water drops at them. Adults' shots are accurate at distances up to 2–3 meters. Though archerfishes have long been kept in aquaria, no one knows how they reproduce.

The nursery fish, also known as the humphead, is unique. One of two closely related species in the genus Kurtus *(family Kurtidae),* Kurtus gulliveri *occurs in the Fly and adjacent regions. The fish is so named popularly because the adult male develops a permanent hook-like structure on the head, above the eyes. The hook is used to carry the eggs, which, though they come in strings during breeding, are packed into a mass around the hook. The male is believed to carry the eggs until they hatch.*

*The northern barramundi (*Scleropages jardini*) is a bonytongue that, like* Osteoglossum *in South America, is a mouthbrooder. But in this case it is the female, and not the male, that carries the large eggs and then, for a time, the newly hatched young. The northern barramundi occurs also in the rivers of northern Australia, and a closely related species, the spotted barramundi (*Scleropages leichardti*), is native to the Fitzroy River of Queensland, Australia. The only other bonytongue in existence is* Scleropages formosus, *an Asian species of Banka, Borneo, Malaya, Sumatra, Thailand, and Cambodia. It too is a mouthbrooder, and the female carries the eggs.*

Maccullochella peeli (2 m)

Gadopsis marmoratus (60 cm)

Retropinna semoni (10 cm)

The system of rivers that includes the Murray and the Darling is the largest of Australia proper, and in terms of land area and river length the system is among the largest in the world. Yet much of Australia is seasonally arid, and the water flow of the whole system amounts only to some 15 cubic kilometers per year—by far the smallest of any of the large river systems of the world. Before European settlers began to construct dams in the 1920s, the system flooded large areas during the wet season, and in the dry season there were only isolated pools in long stretches of an otherwise dry riverbed. These extreme conditions perhaps account for the fact that only 20 species of native freshwater fishes have so far been recorded.

The most conspicuous species—it grows to a size of 2 meters and 100 kilograms—is the Murray cod (Maccullochella peeli). This edible, bass-like fish is not really a cod, but was so named by early settlers. The Murray cod is an opportunistic feeder, well suited to the changing conditions of its habitat. Its breeding coincides with the rise of water and water temperature brought on by rains. Spawning typically occurs in hollow trunks and on branches of gum trees (Eucalyptus camaldulensis) that have fallen into the river through erosion of the riverbank. The species may live over 30 years.

An enigmatic fish restricted to the smaller and higher tributaries of the Murray-Darling and adjacent rivers is the blackfish (Gadopsis marmoratus). This insectivorous species was once more abundant, but its numbers have diminished, possibly due to the introduction of Northern Hemisphere trout, which eat the same sorts of food. Because its relationships to other fishes are obscure, the blackfish has traditionally been placed in its own family (Gadopsidae) among perch-like fishes.

With many species in southern Australia, Tasmania, and New Zealand, the family Retropinnidae is the southern counterpart of the smelt family (Osmeridae) of the Northern Hemisphere. Some species occur in the sea near river mouths, but enter fresh water to spawn. Other species are entirely freshwater in habit. Like their northern relatives, southern smelts are immediately recognizable by the small adipose fin between the dorsal and caudal and by a distinctive odor reminiscent of cucumbers. The Murray-Darling species is Semon's smelt

Bidyanus bidyanus (60 cm)

Tandanus tandanus (60 cm)

Galaxias maculatus (20 cm)

(Retropinna semoni). *It feeds on plankton, particularly algae, and insect larvae. It is a favorite food of the Murray cod.*
Another southern counterpart, this time of the trout and salmon family (Salmonidae) of the Northern Hemisphere, is the family Galaxiidae. Members of this family are easily distinguishable from their northern relatives; Southern Hemisphere fishes lack an adipose fin and they are without scales. Southern trout species occur in the temperate streams and rivers of South Africa, southern South America, New Zealand, Tasmania, and southern Australia. There is even one species in tropical New Caledonia. Scientists have long wondered whether this kind of distribution is due to the effects of continental drift or to the ability of the fishes to migrate through the oceans. One of the more interesting species is the jollytail, or New Zealand whitebait (Galaxias maculatus). This species is widely distributed, with populations in Australia, Tasmania, New Zealand, and South America. Perhaps the most fascinating aspect of the jollytail is its spawning habits. Adult individuals migrate downstream to river estuaries and spawn among aquatic plants during the peak of the spring tides. The eggs remain attached to the plants, and out of direct contact with the water for 28 days, until the high tides of the next lunar month. How jollytails know when to lay their eggs is still a mystery.
Two other large fishes typical of the Murray-Darling are the tandan (Tandanus tandanus) *and the silver perch* (Bidyanus bidyanus). *A member of the family Plotosidae, the tandan is a catfish that may grow as large as 90 centimeters. The silver perch is not a perch at all, but rather one of many species of grunters* (Theraponidae) *that are distributed along the coasts of the Indian and western Pacific oceans. (Grunters are so named because of the sounds, made by contracting muscles attached to the swimbladder, the fishes make when removed from the water.) The silver perch spawns planktonic eggs that are just a little heavier than water and sink to the bottom under quiet conditions. As is typical for fishes of this region, tandans and silver perch spawn when the water level and temperature rise with the coming of seasonal rains.*

Representative Freshwater Fishes: The Ganges

Barilius bola (30 cm)

Barbus tor (1 m)

Pangasius pangasius (1.5 m)

The first scientific report of the freshwater fishes of India was published in Edinburgh, Scotland, in 1822 by Francis Hamilton, a surgeon of the British East India Company. His report, An Account of the Fishes Found in the River Ganges and Its Branches, described some 270 species, of which 100 were marine forms that he found in the lower Ganges near Calcutta. Of the 170 freshwater species, 80 were minnows and 50 were catfishes. There is no up-to-date list of Ganges fishes, but for India as a whole, there are now about 700 known freshwater fishes. One-half are minnows, and one-fourth are catfishes.

Minnows and catfishes, together with characoids and electric eels, are the four major types of a group of teleostean fishes named Ostariophysi. All species have a bony interconnection between swimbladder and internal ear that enhances hearing. Ostariophysans, which number about 5,000 species worldwide, are usually the most conspicuous freshwater fishes in continental areas.

To most people a "minnow" is a small, nondescript freshwater fish, but actually minnows, ostariophysans of the family Cyprinidae, may vary markedly in appearance, existing in all sizes and shapes. One of the prettiest minnows of the Ganges is the Indian trout (Barilius bola). In form and color it resembles trout of the family Salmonidae. The Indian trout occurs in many rivers of the north, from the Punjab to Burma, where it lives in clear streams with rocky bottoms. Like trout, it feeds on insects and small fishes.

One of the largest minnows of the world is the tor mahseer (Barbus tor). Like the Indian trout, it is widely distributed in the foothills of the Himalayas. The tor mahseer has a tendency toward fleshy development of the lips, very pronounced in some individuals. Its colors are striking: golden-green back, gold sides, silver belly, and red-orange fins except for the dorsal, which is dark blue-green. It feeds mostly on plants, but may also eat fallen leaves and snails. Like other fishes that feed predominantly on plants, it has a long intestine that is up to five times the length of the fish itself.

Another giant of its kind is the Pungas catfish (Pangasius pangasius). Reaching a meter and a half, it is still a dwarf in comparison to its sister species from Thailand (Pangasius

Anabas testudineus (25 cm)

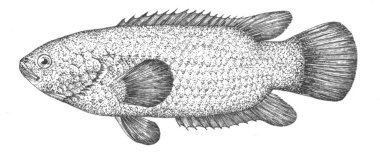

Heteropneustes fossilis (70 cm)

Aplocheilus panchax (8 cm)

sanitwongsei), *which reaches twice that length. The Pungas catfish lives in large rivers and estuaries from India to Java. It is said to breed in the lower estuaries during the rainy season. Perhaps because its haunts are so near the sea, it is locally known as a freshwater shark. It is active at night and is apt to eat anything, including refuse.*

Some fishes of tropical fresh water have air-breathing organs that enable them to live in unfavorable conditions. Tropical fresh water is often low in dissolved oxygen, not only because high temperature reduces oxygen solubility in water, but also because there is often organic matter undergoing bacterial decomposition and thereby consuming what little oxygen there is. Air-breathers of the Ganges include several families of teleostean fishes, among which are the Anabantidae and Heteropneustidae. The 25-centimeter climbing perch (Anabas testudineus), *which is widespread in the Asian tropics, has an air-breathing organ in the gill cavity. Its eggs float to the surface where they find sufficient oxygen for survival. Other members of the family build nests of bubbles wherein the eggs develop at the water surface.*

In 1791 an observer found an Anabas 1.5 meters above the ground, climbing a Palmyra palm tree, in a freshet of rainwater running down the trunk. Since then it has had the name and reputation of a climber. Actually, however, it has the habit of traveling overland for only short distances in order to move from one body of water to another. The air-breathing catfish (Heteropneustes fossilis) *is similarly widespread. Its air-breathing organ is unique among fishes: the organ is formed by two hollow tubes that extend from the gill cavity through the muscles of the sides and towards the tail. The fishes' pectoral spines are sharp and said to be venomous.*

One of the many small tropical fishes kept in home aquaria is the blue panchax (Aplocheilus panchax), *a killifish of the family Cyprinodontidae. As an aquarium fish it is pretty, needs little care, and does not seem to mind humans observing its reproductive activities. This fish lives in small streams, and also in ponds and ditches, where it is valued because it consumes mosquito larvae. Blue panchaxes range from India to Indonesia.*

Representative Freshwater Fishes: The Danube

Perca fluviatilis (50 cm)

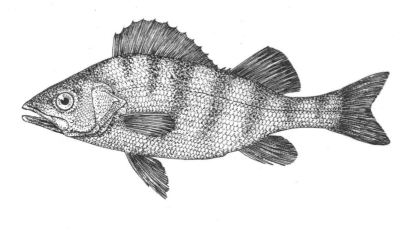

Rutilus rutilus (50 cm)

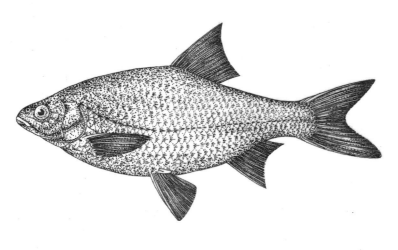

Rhodeus amarus (9 cm)

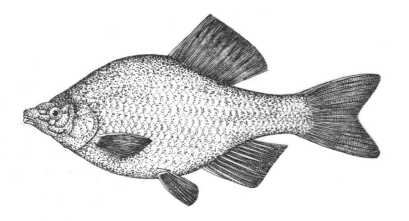

The Danube, at 2,850 kilometers, is Europe's second longest river. Only the 3,690-kilometer Volga is longer. About 75 species of fishes occur in the Danube.

The principal families are minnows (Cyprinidae), loaches (Cobitidae), and true perches (Percidae). Loaches are found throughout temperate and tropical Eurasia. Most are bottom-dwelling forms that resemble either catfishes (they have three or more pairs of barbels around the mouth) or eels (some species are elongate). Of the six species of loaches that occur in the Danube, the weatherfish (Misgurnus fossilis) is the largest, sometimes reaching 30 centimeters. It prefers swampy conditions where oxygen is low. To compensate, it occasionally swallows air at the surface. Bubbles pass through the intestine and out the vent; meanwhile oxygen is absorbed by the folded mucus lining of the gut. The weatherfish has long been kept in home aquaria, where it has gained the reputation of sensing approaching thunderstorms, at which time the fish is uncharacteristically active. Thunderstorms are accompanied by low atmospheric pressure; any bubble in a loach would expand as the barometer falls. No wonder the fish might become active at such a time.

Of the many large minnows fished for sport and food in Europe, perhaps the best known is the roach (Rutilus rutilus). This attractive species is extremely abundant throughout its large range, from England to central Russia. It is tolerant to low oxygen, warm water, and moderate pollution, and its feeding habits are diverse. It has been introduced in many areas the world over.

The bitterling (Rhodeus amarus) is a minnow native to a region extending from northern France to the Black and Caspian seas. It frequents weedy areas of ponds, small lakes, and sluggish streams. It, too, can withstand low oxygen levels. The bitterling has a cunning reproductive strategy. Its reproduction proceeds with the cooperation of a freshwater mussel (Anodonta cygnaea), into which the female deposits her eggs by means of a long tube (ovipositor). The male releases sperm in the vicinity, which the mussel obligingly draws in through the incurrent siphon. Fertilization of the eggs and development of the young fish occur within the clam over a period of 2–3 weeks. The young

Misgurnis fossilis (30 cm)

Lota lota (1 m)

Salmo trutta (140 cm)

emerge a few days after hatching, leaving the mussel intact, but with nothing in return for the shelter it provided. Earlier in this century the bitterling was introduced into New York State with no apparent result, suggesting to one observer that the native American mussel is inadequate to the task of nursing fish eggs and embryos. Since then Rhodeus *has been sporadically collected, as recently as 1980, in the area of its introduction, indicating that the fish somehow manages to cope, even without the mussel of its choice.*

True perches (Percidae) are among the fishes that typify life of Northern Hemisphere fresh water. There are about 125 species. The two species best known are the yellow perch (Perca flavescens) *of North America and the closely related and very similar river perch* (Perca fluviatilis) *of Europe and temperate Asia. The latter species is at home in weedy areas of lakes and quiet rivers. Very large specimens attain nearly 5 kilograms, but most are small, as every angler knows. The fish preys on invertebrates when it is young; later it consumes small fishes.*

A freshwater species ubiquitous in the Northern Hemisphere but seldom seen or caught is the burbot (Lota lota). *The burbot is the only freshwater cod* (Gadidae). *It attains a large size (1 meter) and is of a distinctive shape with a single whisker (barbel) on the chin. It is a secretive bottom fish active only in the dim light of dawn and dusk. Large females produce eggs, which number into the millions.*

Although Salmo trutta *belongs to the same genus as the Atlantic salmon* (Salmo salar), *it is variously called a European trout, brown trout, or sea trout. In the northern part of its native range in Europe, it migrates to the sea, but some 6 months to 5 years later returns to fresh water to spawn. Permanent freshwater populations occur in rivers of southern and eastern Europe, where the warm waters of the Mediterranean are an obstacle to migration. To provide sport fishing, usually at the expense of native fishes,* Salmo trutta *has been introduced "successfully" in many areas around the world: North and South America, New Zealand, Australia, Africa, and India.*

Polyodon spathula (2 m)

Atractosteus spatula (3 m)

Lampetra lamottei (20 cm)

The Mississippi River, it is said, was discovered by Hernando de Soto in 1541, and rediscovered by Jacques Marquette and Louis Jolliet in 1673, when they traveled down the Wisconsin River to its mouth. According to legend the explorers were warned by local Indians to go no farther, for ahead lay certain destruction in the form of river demons and giant fishes. Mark Twain later surmised that the paddlefish (Polyodon spathula) was one of the fishes that the Indians had in mind. The American paddlefish is large—particularly the female—reaching a length of over 2 meters and a weight of 50 kilograms. It is an inoffensive creature that swims along slowly, feeding on plankton. The function of the long paddle-like snout is still a mystery, as are many of the habits of this primitive bony fish. There is only one species of paddlefish in North America, and one related species (Psephurus gladius) that lives in the Yangtze River of China. The two species are grouped in their own family (Polyodontidae).

North America possesses two other sorts of unique and primitive bony fishes, both present in the Mississippi: gars (Lepisosteidae) and the bowfin (Amiidae). There are seven species of gars in two genera (Lepisosteus and Atractosteus). These fishes resemble bichirs, with heavy enamel-covered scales (sometimes used for making jewelry) and elongate bodies, but they are distinguished principally by their long snouts, which have developed differently in the various species. Reaching a length of over 3 meters and a weight of 150 kilograms, the alligator gar (Atractosteus spatula) is the largest species. Despite its size, the alligator gar has the shortest snout of the seven species. The gars' snouts are primarily fish-catching devices, and they are well supplied with many sharp teeth. Although it is primarily a fish-eater, the alligator gar has been known to feed on birds.

The bowfin (Amia calva) is widely distributed throughout the Mississippi Valley, the Great Lakes, and the Atlantic coastal plain as far north as New York. It prefers quiet water and swampy conditions. It is an air-breather, using its swimbladder, which is richly supplied with blood vessels, as a lung. Air-breathing is usually discontinued in cold weather, when the fish are less active, but in lakes that are particularly low in oxygen,

Amia calva (1 m)

Etheostoma nigrum (7 cm)

Alosa alabamae (40–50 cm)

bowfin may surface to breathe so frequently that an area of open water on a lake surface that would otherwise freeze entirely in winter remains unfrozen. Bowfin spawn in the spring in a nest prepared by the male, who guards the eggs and for a time herds the swimming young into a compact school. Bowfin eat aquatic organisms of all sorts, but adults concentrate on fishes. There is only one species of bowfin, and it is classed in its own family (Amiidae).

Lampreys are very primitive animals without jaws or paired fins. They resemble eels, although eels are related more closely to sharks than to lampreys. There are about 24 species that inhabit the temperate parts of both Northern and Southern hemispheres. (Most species occur in the north.) The American brook lamprey (Lampetra lamottei) is rarely seen except by the determined collector. The lamprey spends most of its 5-year life span as an immature form, burrowing within soft-bottomed areas of streams. It feeds on microscopic organisms strained from the water. Toward the end of its fourth or fifth year—it has by this time reached a length of 20 centimeters—it stops feeding and begins to transform into the adult. The eye enlarges, the color changes from brown to silvery, and the animal shrinks a centimeter or so. In spring, the lamprey spawns, after which all the adults die.

Aside from its collection of primitive curiosities, the Mississippi harbors nearly 300 other fish species, of which the minnows (Cyprinidae) and perches (Percidae) predominate. Of minnows, species of the genus Notropis are legion. Of perches, darters of the genus Etheostoma are also very numerous and uniquely North American. The johnny darter (Etheostoma nigrum) is one of the more commonly encountered. It is found in streams and rivers where it feeds primarily on insect larvae. When johnny darters spawn, they turn upside down, attaching the eggs to the undersurface of rocks. Another fish of the Mississippi is the Alabama shad (Alosa alabamae), one of 300 species of herring-like fishes (Clupeidae and Engraulidae) found the world over. Shads occur in the North Atlantic, and in land-locked lakes of adjacent regions. In spring they run upriver to spawn. The adult Alabama shad reaches a size of 40–50 centimeters.

Representative Freshwater Fishes: Lake Baikal

Comephorus dybowskii (20 cm)

Procottus jeittelesi (18 cm)

Abyssocottus pallidus (18 cm)

Baikal is the world's deepest lake (1,600 meters) and one of the largest (31,500 square kilometers of water surface and more than 2,000 kilometers of shoreline). It is home to about 1,200 species of animals, over one-half of which occur nowhere else. There are approximately 50 species of fishes, half of which are known only from the lake and its immediate vicinity. Such species are termed endemic. Generally speaking, endemism is the result of isolation, which in the case of Baikal began perhaps as long ago as 100 million years. For living organisms, isolation in a lake like Baikal makes possible the evolution of new species— the coming into being of species endemic to a particular area.

Fish species endemic to Baikal are all sculpins, teleostean fishes known as cottoids. Two sculpin families are represented, Comephoridae and Cottidae. The entire family Comephoridae is endemic to the lake, but it includes only two very distinctive species, Comephorus baicalensis and C. dybowskii, sometimes called Baikal cod. Both are live-bearers, the female producing 2,000-3,000 young. C. dybowskii produces young in early spring (February–April), whereas C. baicalensis bears young in the fall (September–October). Throughout their lives both species feed mostly on crustaceans.

The other group of Baikal sculpins, sometimes considered a separate family, the Cottocomephoridae, includes two dozen species. All but three of these species are confined to the lake and its immediate vicinity. Like most sculpins, all but two species are bottom-dwellers. The males of all species guard the eggs that are laid on the bottom. Spawning usually occurs in early spring, but two species, including Procottus jeittelesi, spawn in the fall. Most of the species migrate into shallow water in the spring and return to deep water in winter. Species of the appropriately named genus Abyssocottus are the only freshwater counterparts of deep-sea fishes. An example is the slender miller's thumb, A. pallidus.

Baikal sculpins are fished commercially, but the most important food fish is a lake whitefish, the Russian omul (Coregonus autumnalis). About 10,000 tons of fishes are annually taken from Baikal, of which about 70 percent is omul. There are 30 or more species of

Coregonus autumnalis (35 cm)

Thymallus arcticus (35 cm)

Acipenser baeri (180 cm)

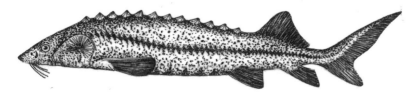

whitefishes in Northern Hemisphere fresh water. As a group they are allied to salmons and trouts (Salmonidae) but are sometimes placed in their own family (Coregonidae). Coregonus autumnalis, *also called the Arctic cisco, normally inhabits the Arctic Ocean, but in its fall spawning runs it ascends rivers along the Arctic coast of the Soviet Union. The Baikal whitefish is isolated by dry land from the ocean, but behaves in a similar way by ascending the small rivers that drain into Baikal. Spawning occurs in the shallows just when the rivers are beginning to freeze in late September. After spawning, the adults return to the lake for the winter. The Baikal whitefish, which reaches 10 years of age, is recognized as an endemic subspecies,* Coregonus autumnalis migratorius.

Other relatives of trouts and salmons are graylings (Thymallus), *sometimes allied to whitefishes, but usually placed in their own family (Thymallidae). Baikal claims two endemic forms of the Arctic grayling* (Thymallus arcticus), *sometimes listed as subspecies* (Thymallus arcticus baicalensis *and* T. arcticus brevipinnis). *This is a strange notion to some scientists, who believe that no more than one subspecies can occur in a given area. The better known of the two fishes, the black grayling* (baicalensis), *frequents shallow water. It spawns in the summer. Its diet consists of insects, crustaceans, and fish eggs. The white grayling* (brevipinnis) *dwells in deeper water; its habits are less well known.*

No fish more typifies life in the north than the sturgeons (Acipenseridae), the largest freshwater fishes. The beluga (Huso huso) *is pre-eminent in its record size (5 meters) and weight (1,500 kilograms). Most of the 25 species live in central Eurasia. Baikal features a land-locked form of the Siberian sturgeon,* Acipenser baeri, *that normally lives in the Arctic Ocean and in the summer ascends rivers to spawn. The Baikal form is considered another subspecies,* Acipenser baeri stenorhynchus. *All sturgeons grow slowly and are long-lived if not molested by humans. The Baikal species does not achieve sexual maturity until males are 11–13 years old, and females 17–18. Sturgeons may be prized for their caviar, but science prizes them as primitive bony fishes with many unique qualities.*

Glossary

Adaptive radiation. The emergence, through evolution from a common ancestor, of a variety of specialized species, each with its own ecological niche or way of life.

Alluvial plain. A flat expanse of rich sediments deposited when a river overflows its banks; a flood plain, which fills and levels a previously deep valley.

Alluvium. Sedimentary materials deposited by flowing water, as in flood plains, deltas, the continental shelf, and exposed coastal plain.

Angara River. The only outlet from Lake Baikal and a major tributary to the Yenisei; a river 1,842 kilometers long that runs through Siberian coniferous forest.

Aristotle. 384–322 B.C. Great Greek philosopher who was a keen observer and interpreter of the natural world, including plants and animals. Much of his zoological work in his *On the Parts of Animals* is still valid today.

Backwater. A quiet, almost currentless pocket off a river's main channel. In backwaters, life forms resemble those of a pond more than those of flowing water.

Brackish water. A mixture of fresh inland water and salt water from the ocean; a general term referring to water of reduced salinity.

Brook. A general term applied to upland headwaters. Typically, the volume of a brook is small; velocity is high, and the waters are cold, turbulent, highly oxygenated, and clear. Brooks are usually seasonally variable.

Condensation. The process by which coalescing, airborne water molecules form water droplets which in turn continue to grow until gravity causes them to fall. Before falling, condensed water molecules are visible as clouds.

Continental shelf. The portion of a continent that extends out beneath the surface of the sea in relatively shallow water. Beyond the shelf, the continental slope descends to the ocean floor.

Leonardo da Vinci. 1452–1519 A.D. Italian painter, sculptor, architect, musician, engineer, mathematician, and scientist who paid special attention to the workings of the human body and to natural and physical laws governing the earth and solar system.

Delta. A roughly triangular flat deposit of alluvial soil at the mouth of a river, usually shot through by diverging branches of the main stream. Deltas are often heavily vegetated regions with abundant wildlife.

Detritus. Extremely fine particulate matter of organic origin, the result of decay of vegetation.

Ephemeral river. A river whose channel is flooded only at certain times of the year due to seasonal rainfall or snowmelt; at other times the riverbed may either be completely dry or consist of unconnected pools.

Estuary. A variable habitat that is created as a river nears the sea,

becomes subject to oceanic tides, and blends its fresh water with salt water.

Evaporation. The conversion of surface water or ice molecules into widely dispersed gaseous form; when water evaporates, an enormous amount of heat is lost in molecular activity, making this a cooling process.

Everglades. Flooded sawgrass swamps which actually compose an enormous, slow-flowing river 10,300 square kilometers in area. The primary source of the Everglades is Lake Okeechobee.

Fall line. The boundary in a river between an ancient continent and the sedimentary deposits of its coastal plain. The fall line is marked by rapids or waterfalls.

Fjord. A deep, narrow coastal valley that has been flooded because of a rise in sea level; ground out by glaciers, it may be nearly 1,300 meters deep at the mouth.

Floodplain. A flat, alluvial floor of a river valley resulting from the deposit of sediments during seasonal peaks in river flow that follow the melting of snow or spring storms.

Flotsam. Material, often of organic origin (leaves, twigs, dead insects, etc.) carried along by the current of a stream.

Gastroliths. Rocks, pebbles, or other foreign objects ingested by crocodilians and held in a gizzardlike portion of the stomach. Gastroliths are used as mechanical aids to digestion in crocodilians;

muscular contractions of the stomach wall cause the stones to grind the food into finer particles, making chemical digestion easier. In effect they serve as "chewing" teeth, since the actual teeth of crocodilians are used primarily for grasping prey.

Glaciation. The process by which glaciers are formed: when snow that falls at high altitudes does not completely melt or evaporate during warm seasons, the result is a gradual accumulation of ice crystals.

Glacier. An enormous mass of ice formed from compacted snow accumulated over long periods of time. The great weight of the ice causes the bottom of a glacier to become "syrupy," and allows the entire mass to move very slowly downslope.

Gorge. A narrow, steep-walled rocky cleft through which a torrential stream runs, its high velocity assured by the confining walls. Some gorges today, however, may either be dry or contain ephemeral streams.

Great Dividing Range. A rambling, loosely connected mountain range paralleling the coast of eastern Australia, forming a divide between the short east coast streams and the watershed to the west which gives rise to the Murray-Darling system. The range stretches for approximately 3,200 kilometers.

Ground water. Water that saturates the soil, forming a water table. The more water in the soil, the closer ground water lies to

the surface; this depends on the amount of rainfall, land slope, and depth of the soil above the impermeable rock layer.

Hammock. A rise, almost an islet, in the flooded Everglades. Hammocks are crowned with dense vegetation including trees that prefer a somewhat drier soil that is otherwise unavailable in this area.

Headstream. An upper tributary—usually the one leading from the source—of a large river.

Headwater. The stream flowing from the source—a spring, lake, or glacier—of a major river.

Iron Gate. A violent, impressive gorge in the Danube on the Rumanian and Yugoslavian borders, about three kilometers long. It was a severe navigational hazard until a bypass canal was constructed in 1890, and in the 1960's a dam that regulated flow was added.

Kunlun Mountains. A great range over 1,600 kilometers long, close to the Himalayas, that is the source of the Yangtze, Mekong, and Hwang (Yellow) Rivers; it constitutes the natural northern boundary of Tibet.

Lake Okeechobee. Next to Lake Michigan, the largest body of water held within the continental United States. The lake's area is 1,900 square kilometers, but it is very shallow—no more than five or six meters deep.

Levee. A man-made or natural earthen embankment that runs

parallel to a river's course, altering or preventing floodplain inundation.

Meander. A winding stream created as the result of deflection by irregularities along one bank which directs waterflow toward the opposite bank.

Meltwater. River water whose source is either a snowfield or the edge of a glacier. At the close of each glacial epoch, meltwater rivers were among the largest ever to exist and profoundly changed the face of the land.

Monotreme. The lowest order of mammals, including only the platypus and the echidna. Both of these animals lay eggs and have other primitive characteristics.

Mount Huagra. The 5,100-meter Peruvian mountain from which the Huaraco—the source of the Amazon—arises as a spring.

Mud flat. A deposit of fine particulate matter with a high organic content. Mud flats may be precursors to salt marshes if conditions permit the establishment of cord grass.

Oxbow lake. A pond or lake created when a meander loops to such an extent that the stream breaks through an increasingly narrow isthmus, isolating the loop channel which then becomes still water.

Percolation. The permeation and descent of water—pulled downward by gravity—through soil. Ultimately the water table is reached; percolated water may then move horizontally.

Permafrost. A permanently frozen layer which lies under tundra soil. Permafrost is the result of severe annual temperatures that average −2.2° Celsius.

Plankton. Minute aquatic organisms, both plant and animal, that live close to the surface of slowly moving or still water, and which drift about and are carried by water movement.

Plate tectonics. The science of movements of the earth's great crustal plates which carry with them the continents. Perception of the change of position in continents relative to one another was known earlier as continental drift, but is now recognized as only one feature of plate tectonics.

Pneumatophore. A branchlike structure that rises from the roots of mangroves in shallow water. It allows an exchange of gases between plant and atmosphere.

Pool Malebo. A large shallow lake, 35 kilometers long and 23 kilometers wide that interrupts the Zaire. It was formerly called Stanley Pool.

Rift Valley. A great tear in the earth's surface in western Africa that resulted from the shifting of crustal plates. It occupies 173,854 square kilometers and in its 100-kilometer-long extent includes many inactive volcanoes and lakes.

River basin. A major topographic feature that is the result of prolonged erosion by river currents; often partly or heavily filled by sediments and alluvium with a river channel

coursing through the center.

Ruwenzori Range. A huge, 125-kilometer-long block of faulted rock arising from the old African floor, with a series of lakes and peaks rising to over 5,000 meters; on the border between Uganda and Zaire.

Salt front. A fairly abrupt change in salinity in the lower reaches of a river caused by an incoming flood tide bringing with it the salts of the ocean.

Salt marsh. A flat, coastal grassland of extraordinary productivity that is inundated periodically by high tides, especially monthly spring tides, that occur during the full moon.

Sargasso Sea. A vast "eddy" in the central Atlantic, 20° to 35°N by 30° to 70°W over depths up to 7,000 meters. It is characterized by weak currents, low rainfall, high rate of evaporation, and by light winds.

Johannes Schmidt. 1877–1933; Danish biologist who first successfully worked out the life history of the European eel; previously the life cycle of this fish had been shrouded in mystery and encumbered by myth and legend.

Sedimentation. The process by which fine particulate matter, formerly carried by river current, begins to drop out of suspension as current velocity diminishes, forming a thick substrate on the bottom of a bay or offshore.

Sirenian. An order of aquatic herbivorous mammals which includes

only five species: three species of manatee and two species of dugong. All of these quiet, defenseless animals are endangered due to extensive hunting.

Spring. Water which issues from the earth as a result of an aquifer, or water-bearing stratum, and emerges at the surface. Often springs occur far from where water originally percolated downward into the ground.

Stream. A general term applied to flowing water intermediate between a brook and a river. Typically a stream is more variable in temperature than a brook, slightly turbid but still transparent to light, slower, and with less dissolved oxygen.

Stream capture. A process by which one stream cuts through a separating divide into a valley occupied by another stream; the first diverts the waters of the second into its own channel. Downstream from the point of capture, the second stream must begin over again, its flow much-reduced.

Substrate. The bottom of a body of water. It may consist of a rock outcropping, boulders, gravel, sand, silt, or organic detrital sediment.

Tethys Sea. An ancient ocean that 300 million years ago formed a barrier between the southern supercontinent, Gondwanaland, and the northern supercontinent, Laurasia.

Tributary. A stream that contributes to a larger stream or river; each great river is the sum of its hundreds or thousands of tributaries.

Turbidity current. The rapid flow of dense sediments which, having accumulated beyond the mouth of a river on the continental shelf, flow rapidly down the continental slope and erode submarine canyons.

Waterfall. The abrupt descent of a river or stream from a high level to a lower one.

Waterfall recession. The process by which waterfalls recede slowly upstream from their original sites. This occurs when high water velocity plunging over a lip creates an erosional turbulence at the foot that undercuts the cliff and causes the lip to crumble from time to time.

Watershed. A high point, often a ridge, that divides two drainage areas; water falling only meters apart may ultimately be deposited in entirely different oceans, carried there by rivers flowing in opposite directions in the two drainage areas.

Water table. The depth below which soil is saturated with water that has percolated down from rain, or entered horizontally from rivers and lakes.

Index

Page numbers in bold face type indicate illustrations

227